Vermeer

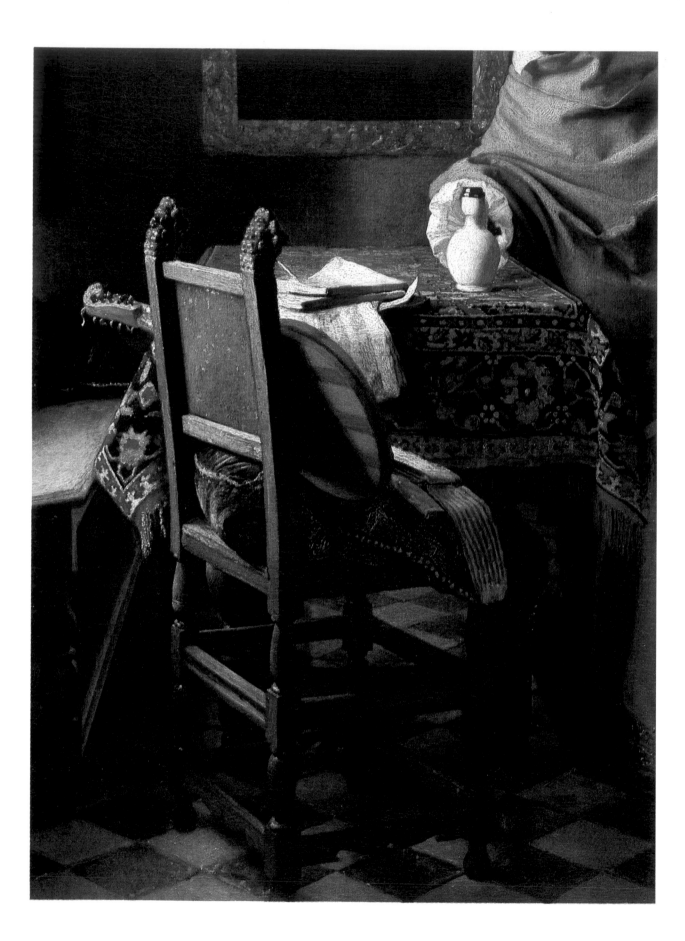

John Nash

Vermeer

Scala Books
Published in association with
the Rijksmuseum Foundation, Amsterdam

© 1991 Rijksmuseum, Amsterdam

First published in 1991 by
Scala Publications Ltd
3 Greek Street
London W1V 6NX

Distributed in the United States and Canada
by Rizzoli International Publications, Inc
300 Park Avenue South
New York
NY 10010

ISBN 1 870248 62 7 hardback
ISBN 1 870248 63 5 paperback

Designed by Andrew Shoolbred
Edited by Paul Holberton
Produced by Scala Publications
Typeset by August Filmsetting, St Helens, England
Printed and bound by New Interlitho S.P.A., Milan, Italy

Frontispiece:
Johannes Vermeer
The glass of wine (detail)
Gemäldegalerie, Berlin-Dahlem
(Reproduced in full on p.69)

Contents

Introduction: The View of Delft

The great *View of Delft* by Jan Vermeer, now in the Mauritshuis, The Hague, the first of his paintings to enter a public collection, is unique among his known works. The canvas known as *The little street [Het Straatje]*, in the Rijksmuseum, and a lost piece recorded as "A view of some houses" are the only other exteriors. The *Little street* is a small work, little more than a fifth the size of the *View of Delft*, and the lost work is unlikely to have been larger. But the *View of Delft* (98.5 × 117.5 cm) is almost the largest picture the mature Vermeer ever painted.

It is not a landscape in the contemporary manner. That is, it is not a pictorial invention with a rural motif. It is a topographical view of the town, apparently giving an accurate record of its appearance from the south as it was in the early 1660s. Prominent, immediately across the river Schie, are two of the city's gates, the Schiedam gate on the left and the Rotterdam gate on the right. In the distance, above the roof-tops can be seen the towers of the Oude Kerk (Old Church) on the left and the Nieuwe Kerk (New Church) to the right. So vivid and distinctive is the impression of visual accuracy given by the painting, that it has been suggested that despite its considerable scale and the novelty and impracticability of the procedure at the time, it must have been painted on the spot, directly from observation, rather than in the studio after drawings. The discovery on a map of Delft published in 1649 that on the bank of the river Schie among gardens and open land is a solitary building at exactly the spot where the artist would have needed to work has given credibility to the hypothesis. It has even been proposed that the building could have, at least temporarily, housed a *camera obscura*. This optical device would have projected an image of the town on to a screen. By its aid, Vermeer could have achieved the precise perspective his painting exhibits and also certain curious optical effects that are unique to his work. For what strikes the viewer of the painting itself is its total difference from the topographical pieces of Gerrit Berckheyde or Jan van der Heyden or others. They show every brick and minute feature of the scene. Vermeer establishes the scene as viewed from a distance. And he achieves this by brilliant optical and painterly inventions that can only have been developed in front of the subject.

Topography is a branch of geography and by the second half of the seventeenth century topographical representations were of two principal types. There was the bird's-eye view, which provided a quasi-map and called for considerable inventive ingenuity from the artist, and there was the panoramic profile. Among the earliest of the latter is an anonymous woodcut *View of Antwerp* of 1515. This already has the format adopted by later topographers. The town is presented as a frieze of architectural elevations with a narrow band of sky (cluttered with inscribed cartouches, escutcheons and allegorical figures) above and below the river busy with maritime traffic, and the near bank of the river appears as a narrow strip along the bottom edge. In paper prints the scroll format is attractive, in paintings it is less so. Yet in the flat Netherlands, it was hard to avoid. When the draughtsman was at the distance necessary to view the full extent of the town it became on his drawing paper a narrow

Johannes Vermeer
View of Delft
Canvas, 98.5 × 117.5 cm
Mauritshuis, The Hague

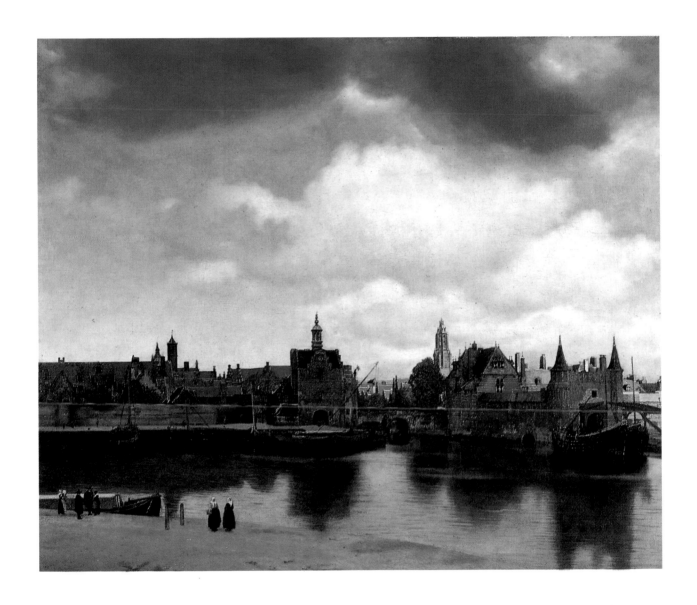

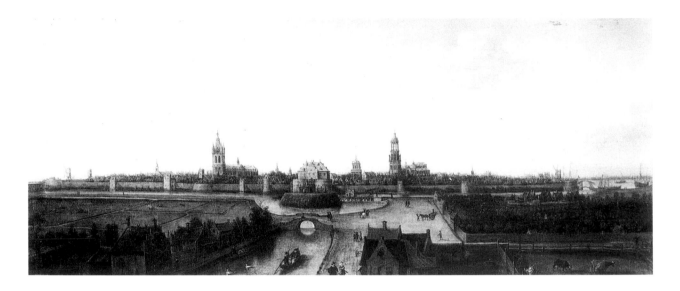

Hendrick Vroom
View of Delft
Canvas, 71 × 160 cm
Gemeente Musea, Delft

ribbon spiked with towers. So the majority of painted topographical views of towns are cast in the narrow extended form of the topographical print.

This is true of two views of Delft that Vermeer must have known. These were both by Hendrick Vroom and both are now in the Delft Stedelijk Museum "Het Prinsenhof". There is a *View of Delft* from the west of 1615 and a *View of Delft* from the north-west dated 1617. In area, these canvases are only slightly smaller than Vermeer's painting but their proportions are very different, both over twice as wide as they are high, approximating 71 × 160 cm. Both show the full extent of Delft as seen from its chosen direction. In both cases the town is reduced to a narrow band above which are the towers of the two churches and the Prinsenhof project. In both, though, the town is shown in profile, and the view of the foreground is from an unexplained lofty vantage point.

Against this tradition, Vermeer's invention is remarkable for its subtle ingenuity. He takes the traditional high viewpoint that divides the composition into four bands with the town spread across the picture between sky above, the river and near bank below. Indeed, he exaggerates the frieze-like aspect of the perspective. It is established and dominated by the parallel horizontals of the red roofs and wall on the left, confirmed by the four-square rectangularity of the Schiedam gate at the centre of the composition and continued to the Rotterdam gate by the bridge across the entrance to the Oude Delf canal. But it is not immediately striking that the buildings that make up the Rotterdam gate (the one with the high-pitched roof beside the bridge and the actual gate with its twin spires linked by a lower building with a long pitched roof) are at right angles to the bridge and the entire line of the waterfront on the left. Indeed, the bascule bridge that appears to the extreme right of the painting connects the gate with the near bank of the Schie. This is concealed by several devices. The horizon is level with the line of the roof linking the two main buildings of the gate, so bringing it into line with the horizontals of roof-tops and bridge. Then, again, the horizontal below the pitched roof of the rear building and the crenellated top of the gate, below its twin spires, are almost aligned with the sunlit roof visible between the two main buildings, so presenting a rectilinear unity. The impression created by these devices is furthered by a cunning use of light. Judging by the sunlit roofs and tower in the distance, the sun appears to be behind and over the right shoulder of the viewer. This might be expected to have created a striking contrast, in the foreground, between the façades of

8

the Schiedam gate and the main buildings of the Rotterdam gate in strong sunlight and the flank of the Rotterdam gate that should have been in deep shadow. But it appears from the clouds overhead that the foreground is overcast, and so those contrasts are reduced. A recent study of the painting by X-ray has revealed a number of small alterations, notably in the extension of the reflections, that further contribute to the impression of the town spread across the horizon opposite the viewer.

The most appropriate position from which to represent Delft would have been, without question, that chosen by Vroom for his painting of 1615. The town had grown about two long canals, the Oude Delf and its parallel Nieuwe Delf, with the Oude Kerk built between them. Despite an expansion to the east in the mid-fourteenth century, the older part of the town and the more important buildings remained extended along the lines of the original canals. From Vroom's perspective from the west, the line of the canals and, thus, of the entire town lay spread across his canvas, secure behind its defensive wall. To the extreme right can be seen the small bascule bridge that re-appears to the right of Vermeer's view. In his second view, from the north-west, Vroom again embraced the entire visible expanse of the town but from a viewpoint that reversed the orientation of old and new churches.

Perhaps Vermeer was unwilling to repeat what Vroom had achieved so impressively. But it is also remarkable that he did not attempt to embrace the entire panorama of the town from the south. Immediately to the left of his composition would have been the line of the western fortifications running, perhaps out of sight, into the distance. To the right there extended the expanse of the newer part of the town. But he chose to set at the centre of his composition the bridge that marked the extreme end of the two canals, the Oude Delf and Nieuwe Delf, where they join the river Schie. He set himself down at the very point at which the older town would have appeared most sharply foreshortened if it had not been concealed by its own river gates. The panorama Vermeer spreads across his canvas is only a corner of the town that extends beyond it

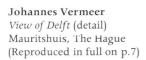

Johannes Vermeer
View of Delft (detail)
Mauritshuis, The Hague
(Reproduced in full on p.7)

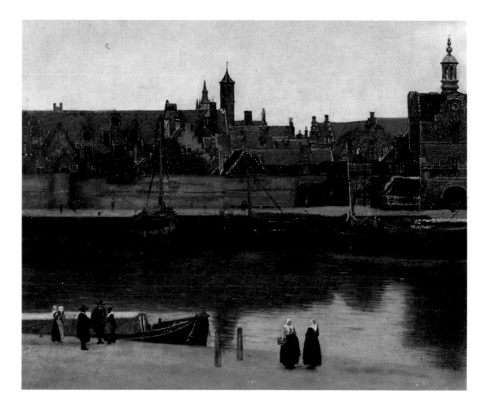

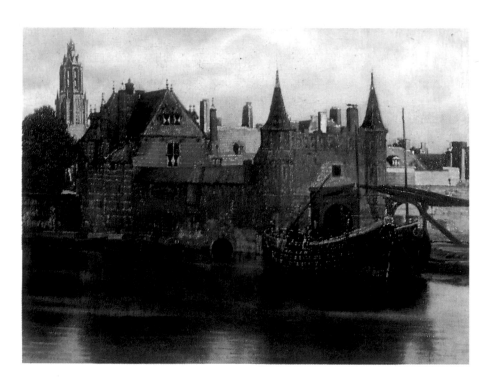

Johannes Vermeer
View of Delft (detail)
Mauritshuis, The Hague
(Reproduced in full on p.7)

into the depth of the picture.

It is, perhaps, a sense of the living town, with all its human activity, extending deep into the distance, invisible beyond the visible screen of houses, that is part of the picture's power. It is characteristic of Vermeer's art that just as we learn to recognise in the rich and strange manipulations of paint the material reality of the visible town, so we must learn to scan that reality for what lies beyond it. The glimpsed vista of sunlit roofs that indicate the existence of the town beyond is complemented below by the eddies and ripples that reveal the horizontal expanse of the water's surface extending to the bridge and beyond. Also above, the darker cloud that overcasts the water-gates brings the sky over our heads, while the paler, sunlit clouds carry our gaze over the visible rooftops and beyond. Vermeer's view encompasses both the visible and the unseen heart of Delft.

Rediscovery

The *View of Delft* must be the painting listed in the inventory of a sale held in Amsterdam on 16 May 1696 as item 31: "The Town of Delft in perspective, to be seen from the South by J. vander Meer of Delft". The painting sold for the good sum of 200 guilders. It then disappeared from the records for one hundred and twenty-six years and six days, when it appeared for the second time at an auction in Amsterdam. It was offered for sale on 22 May 1822 as item 112: "This most capital and most famous Painting of this master, whose works seldom occur, shows the town of Delft, on the river Schie; one sees the whole town with its gates, towers, bridges etc.; in the foreground there are two women talking together, while on the left some people appear to be preparing to step on board a canal-barge; furthermore in front of and against the town lie diverse ships and vessels. The way of painting is one of the most audacious, powerful and masterly that one can imagine; everything is illuminated agreeably by the sun; the tone of light and water, the nature of the brickwork and the people make an excellent ensemble, and this Painting is absolutely unique of its kind. Height 99 dm, 8 cm; width 1 m, 1 dm, 6 cm. Canvas". It was purchased for 2900 guilders by the State of the Netherlands and presented to the Mauritshuis Royal Cabinet of Paintings that same year, coinciding with the inauguration of the palace as a public museum.

Until that time, Vermeer was almost unknown outside the Netherlands. Many connoisseurs and scholars knew of his work only by reputation. As late as 1834, the Englishman John Smith in his remarkable series of Catalogues Raisonnés of the works of the most eminent painters, could do no more than make two mentions of Vermeer, first among "pupils and imitators of Gabriel Metsu", where he wrote: "Writers appear to have been entirely ignorant of the works of this excellent artist, [whose] pictures are treated with much of the elegance of Metsu mingled with a little of the manner of De Hooge." Writing of the "Pupils and Imitators of Peter de Hooge", Smith again mentions Vermeer: "This master is so little known, by reason of the scarcity of his works, that it is quite inexplicable how he attained the excellence many of them exhibit."

In a volume of prints published in 1792, the French art dealer, Jean Baptiste Lebrun, who had connections with Holland, wrote of an engraving after Vermeer's *Astronomer*: "This van der Meer, of whom historians say nothing, merits special attention. He is a great painter in the manner of Metsu. His works are rare, and they are better known and appreciated in Holland than elsewhere. One pays almost as much for them as for those of Gabriel Metsu"

It was the public display in the Mauritshuis of the prodigious *View of Delft* that led to Vermeer's discovery and eventual elevation to become one of the most famous (even, in the light of the van Meegeren forgeries, most notorious) artists in the world.

In 1857, in the *Revue de Paris*, Maxime Ducamp, returning from visiting the museums of Holland, praised the painting in the Hague museum: "It is painted with a vigour, a solidity, a firmness of impasto, very rare among the Dutch landscapists. This Jan van der Meer, of whom I know nothing but the name, is a rugged painter, who proceeds with flat colours liberally applied, built up thickly. . . ."

In 1858, Théophile Gautier, amazed by the same picture, wrote in the *Moniteur*: "Van Meer paints spontaneously with a force, a precision and closeness of tone that are unbelievable . . . The magic of the diorama is achieved without contrivance."

All this was noted by Théophile Thoré, the French critic and politician, in the first major study of Vermeer, published in the *Gazette des Beaux-Arts* in 1866 under the pseudonym of W. Bürger. "A dozen years ago, Jan van der Meer of Delft was almost unknown in France", wrote Thoré. "His name was missing from the biographies and histories of painting; his works were missing from the museums and private collections."

Thoré devoted twenty years of travel and research, in part as a political exile (hence the pseudonym), on this study of Vermeer, and in it he established not only the foundation but much of the edifice of our modern understanding of Vermeer. He begins his study with an account of his own first encounter with the *View of Delft*. "In the museum at the Hague, a superb and most unusual landscape captures the attention of every visitor and powerfully impresses artists and connoisseurs. It is the view of a town, with a quay, old gatehouse, buildings in a great variety of styles of architecture, garden walls, trees and, in the foreground, a canal and a strip of land with several figures. The silver-grey sky and the tone of the water somewhat recalls Philip Koninck. The brilliance of the light, the intensity of the colour, the solidity of the paint in certain parts, the effect that is both very real and nevertheless original, also have something of Rembrandt.

"When I visited the Dutch museums for the first time, around 1842, this strange painting surprised me as much as *The anatomy lesson* and the other remarkable Rembrandts in the Hague museum. Not knowing to whom to attribute it, I consulted the catalogue: 'View of the Town of Delft, beside a canal, by Jan van der Meer of Delft'. Amazing! Here is someone of whom we know nothing in France, and who deserves to be known!

"Even after seeing the *Night Watch*, the *Syndics* [by Rembrandt] and the other marvels of the Amsterdam museum, I retained an indelible memory of this masterpiece – by van der Meer of Delft! Well! In those days, we all thought of painting as something to please the eye and to write elegant descriptions of, without worrying too much about the history of art and artists.

"Later, even before 1848, having returned to Holland several times, I also had the opportunity of visiting the principal private galleries, and in that of M. Six van Hillegom – the happy owner of the celebrated portrait of his ancestor, Burgomaster Jan Six, by Rembrandt – there I found two more extraordinary paintings: a *Servant pouring milk* and the *Façade of a Dutch house*, – by Jan van der Meer of Delft! The astounding painter! But, after Rembrandt and Frans Hals, is this van der Meer, then, one of the foremost masters of the entire Dutch School? How was it that one knew nothing of an artist who equals, if he does not surpass, Pieter de Hooch and Metsu?

"Later – after 1848 – having become, of necessity, an exile, and, by instinct, a cosmopolitan, living in turn in England, Germany, Belgium and Holland, I was able to explore the museums of Europe, collect traditions, read, in all languages, books on art, and attempt to untangle somewhat the still confused history of the Northern schools, especially the Dutch school, of Rembrandt and his circle – and my 'sphinx' van der Meer.

"In the first volume of *The Museums of Holland*, in 1858, I drew attention to the landscape in the Hague museum and the two pictures in the Six van Hillegom collection In 1860, in the second volume of *The Museums of Holland*, I authenticated more than a dozen van der Meers, and brought together a quantity of information that

Johannes Vermeer
The little street
Canvas, 54.3 × 44 cm
Rijksmuseum, Amsterdam

Johannes Vermeer
The milkmaid (detail)
Rijksmuseum, Amsterdam
(Reproduced in full on p.95)

enabled me later to recover almost the entire œuvre of the painter of the *View of Delft*.

"This obsession has caused me considerable expense. To see one picture by van der Meer, I travelled hundreds of miles: to obtain a photograph of another van der Meer, I was madly extravagant. I even retraced my steps all round Germany in order to verify with conviction works dispersed between Cologne, Brunswick, Berlin, Dresden, Pommersfelden and Vienna. But I was amply recompensed, more especially as I had the pleasure, not only of admiring the works in museums and galleries, but in acquiring more than a dozen, some that I bought for my friends MM. Pereire, Double, Cremer, and others; others that I bought for myself

"At the same time as I was researching van der Meer's pictures, I was gathering together all the written documents and traditions concerning the man: I leafed through old books, old catalogues, the Dutch archives

"On the biography, it is true that I have still only some chronological landmarks and a few certain facts"

Thoré knew little of Vermeer's life. He knew nothing of his marriage or even the date of his death. When he found the catalogue of the sale in Amsterdam of 16 May 1696, at which, in addition to the *View of Delft*, twenty other Vermeers were listed, he surmised that the sale may have followed the recent death of the artist, or had been of the effects of another van der Meer, of Haarlem, who had also been a picture dealer and had died, so he had learned, in 1691.

Biography

Thoré complained that he found the archives of Delft had been dispersed. In particular, he had been told, the registers of the Delft Guild of St Luke, the painters' guild, which had long before disappeared from the Town Hall, were known to be in the hands of a curious Dutchman who would, no doubt, eventually publish them in their entirety, but who had released fragments of information to Thoré, via a friend.

Whatever the truth of this, the masterbooks and register of new inscriptions of the Guild of St Luke in Delft were later published as part of F. D. O. Obreen's monumental seven-volume *Archief voor Nederlandsche Kunstgeschiedenis* (1877–90). The first systematic searches of the archives for documents related to Vermeer were made by Abraham Bredius, who published a number of important documents between 1885 and 1916. Between the two World Wars little was discovered about Vermeer's circumstances, but between 1977 and 1989 J. M. Montias published a great many curious documents and re-examined and corrected earlier published versions of already discovered documents. It now seems unlikely that many other records of Vermeer's career (in so far as it was confined to Delft, as it appears to have been) remain to be found. And even now, though it is known, thanks to Montias, that Vermeer's maternal grandfather risked execution for counterfeiting, that his paternal grandmother was involved in a fraud over a lottery licence and that his mother-in-law divorced because of her husband's cruelty, of Vermeer himself the documented circumstances remain few.

His father, Reynier Jansz., was the son of a tailor and a woman who, besides her lottery fraud, during the course of two further marriages also became a bedding maker and second-hand dealer. He trained in Amsterdam as a caffa worker (a weaver in silk-satin), registered in 1631 in the Delft Guild of St Luke as a master art dealer, but lived most of his life as an innkeeper. It was while he was keeper of an inn called *The Flying Fox*, that Reynier Jansz. first followed the new fashion for surnames and adopted that of Vos. It was not until 1640 that he followed the example of his younger brother, Anthony, and changed his surname to Vermeer.

In 1615, Reynier Jansz. had married a young woman from Antwerp, Digna Balthazars or Baltens, the ceremony being performed in the New Church in Delft before Jacobus Triglandius, a notable Calvinist preacher. Five years later, the couple had a daughter, Gertruij, but it was not until 1632 that a second child, the future painter, was born to them. The record of his baptism on 31 October 1632, in the New Church of Delft, as Joannis, is the only evidence of his existence until 5 April 1653 when banns of his marriage with Trijntge Reijniers negotiated. Eight months later, in the register of the Delft Guild of St Luke, "on 29 December 1653, Johannes Vermeer had himself registered as Master Painter, being a burgher, and paid one guilden 10 stuivers towards his master's fee. 4 guilden 10 stuivers remain to be paid. On 24 July 1656 the total amount is paid."

Within these two documents and, perhaps, in their sequence, may lie the key to Vermeer's career. This registration as Master Painter shortly after his twenty-first

birthday, in the absence of any record of the necessary apprenticeship, is made the more extraordinary by following rather than being a necessary qualification for his marriage. For until his registration as a Master with the Guild of St Luke, Vermeer would not have been able to practise as a professional painter. And although, like his father, Vermeer did occasionally deal in art, it was as Painter that he always styled himself. J. M. Montias offers the hypothesis that the marriage is the key to all these problems.

Vermeer's bride, "Trijngen Reijniers", was Catherina Reyniers Bolnes, daughter of Reynier Cornelisz. Bolnes, a prosperous brickmaker, and Maria Willems Thins. Maria Thins was from a wealthy, distinguished, landed, old Catholic family from Gouda, where she had married Bolnes in 1622. But in 1641 she had divorced him and moved with her daughters to Delft. It was in Delft that, on 5 April 1653, when Vermeer and Catherina sought Maria Thins's consent to their marriage, a notary recorded that Maria Thins gave "for an answer that she did not intend to sign and to put her signature to [the act of consent], but would suffer the vows to be published and would tolerate it, and said several times that she would not prevent nor hinder those". The couple are recorded as marrying in Delft on 5 April 1653, with "attestation given in Schipluij 20 April 1653". 20 April 1653 was a Sunday and Schipluij, which was an hour's walk from Delft, was still a Catholic stronghold. Montias is confident that Vermeer, the son of a Protestant craftsman, converted to Catholicism to marry the daughter of Catholic landowners and that the rites were performed at Schipluij.

Montias also suggests that as there is no record of Vermeer being apprenticed in Delft he must have served the necessary four years elsewhere, possibly in Amsterdam or (in Montias' opinion, more probably) in Utrecht. Montias prefers Utrecht for two reasons: because of Vermeer's later evident predeliction for the works of the Utrecht Caravaggists and because the doyen of Utrecht painters, master of the Caravaggists and still working until his death at 87 in 1651, Abraham Bloemart, was related by marriage to Maria Thins. Montias suggests that it could have been while Vermeer was apprenticed to the Catholic Bloemart that he met his future bride.

These are hypotheses. What is on record is that by 1660 Vermeer with his wife and growing family were living in the house of his mother-in-law on the Oude Langendijck in Delft, and there they remained until his death fifteen years later. While he appears to have had little to do with his blood relatives, he did come to play a considerable part in the affairs of his family by marriage and in particular of his mother-in-law. This was only fitting because, in all probability, Vermeer and his family were economically dependent on the wealth of Maria Thins. She is recorded as having made many loans and gifts to her daughter and her husband. An unmarried brother and an unmarried sister left considerable legacies to the couple. Montias suspects that the family lived rent-free in Maria Thins's house in which, it would seem, Vermeer had a studio large enough to paint such spacious interiors as *The music lesson*. For an artist who may have painted no more than two works a year and whose dealings in other artists' works do not seem to have been extensive, the situation had much in its favour.

Of Vermeer's career as a professional painter, the records have little to say. On two occasions he was elected one of the headmen of the Guild of St Luke. On the first occasion, in 1662, he was approaching his thirtieth birthday. His second term of office came nine years later, in October 1671. In 1672, he was one of a number of artists and other experts to be asked to judge the authenticity of a number of extravagantly attributed Italianate works being offered for sale by the Amsterdam dealer Gerrit Uylenburgh.

Of his acquaintance with professional painters outside the activities of the Guild of

St Luke, there are few clues. He must have known Leendert or Leonaert Bramer (1596–1674), the history painter, not only because Bramer served as headman of the Delft Guild of St Luke for three periods of office during the years of Vermeer's membership. Vermeer's father, having enrolled in the Guild in order to practise as a picture dealer, would already have known Bramer. Certainly Bramer included the name "Reynier Vermeer" in a list of eleven dealers and collectors he made on the back of a drawing, possibly in 1652. That Bramer was acquainted with Vermeer even before the younger painter joined the Guild of St Luke is proved by a document of the following year. It was Bramer, along with a Captain Melling, who went before the notary on 5 April 1653 to attest that they had been witnesses on the previous night that Maria Tints (or Thins) was willing neither to consent nor to oppose the marriage between her daughter and Vermeer.

It was only two weeks later, on 22 April 1653, that the only other documented encounter between Vermeer and another professional painter occurred. He and "Monsr. Gerrit Terburch" witnessed an "act of surety", probably at the request of the notary, who lived nearby and for whom Vermeer served as witness on several occasions. This document is also the only evidence that ter Borch ever visited Delft.

Two documents testify to Vermeer's standing as a painter during his lifetime. When the Frenchman Balthasar de Monconys, on 21 August 1663, made a flying visit to Delft, for a single afternoon, he was taken to call on Vermeer who, unfortunately, had no paintings to show him. "But we did see one at a baker's, for which six hundred livres had been paid, although it contained but a single figure, for which six pistoles would have been too much, in my opinion." If not in the view of the visitor, then apparently in the eyes of his fellow citizens, Vermeer was a painter of repute.

This is more than confirmed in a history of Delft, *Description of the City of Delft* by Dirck van Bleyswyck, published in 1667. Van Bleyswyck lists artists living at the time of writing and to the name of Johannes Vermeer, the last on his list, simply appends (correctly) his birthdate, 1632. But on pages 853–54 there appears a poem of eight

Johannes Vermeer
The music lesson (detail)
British Royal Collection
(Reproduced in full on p.75)

stanzas written by the printer of the volume, Arnold Bon: "On the sad and most miserable death of the most famous and most artful painter, CAREL FABRICIUS". In the three copies of the *Description . . .* in the Royal Library in The Hague the poem appears in two versions. On page 853, seven stanzas praising Fabritius are identical in all three copies. But the final stanza, overleaf, is printed in two copies as:

> Thus expired this Phoenix to our loss
> In the midst and in the best of his powers,
> But happily there rose from his fire
> VERMEER, who, masterlike, trod his path.

In the third copy this stanza differs in its first and fourth lines:

> Thus died this Phoenix when he was thirty years of age,
> In the midst and in the best of his powers,
> But happily there rose from his fire
> VERMEER, who, masterlike, was able to emulate him.

The oddest aspect of this change is that it appears to have been made on this single page in the course of printing what is otherwise a single edition. The first version has been the better known and is, apparently, the original, since it agrees with the catchword (the first word of a page placed by early printers also at the foot of the preceding page to assist continuity in printing) on page 853. Albert Blankert was the first to discuss both versions but, curiously, when he had worked in the same library Thoré read the copy containing the second version. Why the printer, and author of the poem, made the change can only be guessed.

The implication of the verses is remarkable. To Bon, at least, Fabritius had been an artist of unique quality. Like the legendary phoenix, there could not be another like him in his lifetime, but after his death he had, again like the phoenix, been reborn.

Though Arnold Bon saw Vermeer as Fabritius's successor there is no evidence that he was Fabritius's pupil. Fabritius, who had trained in Rembrandt's studio, settled in Delft in 1650, at the age of twenty-eight, but registered with the Guild of St Luke only two years later, in October 1652. As he would not have been permitted to have pupils before his registration as a master he could not have been Vermeer's teacher for more than fourteen months before the latter, in his turn, registered as a master.

Nevertheless, in the inventory drawn up following Vermeer's death are recorded "a painting by Fabritius" and "two paintings, heads by Fabritius". The only other paintings by a contemporary listed in that inventory are two heads by Samuel van Hoogstraten, who was in Rembrandt's studio in the same years as Fabritius.

On what appears to have been the most important professional acquaintance of Vermeer's career the archives are silent. Pieter de Hoogh was inscribed in the Delft Guild of St Luke in February 1655, paid his dues to the Guild in 1656 and again in 1657 and may have lived in Delft until 1661. On the evidence of their works there can be little doubt that they knew each other well, if not as friends then as competing rivals. But nothing beyond the record of their necessary membership of the Guild of St Luke otherwise establishes their acquaintance.

Vermeer died abruptly, in all probability after a stroke rather than a heart attack. It is now that, after forty-two years of reticence, the archives yield a poignant glimpse of the artist at his end. His widow made a deposition: "During the ruinous and protracted war [with the French, he was] not only unable to sell any of his art but also, to his great detriment, was left sitting with the paintings of other masters that he was dealing with, as a result of which and owing to the very great burden of [his] children, having

Johannes Vermeer
Girl asleep at a table (detail)
Metropolitan Museum of Art,
New York
(Reproduced in full on p.55)

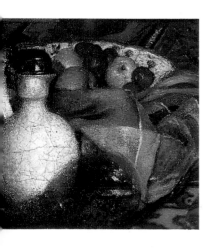

nothing of his own, he had lapsed into such decay and decadence, which he had so taken to heart that, as if he had fallen into a frenzy, in a day and a half he had gone from being healthy to being dead.'' He was forty-two. His burial, in the Catholic Old Church, was recorded on 15 December 1675. It is not surprising that he found his children a very great burden. He left eleven children under age (infants of Johannes Vermeer are recorded as having been buried in 1667, 1669 and 1673, the first in the New Church, the second and third in the Old Church, Delft).

The phrase ''having nothing of his own'' may be taken as an understatement. Vermeer's affairs were in disarray. He left considerable debts and may even have been guilty of embezzling money from his mother-in-law. As J. M. Montias traces the story: on 20 July 1675 Vermeer visited Amsterdam. He had, on his mother-in-law's instructions, withdrawn from the Orphan Chamber in Gouda 2900 guilders. Vermeer then pledged this money to borrow 1000 guilders from a merchant, Jacob Rombouts. After her son-in-law's death, Maria Thins had to repay the loan and return the 2900 guilders, on which she had lost interest, to the Orphan Chamber.

In addition, the artist's widow was beset by creditors. The baker, Hendrick van Buyten, was owed the considerable sum of 617 guilders 6 stuivers. He agreed to accept two paintings in settlement of the debt and so became, perhaps by default, one of Vermeer's few identified patrons. To settle a debt for ''various merchandise'' due to a certain Jannetje Stevens, a picture dealer from Haarlem, one Jan Coelenbier bought from Vermeer's widow 26 paintings, large and small, for 500 guilders. The average price of under 20 guilders makes it unlikely that many of these pieces were by Vermeer. More probably they were ''the paintings of other masters that he was dealing with''.

At the end of February 1676, a notary came to the house in Oude Langedijk to draw up an inventory of the possessions of Catharina Bolnes and those she owned jointly with her mother. Among the paintings listed there, none is obviously by Vermeer himself, though ''two heads painted in Turkish fashion'' could apply to both the *Girl with a pearl earring* in the Mauritshuis and the portrait of a young woman in the Metropolitan Museum, and ''a painting representing a woman wearing a necklace'' which was ''over in the basement room'' could be the painting now in the Gemäldegalerie, Berlin-Dahlem. Apart from the three paintings attributed to Carel Fabritius and the two heads by Hoogstraten no other pieces are attributed to an artist. All the above are among the items allotted to Catharina Bolnes. She also claimed a large painting representing Christ on the Cross, which could be the work by Jacob Jordaens included in Vermeer's *Allegory of Faith* in the Metropolitan Museum, and a *Cupid* that could be the painting included in the *Woman standing at the virginal* in the National Gallery, London. A still life of a bass viol and skull may be that dimly visible in the *Letter-writer* in the National Gallery, Washington. Also among the movable goods of Catharina Bolnes were several pieces of clothing, notably a yellow satin mantle with white fur trimming, that must have been worn by Vermeer's models in certain of his paintings. Though only the paintings by Fabritius and Hoogstraten are attributed, all the paintings possessed by Catharina Bolnes are identified by subject. But in the inventory of her mother, Maria Thins, most of her many paintings are dealt with summarily. She owned ''a large painting of Mars and Apollo in a bad black frame'', a painting representing ''the Mother of Christ in an oak frame'' and ''one more of the Three Kings''. Otherwise the inventorist preferred to note: ''two paintings somewhat smaller'' and ''four more paintings with bad frames'' and so on.

On 24 April 1676, Catherina petitioned the High Court of Holland and Zeeland for a moratorium on her debts. It was there that she gave her memorable account of Ver-

Johannes Vermeer
Girl asleep at a table (detail)
Metropolitan Museum of Art,
New York
(Reproduced in full on p.55)

meer's last days and death. Her petition was granted and a trustee appointed by the aldermen of the city to administer the estate and settle with creditors.

The appointed trustee was Anthony van Leeuwenhoek who, like Vermeer, was a native of Delft and, like Vermeer, was born in 1632. A later historian of Delft, Reinier Boitet, in his *Description of the Town of Delft* of 1729, described van Leeuwenhoek as skilled in ''navigation, astronomy, mathematics, philosophy and natural science'', but he is now best remembered for the improvements he made to the microscope and the observations he made with it. Art historians have conjectured that Leeuwenhoek, with his experience with lenses, may have helped Vermeer with the *camera obscura* that the artist is thought to have used. Thus, it would be as a friend that he was appointed curator of Vermeer's estate. J. M. Montias doubts that Maria Thins would have welcomed the choice: she would have preferred a Catholic and van Leeuwenhoek was of the Reformed Church. Also, he proved unsympathetic to her in what was the most intriguing of the many legal and financial problems he had to settle.

The matter concerned a painting by Vermeer, the only work specifically identified in any of the documents concerning the artist and his family. In March 1677, van Leeuwenhoek proposed an auction of paintings (in fact, the very paintings already bought by the dealer Coelenbier) but Maria Thins petitioned in court to prevent him including in the sale a painting that her daughter had legally transferred to her in settlement of certain debts. The outcome of the dispute is no longer documented, but there can be no doubt of the value of the painting to mother and widowed daughter. The deed of transfer had been drawn up on 22 or 24 February 1676, a week or less before the taking of the inventory of movable goods at the family home at Oude Langendijck. The painting in question does not appear in that inventory. It must have had great value to the artist's widow for her to have colluded with her mother to attempt to conceal it from her creditors. It is identified in the documents simply as '' a painting wherein is depicted the Art of Painting [*de Schilderconst*]''. It can only be the great canvas now in the Kunsthistorisches Museum, Vienna.

Patrons

On the vital question: who bought Vermeer's paintings? the only evidence lies in inventories made of collections on the occasions of marriages, deaths, bankruptcies and other occasions when assets must be assessed. Though such inventories do survive in considerable numbers, they were often drawn up by notaries or notaries' clerks ignorant of, or indifferent to, niceties of attribution and subject matter.

From this exiguous evidence, Vermeer does not appear to have sold his works widely. Paintings by, or attributed to, him are known in only seven inventories of collections formed in his lifetime.

Three may have had little connection with the artist, as the collectors were not residents of Delft. The sculptor, Jean Larson, who died in The Hague in 1664, may have bought "a head by van der Meer" on a business visit to Delft in 1660. Another outsider was a jeweller and banker of Antwerp, Diego Duarte, who in July 1682 drew up a register of the 192 paintings then in his house that listed as number 182 " a small piece with a woman at the clavecin with accessories by Vermeer, cost . . . 150 guilden", which could, possibly, be either of the paintings in the National Gallery, London.

The third collector from another city is, perhaps, the most interesting. Herman Stoffelsz. van Swoll was a native of Amsterdam. A successful banker, he used his great wealth to collect paintings and to patronise contemporary artists. The catalogue of paintings sold on 22 April 1699 in Amsterdam from van Swoll's estate lists as item 27 "A seated woman with several meanings, representing the New Testament, by Vermeer of Delft, vigorously and glowingly painted 400–0". As this work is now understood as an *Allegory of the Catholic Faith* it is worth remarking that van Swoll was the successful son of a Protestant baker.

With a stronger connection with Delft was the dealer Johannes Renialme who died in Amsterdam in 1657, but who registered with the Delft Guild of St Luke in 1644. He left in his estate "a picture of the visit to the grave by van der Meer, 20 guilders". This must be a biblical painting showing the visit of the three Maries or of Mary Magdalene to the tomb of Christ on Easter Sunday, and, if the attribution was indeed correct, it would have been, in all probability, an early painting.

Of the Delft patrons, the least substantial was Cornelisz. de Helt who, like the painter's father, kept an inn, *De Jonge Prins*. The inventory made on de Helt's death in 1661 listed, among other paintings, "in the front hall first a painting in a black frame by Jan van der Meer", the kind of entry typical of a multitude of contemporary inventories.

More substantial among Vermeer's Delft patrons was the baker, Hendrick van Buyten. Van Buyten could have been the baker visited by Balthasar de Monconys on 11 August 1663. He died a wealthy man, well able to afford "600 livres" for a painting of a single figure, if he so chose. His considerable estate included not fewer than fifty paintings, among which were a large painting by Vermeer in the front hall and two small pieces also by him in the little room next to the hall. If one of these paintings was the presumably small piece seen by de Monconys, the probability is that the other two

were the two paintings that on 27 January 1676 van Buyten had accepted from Catharina Bolnes, the artist's widow, in settlement of that astonishingly large bread bill. These were at that time described as "one representing two persons one of whom writes a letter and the other with a person playing a cithern", which were valued together at 617 guildern 6 stuivers. If these had been the small *Woman with a lute*, now in the Metropolitan Museum, New York, and the large canvas known as the *Mistress and maid* in the Frick Collection, New York, they would, together with the small painting seen by de Monconys, fit the indications of the inventory.

The largest single collection of Vermeer's paintings made, in all probability, in his lifetime was that auctioned in Amsterdam on 16 May 1696. The auction catalogue listed 21 paintings with descriptions that, though brief and sometimes ambiguous, allow the majority to be identified with surviving works. Thoré, who reprinted this list in his catalogue raisonné, assumed that it represented works left on Vermeer's hands at the then unknown time of his death. Following the researches of Abraham Bredius, it has long been assumed that this collection is identical with that outlined far more summarily in the inventory drawn up early in 1683 of the estate and property of the Delft printer, Jacobus Abrahamsz. Dissius. This inventory listed, in the front room, 8 paintings by Vermeer and 3 ditto in boxes, in the back room 4 paintings by Vermeer, another painting by Vermeer in the kitchen, 2 paintings by Vermeer in the basement room and, beside the above items, 2 paintings by Vermeer, making a total of 20 works, only one fewer than the number auctioned in the 1696 sale. But it was J. M. Montias who, a century after Bredius, went back to the Delft archive and discovered not only that Bredius had overlooked one Vermeer listed in that 1683 inventory (he had noted only 19 works) but that the collection had not been formed by Dissius at all. The inventory was of the "estate and property due to Jacobus Abrahamsz. Dissius on his own account inherited as the result of the death of Juffr. Magdalena van Ruyven", Dissius's wife, who had died on 16 June 1682. Magdalena van Ruijven was not yet twenty-seven when she died and had married Dissius only two years earlier. There can be little doubt that the twenty paintings by Vermeer bequeathed to Dissius were part of Magdalena's own inheritance from her father, Pieter Claesz. van Ruijven.

Montias's researches in the archives show that van Ruijven knew Vermeer and that he collected paintings. Montias writes: "The relationship between van Ruijven and Vermeer clearly went beyond the routine contacts of an artist with a client. Van Ruijven lent Vermeer money; he witnessed the will of his sister Gertruij in her own house shortly before her death. More significantly, van Ruijven's wife Maria de Knuijt left Vermeer a conditional bequest of five hundred guilders in her testament." Montias suggests that van Ruijven's loan of 200 guilders to Vermeer and his wife, recorded in a document of 30 November 1657, was an advance on the future purchase of paintings. Montias also notes that van Ruijven's wife's bequest of 500 guilders specifically to Vermeer himself and not to his family was "a rare, perhaps unique, instance of a seventeenth-century Dutch patron's testamentary bequest to an artist".

Direct evidence that van Ruijven and his wife were serious collectors of paintings is provided by their joint will made on 19 October 1665, which stipulated that their collection of paintings should be disposed of as specified in a certain book marked with the letter A, on which would be written "Dispositions of my fine paintings [*Schilderkonst*] and other matters". Unfortunately, that book has been lost.

Though it now seems most probable that van Ruijven bought the greater part of Vermeer's production after 1657, including many of the surviving works, nothing is recorded of the extent to which this relationship affected the character of Vermeer's art. But there are two or three more pieces of evidence from the archives that provoke

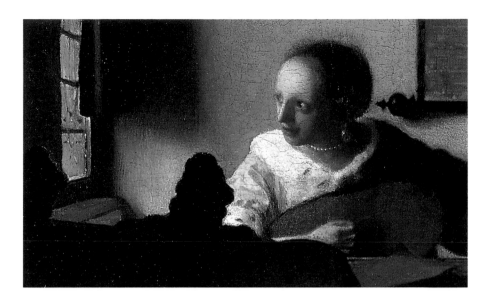

Johannes Vermeer
Woman tuning a lute (detail)
Metropolitan Museum of Art,
New York
(Reproduced in full on p.76)

speculation. Pieter van Ruijven was related to some of Delft's most prominent families, says Montias, but because the family had Arminian sympathies he, like his father before him, was barred from high civic office. His father had been a brewer but Pieter Claesz. van Ruijven is not known to have had any trade or profession. He and his wife inherited wealth which they augmented by judicious investments. And on 11 April 1669, van Ruijven bought for 16,000 guilders land that carried with it the title Lord of Spalant, a title that he used when he witnessed the will of Vermeer's sister only a few months later. Finally, it may be significant that when van Ruijven, who was eight years Vermeer's senior, died and was buried on 7 August 1664, the artist outlived his patron by only seventeen months. All this suggests, but is far from proving, a friend ship between artist and patron that may have influenced Vermeer's art. A further reason for considering the hypothesis sympathetically is that it complements the other probability of Vermeer's career, that he lived a quiet, even isolated, life, dependent on the wealth of his mother-in-law. A friend such as van Ruijven could have been a friend indeed.

The Œuvre

A remarkable number of the works recorded in the collections of Vermeer's contemporaries appear to survive today.

In particular, in the catalogue of the paintings presumably first collected by Pieter van Ruijven, inherited by his son-in-law, the printer Jacob Abrahamsz. Dissius, and dispersed at the sale in Amsterdam on 16 May 1696, the descriptions of works, though terse, are sufficiently precise for the majority to be matched with some conviction with surviving paintings.

Item 1, "A young lady weighing gold, in a box by J.vander Meer of Delft, extraordinarily artful and vigorously painted", is identifiable with the painting in the National Gallery of Art, Washington, now more accurately characterized as *A woman holding a balance*. This fetched the high price of 155 guilders.

No.2, "A maid pouring out milk, extremely well done, by ditto", can only be the famous painting, usually called *The milkmaid*, in the Rijksmuseum. This fetched the second highest price of the sale: 175 guilders.

No.3, a "Portrait of Vermeer in a room with various accessories uncommonly beautifully painted by him", has occasionally been identified with the painting of an artist at work now in the Kunsthistorisches Museum, Vienna. But the low price paid for the item 45 guilders, makes this highly improbable. The painting in Vienna, which is one of the largest Vermeer painted, must be the *Art of Painting* that Vermeer's widow claimed to have given her own mother in settlement of outstanding debts following the death of the artist. Item 3 is not otherwise known.

No.4, "A young lady playing the guitar, very good of the same" and sold for 70 guilders, could be the painting now in the Iveagh Bequest, Kenwood, London.

No.5, "In which a gentleman is washing his hands, in a far room, with sculptures, artful and rare by ditto", and sold for 95 guilders, is not known to have survived.

No.6, "A young lady playing on the clavecin in a room with a listening gentleman by the same", could describe the painting often called *The music lesson* in the British Royal Collection, but the recorded price of 80 guilders looks too low for so large and fine a work.

No.7, "A young lady who is being brought a letter by a maid, by ditto", could be the small painting now known as *The love letter*, in the Rijksmuseum. The price paid of 70 guilders makes it unlikely to have been the large painting now known as *The mistress and maid* in the Frick Collection.

No.8, "A drunken sleeping maid at a table, by the same", fits the painting of *A girl asleep at a table*, now in the Metropolitan Museum, New York. It fetched 62 guilders.

No.9, "A merry company in a room, vigorous and good by ditto", is more uncertain. The merry company [*vrolyk geselschap*] had been a regular and popular subject among painters of the older generation. None of Vermeer's surviving

works exactly fits the genre. The nearest possibility is the painting known as *A woman with two men*, or *Girl being offered wine*, in the Herzog Anton Ulrich-Museum, Brunswick. It was first catalogued in the Brunswick collection in 1711 as "Eine lustige Gesellschaft", which is an established alternative term for "merry company". No.9 sold for 73 guilders.

No.10 is, again, uncertain. "A gentleman and a young lady making music in a room by the same" and fetching 81 guilders could, possibly, be the small badly damaged painting known as *The girl interrupted at her music*, now in the Frick Collection.

No.11, "A soldier with a laughing girl, very beautiful by ditto", that fetched 44 guilders, is without doubt the small painting still given the same description today, in the Frick Collection.

No.12, "A young lady doing needlework, by the same", that fetched only 28 guilders, could be the Louvre *Lace-maker*, which, though exquisite, is remarkably small.

No.31 can only be one work: "The town of Delft in perspective, to be seen from the South, by J. vander Meer of Delft". It fetched 200 guilders.

No.32, "A view of a house standing in Delft, by the same", which fetched 72 guilders 10 stuivers, is probably the so-called *Little street [Het Straatje]*, in the Rijksmuseum.

No.33, "A view of some houses by ditto", selling for 48 guilders, is no longer known.

No.35, "A writing young lady very good by the same, 63–0 [guilders]", could be the painting of that subject now in the National Gallery, Washington.

No.36, "A young lady adorning herself, very beautiful by ditto", describes the painting often called *A woman with a pearl necklace* now in the Gemäldegalerie, Berlin-Dahlem. But the price it fetched, 30 guilders, is low for a painting that is rather larger than nos. 1 and 2 in this catalogue.

No.37, "A lady playing the clavecin by ditto. 42–0 [guilders]", could be one of the two similar paintings now in the National Gallery, London.

No.38, "A head in antique dress, uncommonly artful", fetched 36 guilders. The two last works by Vermeer in the catalogue, no.39 "another ditto Vermeer, 17–0 [guilders]" and no.40 "A pendant of the same. 17–0 [guilders]", are also "heads" [*tronien*]. The *tronie* is not a subject, it is a type of painting, and it shows the head and shoulders of a fictional character, often in exotic head-dress and costume. The painting in the Mauritshuis, *Girl with a pearl earring*, and the *Woman tuning a lute*, in the Metropolitan Museum, New York, could be two of these three *tronien*.

Of the other paintings listed in contemporary documents, it could be claimed that the pair to no.37 from the van Ruijven/Dissius collection and now beside it in the National Gallery, London, is the "piece with a lady playing the clavecin with accessories by Vermeer" priced at 150 guilders in the Diego Duarte collection in Antwerp, in 1682. The *Allegory of Faith* now in the Metropolitan Museum, New York, is that sold from the collection of Herman van Swoll in Amsterdam on 22 April 1699. And the *Art of Painting* in Vienna is the painting left in Vermeer's studio at his death, and given by his widow to her own mother. The three paintings, two small and one large, owned by the baker Hendrick van Buyten at the time of his death in July 1701 appear impossible to identify. But as two might be those accepted from Vermeer's widow in settlement of a bread bill, described in the document of 27 January 1676, and the third that showing a single figure seen by the French visitor, de Monconys, in 1663, some suggestions may

be made. The "person playing a cithern" could be the much damaged painting of that subject in the Metropolitan Museum, New York. The "two persons one of whom is writing a letter" fits the painting formerly in the Beit collection, Blessington, rather well, but if the crude identification of one of the Vermeers as a "large piece of painting" [*een groot stuck schilderie*] in the 1701 inventory of van Buyten's effects is taken into account, the *Mistress and maid* in the Frick Collection may be considered as a possibility. There, the *Mistress* appears to be receiving a letter, but her right hand does hold a pen over an apparently half-filled sheet of paper. As to the third piece, if it was that seen by de Monconys, there are, again, two candidates of similar size among accepted works, the *Woman in blue reading a letter* in the Rijksmuseum, and the *Woman with a ewer* in the Metropolitan Museum.

This would leave seven works listed in contemporary inventories that are either lost or unidentifiable: items 4, 5, 36 and 39 from the van Ruijven/Dissius collection; the "visit to the grave" left by the dealer, Johannes Renialme, at his death in 1657; the *tronie* left by the sculptor, Jean Larson, and the "painting in a black frame by Jan van der Meer" left by the innkeeper, Cornelis de Helt.

On the other hand, in addition to the two problematic alternatives for the paintings owned by van Buyten just discussed, only six of the paintings that are today universally accepted as genuine cannot be matched against descriptions of works listed in seventeenth-century records. These are *The procuress*, which is signed and dated 1656, and the *Young woman reading a letter at an open window*, both of which are in the Staatliche Gemäldegalerie, Dresden; *The glass of wine* in the Gemäldegalerie, Berlin-Dahlem, *The concert* in the Isabella Stewart Gardner Museum, Boston, and the separated pair of *Geographer* and *Astronomer*, now in the Städelsches Kunstinstitut, Frankfurt, and the Louvre, Paris, respectively.

In sum: of the twenty-nine works documented in Vermeer's lifetime, twenty-two appear to survive today, seven seem to be lost. Eight further, undocumented works are today universally accepted as genuine.

But the matching of paintings to records is only the beginning of the task of establishing an artist's œuvre. Not a single work now attributed to Vermeer can be securely documented back to the painter's studio. Of the twenty-one paintings itemised in the Amsterdam sale of 1696, only two, *The milkmaid* and *The woman with a balance*, could be accepted as the works itemised almost entirely on the continuity of their provenance. Of course, there can be little question that the *View of Delft* was indeed no.31, or that the following item, no.32, refers to *The little street* now in the Rijksmuseum, so distinctive are these works. (Yet the latter, like the *View of Delft*, disappeared from view for over a century after the van Ruijven/Dissius sale, re-appearing in the saleroom on 22 November 1799.) Similarly, the descriptions of no.8, "A drunken sleeping maid at a table", and no.11, "A soldier with a laughing girl, very fine", convincingly fit the distinctive paintings in the Metropolitan Museum and the Frick. For the rest, there can be no certainty that surviving works are indeed among those sold in 1696.

Authentication, in the end, depends on visual judgement. Currently, there is consensus among Vermeer scholars on not more than thirty-one works. Of these, seven have chequered histories. *The Art of Painting*, now in Vienna, is not recorded from the time of the court case of 12 March 1677, when Vermeer's mother-in-law attempted to stop its auction, until 1813, when it was bought by Johann Rudolf Count Czernin for 50 fl., as a Pieter de Hoogh. The distinctive and untypical *Allegory of Faith* succeeded in keeping its identity through four changes of hand, but late in the nineteenth century was offered in Berlin as an Eglon van der Neer while carrying the signature "C. Netscher". The painting in the British Royal Collection, which could have been no.6 in

Johannes Vermeer
Woman writing a letter
Canvas, 45 × 39.9 cm
National Gallery of Art, Washington (Gift of Harry Waldron Havemeyer and Horace Havemeyer Jr., in memory of their father, Horace Havemeyer)

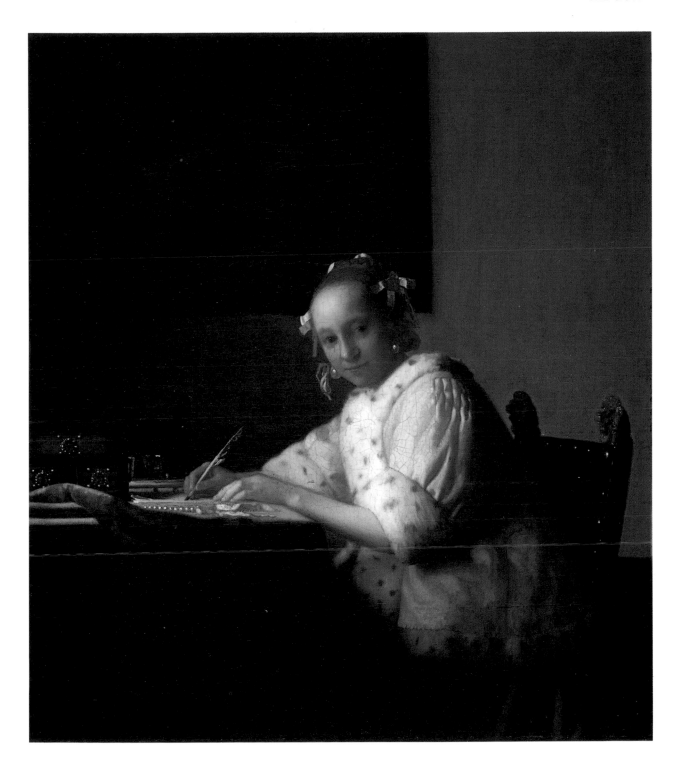

the van Ruijven/Dissius sale, was acquired by George III from Joseph Smith, British consul in Venice, as by Frans van Mieris. No less astounding: what had been, in all probability, no.1 in the van Ruijven/Dissius sale, "A young lady weighing gold, in a box by Jan vander Meer of Delft, extraordinarily artful and vigorously painted", and had been identified as a Vermeer in four catalogues between 1701 and 1777, was offered for sale in Munich on 5 December 1826 as by "Gabriel Metzu, and according to others van der Meer . . .". The Metropolitan *Woman with a ewer*, which today seems so compelling an example of Vermeer's vision, can be traced back no further than 1838, when it appeared at the British Institution, London, as a Metzu (*sic*). Re-attributed to Vermeer by 1878, it was sold only ten years later as by Pieter de Hoogh. The Frick *Soldier with laughing girl*, a most distinctive work that matches so exactly the description of item 11 in the van Ruijven/Dissius sale, did not appear on the market until 10 May 1861, when it was offered by Christie's as by "De Hooghe".

The single work to suffer most from re-attribution is the painting in the Staatliche Gemäldegalerie, Dresden, *A young woman reading a letter at an open window*. It was acquired in 1742 in Paris for Augustus III, Elector of Saxony, and remained in the collection in Dresden through its metamorphoses from Electoral to Royal to State Gallery. The painting, too, suffered changes. In 1753 it was catalogued as "in the manner of Rembrandt"; in 1754, and again in 1782, it was attributed to Rembrandt himself; in 1765 it was called "school of Rembrandt"; in 1783 it was engraved as by Govaert Flinck, and by 1826 it was attributed to Pieter de Hooch. It was not finally and officially attributed to Vermeer until 1858.

But it is notable that these misattributions were all made outside the Netherlands. This is particularly striking in the cases of the two paintings with good eighteenth-century provenances in the Netherlands: the *Woman holding a balance* and the *Allegory of Faith*. None of the Vermeers accepted today was misattributed in its native country. On the contrary, the available evidence is that they were highly valued.

There are records of a dozen Vermeers passing through the Amsterdam sale-rooms in the eighteenth century, several more than once. The *Geographer* and the *Astronomer* passed through five sales between 1713 and 1797, staying pendants until the fifth sale. The *Milkmaid* and the *Woman holding a balance* were each sold four times and the Rijksmuseum *Woman reading a letter*, the *Allegory of Faith* and the Beit *Lady writing a letter with her maid* were each sold three times. The encomiums printed in the sale catalogues follow a conventional pattern, but they no doubt reflect the reputation enjoyed by Vermeer's rare works.

When the *Geographer* and the *Astronomer* were sold for the fourth time, on 25 November 1778, the catalogue declared that in the *Astronomer*, "the pleasing Light, which descends from a Window on the left side, gives a beautiful and natural effect . . . everything painted masterfully and vigorously". A similar account was given of the pendant.

The *Woman holding a balance* was said at the sale on 18 March 1767 to be "painted in a vigorous, elaborate and Radiant way". At a sale on 11 April 1791, of the Rijksmuseum *Woman in blue reading a letter*, it was said: "This Painting is beautifully and naturally done on Canvas, by the Delft van der Meer, the pleasing light and shadow give it a fine appearance commonly characteristic of the works of this famous Master." Finally, the *Milkmaid* was described on its sale on 12 April 1719 as "The famous Milkmaid, by Vermeer of Delft, artful" and three sales later, on 12 September 1798, it was called: "This excellent and beautiful Scene . . . Light, falling through a window at the side, gives a miraculously natural effect, the painting is of vigorous colour, and excellent for its handling of the brush and one of the most beautiful of this

Johannes Vermeer
The geographer (detail)
Städelsches Kunstinstitut,
Frankfurt
(Reproduced in full on p.107)

inimitable Master." Such highly regarded works would have been carefully looked after.

The sale-room catalogues also confirm what Thoré discovered: the greater number of Vermeer's few pieces remained in private collections in the Netherlands throughout the eighteenth century and early years of the nineteenth century. A century after the painter's death the only pieces recorded abroad were those few collected by German nobles in the first half of the eighteenth century. The *Procuress* and the *Young woman reading a letter by an open window* were with the Elector of Saxony, the Duke of Brunswick had acquired the *Man offering wine to two women*, catalogued in 1711 as "A merry company". The Count Schönborn of Pommersfelden owned the *Woman seated at the virginals* now in the National Gallery, London. The nominal exception was George III of England, with the so-called *Music lesson*.

When Théophile Thoré set out "to restore, more or less, the character of van der Meer", he knew only the three works, the *View of Delft*, the *Little street* and the *Milkmaid*. To establish an œuvre, he had, as he said, "to collect traditions, read, in all languages, books on art, and attempt to untangle somewhat the still confused history of the Northern schools", but, above all, he had to rely upon the eye of the connoisseur. "On the biography, it is true that I have still only some chronological landmarks and a few certain facts. But ... Doesn't one say that by the work one knows the worker? Painting reveals the painter, and pictures often compensate for written documents." As he wrote, explaining his purchase of several Vermeers: "One cannot truly know a master well until one owns for oneself several of his works, has them on easels, until one can study them in all lights and one can compare them at leisure."

Of course, he made mistakes. There was much that Thoré may be said to have got wrong. He attributed over 74 paintings to Vermeer, which is more than double the most generous assessment accepted today. There are several causes for this gross over-estimation. Twenty-five no longer accepted works were town- and landscapes, and this was almost certainly because the *View of Delft* and the *Little street* were among the first three Vermeers that Thoré saw. Also, despite his awareness of the problem, he seems to have confused Vermeer of Delft with his namesake, the landscape painter of Haarlem. (There were, as he knew, four painters of that name to be distinguished and none was adequately documented.) Of the rest, many are works listed with some annotation: "to be recovered" or "to be verified", or "to be verified and recovered". Several he notes that he has not himself seen and is relying on the judgement of an esteemed friend. Of the ten major misattributions, three were, unsurprisingly, the work of Pieter de Hoogh. His own collection was mixed. It included a portrait of a man that he thought might possibly be a self-portrait, a life-sized figure of an old woman spinning, two "interiors of convents" and a landscape, none of which are accepted today. But he also owned the Berlin *Woman with a pearl necklace*, the Isabella Stewart Gardner *Concert* and both the National Gallery, London, paintings. For the friends he referred to in his essay, he obtained the Frick *Soldier with laughing girl* and the *Astronomer* for Leopold Double, while the *Geographer* went to Isaac Pereire. The Kenwood *Guitar-player* was the work he bought for his friend M. Cremer of Brussels. On the other hand, of the various works discovered and attributed to Vermeer since Thoré's publications, only six are generally accepted.

Later scholars have made worse mistakes. It is the scholar's eye that the story of the van Meegeren forgeries so disastrously discredits. Yet it is on the eye that the student of Vermeer must, finally, depend, because it is to the eye that Vermeer speaks.

Style

In 1834, John Smith had made his two brief references to Vermeer under the headings "Pupils and imitators of Gabriel Metsu" and "Pupils and imitators of Peter de Hooge". Of the seven misattributions of Vermeer's paintings noted earlier, two had been to Metsu, two to de Hoogh, one to Frans van Mieris and one, the *Allegory of Faith*, both to Caspar Netscher and Eglon van der Neer. Conversely, Thoré had attributed to Vermeer (though not with total conviction) a *Woman peeling an apple for a child* by ter Borch, in Vienna, and a *Music lesson* by Jan Steen, in the Wallace Collection. The last attribution is the most incongruous, but the selection has much in common. Ter Borch, born in 1617, was the oldest; the rest were born between 1626, the year of Steen's birth, and 1639, when Netscher was probably born. Metsu and de Hoogh were both born in 1629, three years before Vermeer; van der Neer was born in 1634 and van Mieris in 1635. Geographically, they are more disparate. For much of the 1650s, Metsu, van Mieris and Steen were working in Leyden, Netscher was training with ter Borch in Deventer and de Hoogh and Vermeer were in Delft. Van der Neer was out of the country. But despite the differences of age and of geography, they all (even Steen, on occasion) painted scenes of contemporary life distinguished by their affluence and sometimes opulence. The paintings themselves were distinguished by their small scale and minutely detailed craftsmanship, notably in the work of ter Borch, van Mieris and Netscher (though Steen, a consummate painter, could effortlessly match them when he chose). Images of opulent scenes were themselves opulently painted. With minute and delicate precision, these painters represented the play of light over the luxurious texture of their subjects' costumes and furnishings.

Vermeer's mature art shares much with these "fine painters" [*fijnschilders*], as they have become known, both in subject and in manner. It is understandable that his handful of works – he may have painted as few as forty and almost certainly fewer than fifty – would become lost among the fluent production of his peers. In the course of a long and prolific life, ter Borch may have painted over 300 works of which the bulk was portraiture but included perhaps 100 small scenes. Frans van Mieris probably painted more than 120. Pieter de Hoogh is credited with anything between 163 and 350 similar pieces.

What is distinctive in Vermeer's work is something in his visual style that is striking but elusive. Only two of his paintings were published in engravings before the end of the eighteenth century, but even if more had been reproduced they would have made little difference to an understanding of his art, because engravings can give little idea of its distinctive character. It was not until photography was invented that connoisseurs and art historians had a ready means of analysing and comparing Vermeer's work and of thus slowly reconstructing an œuvre.

This seems to be more than the coincidence of an elusive style and a modern analytic technique, for Vermeer's art has often been likened to photography, and it has been generally accepted that Vermeer was familiar with, and probably owned and used, a *camera obscura*.

The *camera obscura* had been known for some considerable time before Vermeer's day. Initially it had been, as the Italian term indicates, a darkened room in the shutter of which was a pinhole. In the sunlit Mediterranean, this would admit enough light to produce on a white wall a bright image sharply focussed by the narrow pinhole. In the gloomier north, to produce a sufficiently bright image that was also sharp, a lens was needed to gather and focus enough light. Lens grinding was an established skill in seventeenth-century Holland. It has been argued that because Anthony van Leeuwenhoek, the inventor of the microscope and therefore familiar with lenses, was appointed executor of Vermeer's bankrupt estate after his death, he must have been a friend of the artist in life. It is a hypothesis to account for Vermeer's apparent familiarity with the apparatus: Leeuwenhoek would have had the expertise. By the middle of the seventeenth century, portable boxes were produced that were the precursors of the photographic camera and almost identical in structure to the earliest models, with a lens mounted at one end that could be adjusted by sliding it in and out to focus an image on a screen, possibly of waxed paper, fixed at the other end. As this image would be both reversed and inverted, a mirror would be used to correct it.

The assumption that Vermeer used a *camera obscura* has been employed to explain three characteristic features of his works. First and most distinctively, the definition of forms, in his mature paintings, seems to anticipate the quality of photographic images in certain ways. Most strikingly, but superficially, there is the way that certain features appear to be in focus while others look out of focus. This characteristic is particularly insistent in the Louvre *Lace-maker* where the two threads the lace-maker is actually manipulating are represented by fine, sharply defined lines while what are, presumably, similar threads trailing from a workbox in the foreground are represented by broad, blurred strokes. And it has been suggested that the circular dabs of light paint against darker areas that can be seen, for example on the young woman's lace collar, the tassels on the workbox and the pattern of the Turkey carpet in the foreground derive from an effect alien to normal perception but visible in images produced by a *camera obscura*: the so-called discs of confusion produced in slightly out-of-focus images from the reflected highlights of metal or glass objects.

Another feature of Vermeer's mode of representation is less obviously dependent on the use of a *camera obscura*. This is his gift for ruthless abstraction of form and colour. He created foreshortenings that are so bold as to challenge the viewer's powers of perception. There is the sharp contrast in scale between soldier and laughing girl in the Frick painting. There is the challenging foreshortening of the hand and forearm gripping the ewer in the *Woman with a ewer* in the Metropolitan Museum. There are the logical simplifications of tone and colour there, and even more boldly developed in the Kenwood *Guitar-player*. And there is the entirety of the Louvre *Lace-maker*. All these idiosyncratic features are foreign to the traditions and means of representation employed by Vermeer's contemporaries. Unlike effects of focus and discs of confusion, such features are not essentially the product of a *camera obscura*, but they are elusive aspects of appearances that had been ignored by artists until Vermeer developed them, and it has been suggested that the *camera obscura* both enabled Vermeer to observe and analyse such features and also gave credibility to his incorporation of them in his paintings.

The distinctive character of Vermeer's mode of representation has been recognised, most famously, in his *Girl with a pearl earring* in the Mauritshuis, which has been contrasted with Frans van Mieris's portrait of a woman (possibly his wife) in the National Gallery, London. The latter is painted with the minute precision characteristic of the *fijnschilder*. Not only is every form rendered clearly but so is every texture.

Johannes Vermeer
The lace-maker (detail)
Louvre, Paris
(Reproduced in full on p.111)

Frans van Mieris
The artist's wife
Vellum, 11.1 × 8.2 cm
National Gallery, London

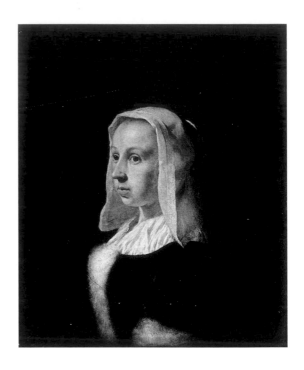

Johannes Vermeer
Girl with a pearl earring
Canvas, 46.5 × 40 cm
Mauritshuis, The Hague

And although the initial effect is of unmediated realism, a comparison with other paintings by van Mieris and his contemporaries reveals that such effects are rendered by established procedures and skills.

Vermeer's painting is no less artful, but the character of its skill is less obvious. He has used no fine brushwork to establish contours and textures. As has often been remarked, he does not give the bridge of the nose a contour to distinguish it from the far cheek; the junction of the lower lid and eyeball of the right eye is almost imperceptible. The pearl earring lacks precise contours. Everywhere, even where contrasts of light and shade are vigorously established, as in the folds of the turban, the paint has a soft, fluid quality. All these features seem typical of Vermeer's mature style and have been seen as evidence of his use of a *camera obscura*.

But there is a deeper significance to this comparison that may be missed when looking at reproductions. The van Mieris is a fraction of the size of the Vermeer, virtually a miniature, and the meticulous precision of its brushwork is that of the miniaturist. It must have been painted with the aid of a lens and the finished work requires a lens for its adequate appreciation: the dexterity of the brushwork calls for such admiring attention. The viewer must peer at the fine textures of the stuffs and the fine strokes with which the paint has been applied.

The Vermeer is over twenty times the size of the van Mieris. And though the canvas is much the size of many of his smaller mature works, being almost identical with the Rijksmuseum *Woman in blue reading a letter*, his image is far from miniature. On the contrary, it approaches the scale of life and by this factor requires the viewer to stand back. The qualities of the brushwork may be pleasing but its essential effect is to establish a distance between the viewer and its subject. However closely the surface of this paint is examined it will never reveal the intimate textures of flesh and fabric. On the contrary, in order to see the paint as portrayal the viewer must retreat. At a modest distance the viewer can recognise in the liquid reticence of the paintwork the subject's irreducible remoteness. Or again, the paintwork may be seen to have something of the

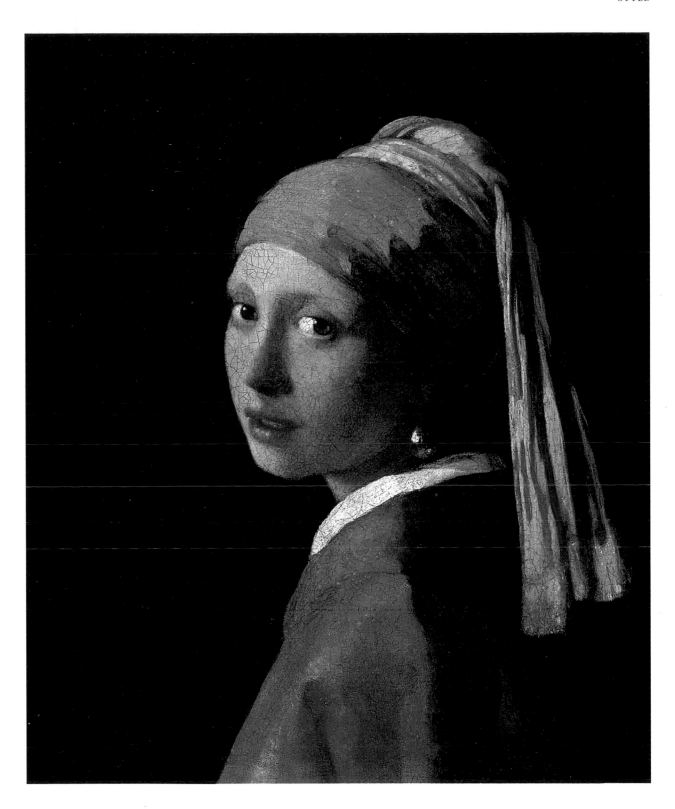

quality of an image in a looking glass, provoking the viewer to take up a position as far before the painted surface as the girl appears to be beyond it.

From a proper distance, the viewer may perceive the softness of the girl's cheek, the moisture of her lips, the precise projection of the tip of her nose, the recession of the delicate curve of her jaw down to her throat. And the viewer's eye is met by the dark and luminous gaze of the girl. It is as if she had, by chance, turned her head and has been transfixed by what her gaze has discovered. It could be the stare of a stranger or, equally, the unexpected sight of her own image in a glass: either might be the source of the wondering uncertainty reflected in her face.

Although Vermeer's flowing paint is quite unlike the rugged impasto of Rembrandt, this head has a Rembrandtian quality in its firm, broad modelling and its chiaroscuro. The turban, too, recalls the exotic costumes Rembrandt used, and it suggests that this is not primarily a portrait. It is in this that it is most profoundly Rembrandtian, confronting us, without obvious pretext, with an anonymous individual with whom we engage, as if in mutual contemplation.

Though this painting appears to offer in salient form so many of the distinctive features of Vermeer's style a close consideration of it discloses the impossibility of separating form from content in his art. Above all, it demonstrates that if Vermeer did use the *camera obscura* it was not to produce a handmade anticipation of the photograph.

Two further general remarks should be added here. Although they retain more of the distinctive quality of Vermeer's images than engravings, photographic reproductions, too, have their dangers. They assimilate the painting into their own photographic quality, losing the sense of the actual painting. But part of the mystery of a piece by Vermeer is that although it is manifestly an object of paint, dense and richly studded in parts, the very procedures of its painting are far from obvious, either in the handling or in the strategies by which the painter set out to capture an apparent moment of time. It is in this character that the small *Woman writing* in the National Gallery, Washington, is so like yet unlike a van Mieris or a ter Borch. Like them, and unlike the Mauritshuis *Girl with a pearl earring*, it is, unmistakably, a piece of fine painting. But where the traditional *fijnschilders* reduce the viewer into awed admiration for their inordinate skills, Vermeer's painting baffles comprehension of the nature of its achievement.

The other danger of the photographic reproduction is that it denies the significance of the original scale of the work. This is true of all photographs of works of art, but it is especially insidious in the case of Vermeer, for whom scale was crucial. This is because his association with the *fijnschilders* is partial. His initial understanding and experience of painting was, as Thoré recognised, derived from the example of Rembrandt, who also was a native of Leyden, the home of the *fijnschilder*, and learned his skills there. The *Girl with a pearl earring* is not the only Vermeer with a Rembrandtian quality. The *Young woman reading a letter at an open window*, in Dresden, had been ascribed to de Hoogh, but only after it had been given to Govaert Flink, the school of Rembrandt and to Rembrandt himself.

Apparent Realism

Before photography, realism remained an ambition, a goal. Reality embraces everything: material and spiritual, of this world and out of it; physical and mental; objective and subjective. Little of this can be made into a visible, comprehensible image on a flat surface. Every attempt is, necessarily, only partial, but it is the part of the power of art to convince us that it is simply true. Seeing is believing, it is said. An image that can convince its audience that it shows things exactly as they appear to sight is an image with great persuasive power. It is persuasive because it seems to be an achievement of the magical arts rather than a feat of skill, which has transformed by the application of a little paint a flat surface into a vision of the world.

Realism, in the sense of showing scenes such as might have been seen in the world around, was the achievement of many of Vermeer's contemporaries. Several achieved a precision and delicacy of perspective and light effects, and an exquisite refinement of technique, that are awe-inspiring. Gerard ter Borch produced delicate, subtle and provoking dumb shows, in which an exchange of glances is not less significant because the women making the exchange are clothed in exquisite gowns consummately rendered. Gerrit Dou painted small interiors cluttered with objects, each object and feature rendered with painstaking detail. Pieter de Hoogh's courtyards and interiors glow with the light reflected from well-ordered surfaces. But none of these or any other of their contemporaries create the intense conviction that they introduce the viewer into a real, once existing interior as do Vermeer's paintings.

It is the sense of the painter, within or without a darkened room, observing rather than inventing, that brings the modern viewer to feel so close not just to the subject but to the artist himself.

The conviction that the viewer before his canvases today sees exactly what the painter saw before him in his studio in Delft in the middle years of the seventeenth century has led a number of scholars skilled in geometry to attempt to reconstruct, both in plan and elevation on paper and also in models, the actual proportions of that studio or studios. There can be no doubt that Vermeer's images are as perspectively correct as they are visually convincing. It has even proved possible to calculate the geometrical relation between the disposition of the scene set up in the studio and the scale of the painted image, and so establish the point at which in the studio the hypothetical lens of a *camera obscura* would have been positioned for a specific canvas. But this only serves to uncover the basic problem. Though at first sight, Vermeer's paintings appear not only to represent the actual appearance of a real room but also repeated views of the same room, a closer comparison between works reveals a number of unsettling discrepancies between apparently identical interiors.

The most unmistakable variations are those played upon the tiling of the marble floor that appears in ten paintings. The basic pattern is of blocks of five black tiles laid in crosses set corner to corner, with single white tiles in the spaces between them. The most obvious transformations are in the British Royal Collection *Music lesson*, in which the pattern becomes a grid of black tiles, and in the *Allegory of Faith*, where the colours

are reversed, appropriately perhaps, to make a pattern of white crosses. More subtle is the difference between the Beit *Woman writing a letter with her maid* and the National Gallery, London, *Woman standing at the virginals*, in which the intersection of floor and window wall differs by the distance of half a tile. But, of course, the windows in these two paintings have differently patterned leading.

Among the fourteen interiors in which they are discernible, the windows display a considerable variety of leading. There are two main types. In six paintings the individual frames have rectangular leads with inset diamonds in the top row. The windows in the Frick *Soldier with laughing girl* and the Dresden *Young woman reading a letter at an open window* appear identical, being five panels high by four panels wide. The window in the *Milkmaid* looks very similar but too little can be seen for certainty. One of its panes is broken. In the identical interiors of the *Astronomer* and the *Geographer*, the windows are not quite identical. Both could be six panels high by four panels wide, but there is a coloured design set into the window of the *Astronomer*. The window in the *Woman standing at the virginals* in the National Gallery, London, is six panels high by five wide. The second window design, too, has three distinguishable variations. In its most distinctive form, in the Berlin *Glass of wine* and the Brunswick *Girl being offered wine*, it is a dominating feature displaying a heraldic device in coloured glass. In the Beit *Woman writing a letter* it appears less obtrusively with a different device in coloured glass, but in a further five paintings, the same pattern of leading is set with plain glass.

While the naïve literalist, after closely studying the paintings, might suppose that Vermeer had set up his apparatus in as many as nine different rooms, the rational art historian might claim, on the contrary, that as an intelligent, gifted painter highly trained in the artistic skills of his day, Vermeer could and would have invented all these variations while working in a single studio that, quite probably, lacked every one of those familiar features.

Certainly his contemporary, Pieter de Hoogh, was capable of the most elaborate pictorial sleights that mixed fact and fiction. Two of de Hoogh's *Courtyard scenes*, both painted in 1658, are almost identical. Both show an enclosed brick-paved courtyard and, on the left, the rear of a house through which an arched passage runs to the street. Above the arch, in both paintings, is an inscribed plaque of 1614 that survives in Delft today. But there are extensive and basic structural differences between the two scenes. In one, in the National Gallery, London, a woman and child enter the courtyard down several steps from a door set high in the enclosing wall. In the variant, now in a British private collection, in which two men seated at a table beneath an arbour talk to a standing maidservant, the courtyard is completely level. In this, probably earlier, version, in the street glimpsed down the passage a canal runs between the houses, while in the National Gallery painting the house seen through the passage appears to be across a common courtyard. Not only the two back courtyards but the very houses display different patterns of brick. Even the inscription on the plaque is varied, and in neither piece is the original literally reproduced. There is no reason to believe that Vermeer was less inventive than de Hoogh.

Perhaps a balanced resolution to the question of Vermeer's fidelity to his motif would be to propose that he may have used three different studios or settings, a reasonable number for a career of twenty-three years. The Dresden *Young woman reading a letter at an open window*, the Frick *Soldier with laughing girl* and the *Milkmaid*, all of which, it is generally agreed, are early works painted soon after *The procuress* which is dated 1656, were done in a studio in which the window frame is flush with the plaster surface of the wall. The *Astronomer* and *Geographer*, of which the former is

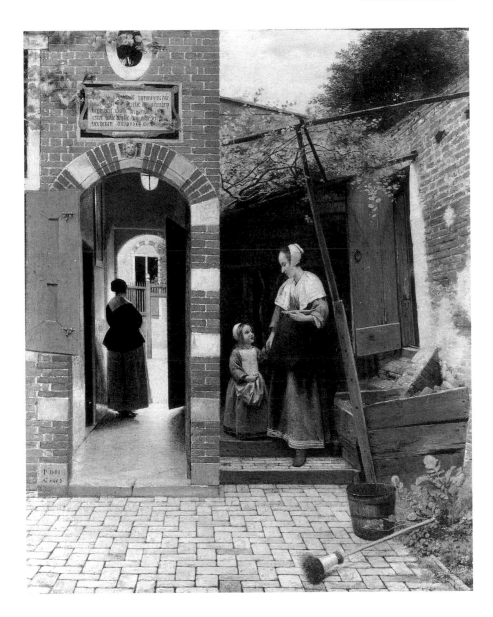

Pieter de Hoogh
The courtyard of a house in Delft, 1658
Canvas, 73.5 × 60 cm
National Gallery, London

dated 1668, are in another room with a distinctive wooden sill to a window set forward of the rear wall. A third large studio that has been calculated to have been almost three metres high, six and a half metres along the window wall and not less than four metres across the visible rear wall, with three double windows, would have served for all the remaining works. Possibly it was an upper room in the house in Oude Langendijck.

Vermeer's art depends on a curious balance of the literal and the imaginative. All the maps and the two globes that appear in seven paintings have been identified with surviving examples of the day and in most cases they are faithfully rendered. But just as the window pattern varies while having the same basic format, so the same map appears almost unrecognisably different in the Frick *Soldier and laughing girl*, the Rijksmuseum's *Woman in blue reading a letter* and the *Love letter*. The same pictorial composition, showing the *Finding of Moses*, appears on two vastly different scales in the Louvre *Astronomer* and the Beit *Woman writing a letter with her maid*.

It is a significant quality of Vermeer's art that it captures not only the appearance of individual objects but of an entire environment, a small corner of the visible world in its totality. These spatial and optical concerns distinguish Vermeer from the *fijnschil-*

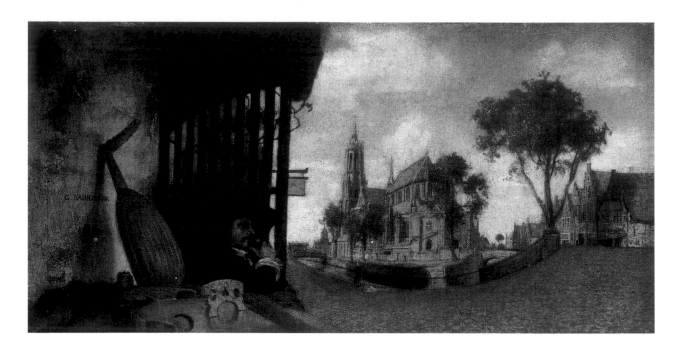

Carel Fabritius
View of Delft, 1652
Canvas, 15.4 × 31.6 cm
National Gallery, London

ders who, whatever their subject, represent stuffs according to a repertoire of technical procedures, showing little interest in qualities of light or spatial composition. De Hoogh does share these preoccupations; he and Vermeer seem, on occasion, to vie with each other. They could be vying for the abandoned mantle of Carel Fabritius.

The explosion of the powder magazine in Delft on 12 October 1654 not only killed Fabritius, it also destroyed many of his works. In consequence, though he had a reputation for illusionistic perspective, only one surviving painting confirms it. In curious contrast with Vermeer's great *View of Delft*, this is the small *View of Delft with a musical instrument seller's stall* in the National Gallery, London. It shows an identifiable corner of old Delft with the New Church in the centre and to its left, in the distance, the Town Hall. The view has been identified as taken from the corner of Oude Langendijk and Oosteinde, not far from where Vermeer's mother-in-law already lived at the time the picture was painted, in 1652. Although this small work on canvas is meticulously precise in its topography it is curiously distorted in its perspective, especially in the foreground. It has been suggested that his view of Delft appears distorted because it is an image calculated to be viewed in a perspective box. There, the canvas would have been curved in a concave arc so that the perspective distortions would be corrected when viewed through a peephole. The near end of the *viola da gamba* would have been painted on the floor of the box. An experimental peepshow using a photograph of the painting has demonstrated the plausibility of this hypothesis. The distortions are invisible when viewed through the peephole.

Among his contemporaries interested in these devices, the most skilful, successful and ambitious was Fabritius's fellow-student from Rembrandt's studio, Samuel van Hoogstraten. Hoogstraten painted, among other things, an illusionist mural painting now at Dyrham Park, Gloucester, that actually closes off, but appears to extend, a corridor, and the amazing perspective peepshow that, by curious coincidence, is now also in the National Gallery, London. This is a five-sided wooden box mounted on a low pedestal. Originally, the sixth side would probably have been covered by waxed paper to let in light but conceal the artifice of its construction. Today the National Gallery displays the box with a transparent side to expose the bizarre distortions of

perspective by which Hoogstraten achieved a complex illusion. When the interior of the box is viewed through peepholes placed in the opposite short sides, the five inside painted surfaces, vertical and horizontal, are seen as the interior of a Dutch house, the viewer looking directly into a hall or central room from which four open doors and a window afford glimpses of further rooms and the outside world. The house is well appointed and inhabited: a dog sits in the central hall, a servant sits reading by a distant door and a woman may be glimpsed in bed.

Because of Vermeer's obvious concern with precise perspective (most notably, perhaps, in the *Music lesson*) and because his contemporaries associated him with Fabritius, scholars have speculated whether certain entries in the Dissius inventory of 1682 and the Amsterdam catalogue of 1696 refer to perspective boxes. In the 1682 inventory there were listed, among the twenty Vermeers, "three ditto by the same in boxes", while in 1696, item 1 was "A young lady weighing gold, in a box by J. vander Meer of Delft...". The consensus is that this is unlikely to have been the case. Images designed for perspective boxes look distorted unless viewed in such a box. A considerable part of their charm lies in the magical way their distortions disappear when seen through the peephole. None of Vermeer's surviving works betrays these characteristics. Their perspectives are not anomalous. The only work specified in a box, in the 1696 catalogue, is further identified as "... extraordinarily artful and vigorously painted", and highly priced at 155 guilders. If, as seems likely, this was the painting now in Washington known as a *Woman holding a balance*, the most credible explanation of the box is that it was to protect so fine and valuable a work.

Nevertheless, Vermeer shared Fabritius's and Hoogstraten's concern with perspective. As one of the mathematical arts, geometrical perspective had long been recognised as prime among the skills that in Quattrocento Florence had transformed painting from a manual craft into a liberal art. The painters of the Netherlands were well aware that Italian artists derided them as ignorant of the true principles of art. But there was more to the superiority of Italian art than perspective. Italians knew the true art of *disegno*, a term that embraced drawing and composition. They also knew the importance to great art of the subject: the *istoria*, or history, which should be taken either from the Bible or from classical history or mythology. Fabritius, Hoogstraten and Vermeer all appear to have been skilled, or "artful" (as it was then termed), intelligent and ambitious artists. Hoogstraten, in his writings, showed that he accepted the Italian criteria for great art. Vermeer appears to have believed he understood the principles of Italian art. In 1672, he was regarded by himself and others as fit to pronounce on the authenticity of several paintings attributed to Michelangelo, Titian, Raphael, Giorgione, Paris Bordone and others. Vermeer's fellow connoisseur, an older artist, Johannes Jordaen, had spent many years in Italy, and together they declared all the contested works to be rubbish and bad paintings.

None of these painters wholeheartedly emulated the Italian manner. But it would be a mistake to believe that Netherlandish painters of Vermeer's generation were unconcerned with anything more than the appearances of daily life, or that they saw geometry as the intellectual skill by which alone painting was elevated from a craft to a liberal art. This may be discovered in a more thoughtful look at Hoogstraten's perspective box.

The four visible exterior surfaces of the box are also painted and they make a striking contrast with the contemporary domestic scene within. While the three sides show conventionally painted Baroque allegories, the top of the box, like the interior, is painted in unconventional perspective. Viewed as if it were a conventional painting, it appears appallingly, even incompetently, distorted. But it cannot easily be viewed as a

Samuel van Hoogstraten
Peepshow with *Views of the interior of a Dutch house* (details)
Panel, external measurements
58 × 88 × 63.5 cm
National Gallery, London

Samuel van Hoogstraten
Peepshow with *Views of the interior of a Dutch house* (detail)
Panel, external measurements
58 × 88 × 63.5 cm
National Gallery, London

conventional painting. The perspective box is mounted on a pedestal so low that most adult viewers must stoop to peep within. The painting on the top, on the other hand, can only be seen obliquely, and it has been calculated to be viewed from this unconventional angle. Seen by an eye raised from the peephole to squint over the rim of the lid at the appropriate point, a naked woman and a child in bed, who can be identified as Venus and Cupid, appear as if in conventional perspective. It is the relation between interior and exterior perspectives that is teasing. Within, the precisely determined viewpoints reveal little but suggestive clues. Hanging by one of the entrances are a man's broad-brimmed hat with a shoulder-belt and sword, while on a chair across the hall, and only to be seen through the opposite peephole, a woman's pearl necklace and comb have been laid. In the view that reveals the man's presence a spaniel can be seen sitting expectantly. Beyond the comb and necklace, seen from the opposite position, can be glimpsed the woman in bed: she may or may not be alone. Through another open door, with a broom beside it, can be seen a woman reading while a man peers at her through a window. Why is one woman in bed in broad daylight? Is she ill? Where is the man whose hat and sword hang on the wall? But only raise your eye from the peephole, straighten slightly, search along the rim of the lid to discover the right position, and there you can look down on Venus and Cupid in bed. The bed is a four-poster, its closed curtains also forming a box-like space. The anamorphosis on the top of the box offers an alternative perspective on its interior: a view that is oblique, metaphorical but unequivocal. Both interior and exterior perspectives are equally cunning illusions that reveal the truth. The allegories on the three sides of the box represent what Seneca, in his *De Beneficiis*, said were the three incentives to painting: Love of Money, Love of Fame and Love of Art.

The complex imagery, both visual and figural, of this box gives clear evidence of the extent to which domestic scenes by Vermeer and his contemporaries were more than demonstrations of technical skill or simply reflected a delight in the world of appearances.

Fabritius's *View of Delft*, too, is more than a topographical view. The National Gallery catalogue entitles the painting *A view of Delft, with a musical instrument seller's stall*, but there is no reason to interpret these features in this way. Music is the food of love: the two instruments are there, perhaps, to signify that the brooding man has an assignation with a woman. The vine-covered arbour under which he sits appears to be part of an inn, as its sign, *The White Swan*, can be seen above his head. It is the sign which in Netherlandish painting, perhaps because swans draw the chariot of Venus, has traditionally been given to an inn of doubtful reputation. There is also the proverb: the swan has white plumage, but her flesh is black. In this perspective, the pleasures of the flesh are close to hand, the spiritual nourishment offered by the Church attainable only by a longer path.

Beeldeken

An art of appearances: that is what is so distinctive, indeed unique, about Vermeer's art. No other painter, before or since, has so attended to and rendered the abstract beauties available to the eye. His subject, it might be thought, is light and its transmutations, the vicissitudes it undergoes in its engagements with the material world. But Vermeer did not paint those motifs that might be thought most to appeal to a painter of appearances. He left behind no independent still lifes (though some of the finest still lifes ever painted are to be found in his works). The only true landscapes by his hand appear as paintings within paintings, on the walls of his interiors or decorating musical instruments. The two townscapes are another matter: they, like all his images, are focussed on the constructions of humans: the human world. It is, despite, or through, appearances, the human world that is Vermeer's theme.

Women predominate in Vermeer's paintings. Of the eighteen single-figure canvases, all but two (the *Astronomer* and the *Geographer*) depict a woman. Men are present in only seven other canvases. In three, a gallant attends a woman who takes a glass of wine: wine is also evident in two of the three paintings of music-making in which a man appears. It is only in the *Art of Painting* that a man, the artist, is present as the protagonist, and there he sits with his back to the spectator. It is the face of his female model we are shown.

The majority of Vermeer's mature works are small. Some are very small: the Louvre *Lace-maker* is only 24.5 × 21 cm. Almost two-thirds of the surviving works vary between 42.5 × 38 cm to 55 × 45 cm, a size of approximately 45 × 40 cm being common. (The two largest works after the early and vast *Procuress* have, interestingly, almost identical dimensions. The *View of Delft* is 98.5 × 117.5 cm and the *Art of Painting* is slightly larger, 120 × 100 cm.) After the fancy costume drama of the *Procuress*, and apart from the two city views, the *Art of Painting* and the *Allegory of Faith*, all the rest show contemporary interiors inhabited most frequently (eighteen pieces) by a single figure. In six other paintings there are two figures, and in only two paintings, those at Brunswick and at Boston, are there three figures.

His subjects are those of his contemporaries, who included de Hoogh and Cornelis de Man in Delft and van Mieris, Metsu and Dou in Leyden, Maes in Dordrecht and ter Borch in Deventer. Such paintings, apparently representing the minor, repetitive activities of daily life, came to be called, in late eighteenth-century France, genre scenes. In contemporary inventories such paintings were seldom identified more precisely than as *beeldeken* (small images) or *stuckjes* (small pieces) followed by the name of the painter, where that was known. The subjects of so many of these paintings do seem too trivial to be remarked on: a man and a woman take a glass of wine together, a woman plays a musical instrument, sometimes alone, sometimes in the company of others, musicians or audience, a woman writes or reads a letter or a servant offers a drink to a child. But however trite the subject it is painted with meticulous precision. It is this virtuoso craftsmanship that first catches and holds the eye. Is it this and the sheer visual pleasure afforded by these works that account for their being made? At

first, there seems to be no answer to this fundamental question. The silence of the inventories remains unbroken in other contemporary sources.

Nevertheless, it is possible to hazard an interpretation, because, despite their distinctive character, these pictures of daily life of the 1650s and 1660s were not without precedent. Scenes of contemporary life without immediately obvious narrative or symbolic purposes had been painted by painters working in Haarlem in the 1620s. Chief among these painters were Esaias van de Velde, Willem Buytewech, Adriaen Ostade and Dirck Hals, and all may have been influenced by Dirck's older brother, Frans. Those paintings, however, had none of the diversity of subject of the paintings of Vermeer's generation. On the contrary, they were almost entirely limited to scenes of conviviality. There were open-air parties, banquets, drinking parties, music parties, gaming parties and inn and brothel scenes, generically known as merry companies. In most cases, the participants were young and richly dressed, gilded youth, though in Ostade's paintings the revellers were grossly brutish peasants.

In Delft, the only painter of any note to produce merry companies was Anthonie Palamedesz. Born in 1601, he was a decade or more younger than the originators of the merry company, and his merry companies are essentially derivative of the inventions of these older painters and are very repetitive. Although he enrolled in the Delft Guild of St Luke in 1621, his earliest dated painting, now in the Mauritshuis, is from 1632, the year of Vermeer's birth. Later, the two painters certainly became acquainted, as Palamedesz. was headman of the Guild of St Luke in 1658, 1663 and 1672. The *Merry company* now in the Rijksmuseum, dated 1633, is a very close variant of the Mauritshuis painting. Adopting what was then a modern viewpoint, that is, low almost level with the table-top, Palamedesz. shows an interior with plain walls decorated by a number of small landscapes lit by a high window on the left which is not unlike the interiors in which Vermeer was to set his own early pieces.

For these festive scenes, there were a number of precedents. Many of the outdoor companies seem modern versions of the northern medieval Garden of Love, or of astrological scenes showing the occupations of those born under the influence of the planet Venus; the "children of Venus", as they were called. Those born under the influence of Venus were not only amorous, they loved music, wine and gaming. It was this kind of behaviour that in the days of Noah had led Jehovah to send down the Flood. In St Matthew's Gospel (25: 38–39) Christ warned his disciples: "For as in the

Anthonie Palamedesz.
Merry company in a room, 1633
Panel, 54.5 × 88.5 cm
Rijksmuseum, Amsterdam

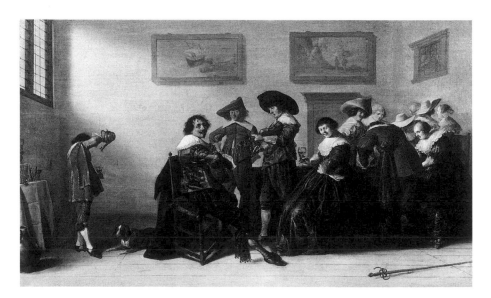

days before the Flood they were eating and drinking, marrying and giving in marriage, until the day that Noe entered into the ark, And knew not until the Flood came, and took them all away; so shall also the coming of the Son of Man be.'' So a scene of contemporary festivity exemplified the folly of mankind, in thrall to the pleasures of the senses, blind to the immanence of Christ's Second Coming and the Last Judgement. In the sixteenth century, the Amsterdam painter, Dirck Barendsz., had designed a pair of engravings showing mankind in the days of Noah with mankind before the Last Judgement. The latter showed a merry company in the modern mode while the debauchery of mankind before the Flood resembled a feast of the gods as painted later, at the turn of the century, by Cornelis van Haarlem and Wtewael. Other scenes of debauchery, usually in an inn, showed the Prodigal Son wasting his inheritance. He would be shown revelling in wine, women and song, running up ruinous debts and being robbed: behind him, a serving maid chalked up his drinks on a slate or tally-board while a whore stole his purse. This story, too, being one of Christ's parables, was most appropriately represented by exemplification in a contemporary setting.

In many of these paintings, the pleasures of all five senses were numbered, to remind the viewer of the folly of their mindless indulgence. Also popular were sets of five small works each showing a single sense. Then there were sets of images of the seven deadly sins, of the four humours or temperaments, the four seasons, the four elements and the four, or more, Ages of Man. Many of these subjects were made as popular engraved prints that included title and commentary. And in almost every case, the taste was to represent these long established categories by modern examples. But a single modern activity might exemplify a variety of traditional categories. A gallant serenading a young woman on the lute could be the Sense of Hearing, the Season of Spring, the Sanguine Temperament, the Element of Earth, Evening, Lust and other possibilities. In engraved form with a caption and explanation attached, and often as part of a set, the specific connotation would be clear. In a painting its significance must be less certain. But at the centre of however large a range of possible interpretations must be the simple certainty: *Amor docet musicam*, Love teaches music. Music is the food of love.

Many of the apparently novel images painted by the artists of Vermeer's generation may be seen to derive from such familiar traditional categories. Some, including many of the inventions of Dou and Metsu, working in Leyden, cannot be so neatly identified. But Vermeer's subjects, in the main, are traditional. Three familiar themes predominate in his surviving œuvre: in four paintings, a young woman drinks wine with a gallant; in eight, a woman makes, or is about to make, music, in company or alone, while a musical instrument lies to hand in two other paintings; and letters read, received or written are the concern of six paintings. More curious is the way that these motifs are knit together in certain works, so that twenty instances of these various motifs are amalgamated into only seventeen paintings. Another eight works are simple or subtle variations on other recognisable traditional themes. The art of Vermeer, it seems, lies in the transformations he worked on these traditional themes. Consequently, our comprehension of his achievement is dependent both on our recognition of his themes and our scrupulous attention to the character of the variations he develops from them. Such variations no longer carry traditional titles. Vermeer's paintings can only be described. The description may be brief, perfunctory and superficial, as in the catalogue of 1696, or it may be extended and scrupulous. The problem is that each description will also be an interpretation of the significance of what is seen. This is the character and fate of cabinet paintings. It is the nature of their appeal to the imagination.

Two Early Works

The two earliest paintings now attributed to Vermeer were among the last to be discovered. The *Christ in the house of Martha and Mary* now in Edinburgh and *Diana and her companions* in the Mauritshuis both made their appearance late in the nineteenth century. The earliest record of the *Diana* is its purchase by Neville D. Goldsmith from whose collection it was bought by the Mauritshuis in 1876 as by Nicolaes Maes. The *Christ in the house of Martha and Mary*, which is first recorded as the purchase of a furniture dealer from a Bristol family for £8, was published as by Vermeer in 1901. In both cases the attribution was prompted by a newly discovered signature. The signature J Meer was discovered beneath Nicolaes Maes's signature when the *Diana* was restored soon after its acquisition by the Mauritshuis: it is sufficiently indistinct for there to be some disagreement about its precise form. The signature on the Edinburgh painting, discovered by a fortunate art dealer, is V Meer with V and M intertwined, which corresponds closely to that on the Dresden *Procuress*, which until the attribution of the *Diana* was the earliest recognised signed and dated work.

A number of problems are posed by these works, taken together and severally. They are the only paintings of traditional historical and mythological subjects attributed to Vermeer. Following the recognition throughout Europe of the pre-eminence of the achievements and ideals of Florentine and Roman Renaissance artists, ambitious painters everywhere accepted that the highest form of art and especially of picture-making was what the Italians had called *istoria* (generally translated as "history"), that is narrative taken from the Bible and the history and myths of classical antiquity depicted more or less according to the principles of Italian *disegno*. Even in the newly independent and stoutly patriotic United Provinces of the Netherlands, many ambitious artists did not relinquish Italianate values and continued to paint histories, among them the Delft painter Leonaert Bramer, who may have been Vermeer's master. Art historians who have understandably recognised in Vermeer's art evidence of considerable ambition, a view supported by the scale and character of the Dresden *Procuress*, have been gratified to find in the Edinburgh and Mauritshuis paintings the kind of large history paintings such an ambitious painter might have attempted in his youth.

Although the *Diana* is actually on a smaller canvas than those used for the *Art of Painting* and the *Allegory of Faith*, its figures are on a much larger and grander scale. Among later works, only the *Procuress* outstrips it in both size of canvas and scale of figures. But the *Christ in the house of Martha and Mary* is larger by far than any other work attributed to Vermeer. The canvas is the height of a small man and so the figures, which are seated and set back in the interior, have a more than life-size scale. So large a work may have been the result of a commission.

Because of the differences of scale, both from later works and between the two paintings themselves, it is hard to form a just assessment of their qualities. The Edinburgh painting is drawn in fluid strokes that look bold even in a small reproduction. In the original they have an astounding vigour and breadth, quite unlike

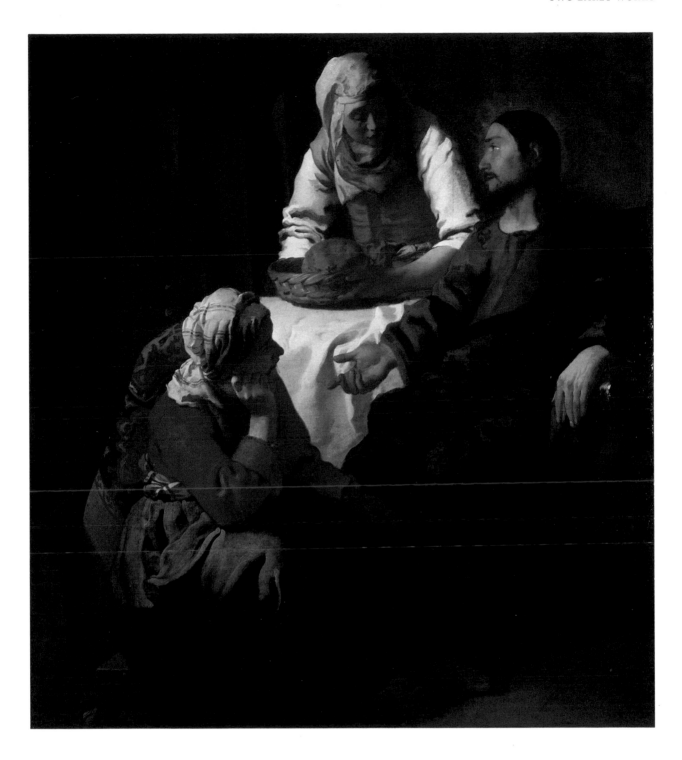

anything in Vermeer's other work, unlike the handling of any of his contemporaries in the United Provinces, having rather the qualities of a follower of Velázquez. The most probable influence would be the Utrecht Caravaggists of the previous generation. Vermeer may already have known the *Procuress* by Dirck van Baburen that he later incorporated as a painting within two of his own paintings, the Boston *Concert* and *Woman seated at the virginals* in the National Gallery, London. But the handling, both in its brushwork and in the concern for light evident in the heads of the sisters, recalls another Utrecht painter, Hendrick Terbruggen. It was possibly the very scale of the canvas that called for broad strokes to hold the composition together and, if it was commissioned for a place of worship, to enhance its visibility for a congregation. In the result, it is both vivid and compelling, a remarkable achievement for so young an artist. Also, it must be recognised that the carpet on the table has a similar pattern to that in the *Girl asleep at a table* in the Metropolitan Museum, New York, and the bodice of the attendant washing Diana's foot reappears in the same painting.

The painting of *Diana and her companions* bears little similarity to the *Christ with Martha and Mary*. It is hard to believe they both come from the same hand. The painting was purchased by the Mauritshuis in 1876 as by Nicolaes Maes, and this is a perfectly understandable attribution. Maes had trained in Rembrandt's studio and the *Diana* has a distinctly Rembrandtian air to it. The crepuscular atmosphere, appropriate to a representation of the moon goddess, is reminiscent of Rembrandt's paintings of the early 1650s. But more intriguing is the resemblance, often noted, between Diana and Bathsheba in Rembrandt's great canvas, *Bathsheba at her toilet*, of 1654, now in the Louvre. Diana's pose is not identical, she is clothed and the image is a reflection of the Bathsheba, but in general disposition, which includes the attendant washing the heroine's feet, and in its melancholic, contemplative mood the similarity to the Rembrandt painting is compelling. Indeed, it may be invoked to refute the suggestion that the Mauritshuis canvas must have been trimmed on its right edge because the nymph washing Diana's foot is cut off at the edge of the picture: the attendant in Rembrandt's painting is similarly cut off.

It has been proposed that the Rembrandt pupil who could have introduced his procedures and values to Vermeer was Carel Fabritius who, despite his miniature illusionistic *View of Delft*, also painted on a grander, more Rembrandtian scale. Fabritius could, possibly, have brought knowledge of Rembrandt's painting, dated 1654, to Delft and Vermeer shortly before the arsenal explosion that killed him and many others on 12 October 1654. Vermeer, on the other hand, could have visited Amsterdam and Rembrandt about that time. This is certainly what Thoré surmised. In Amsterdam, he could also have seen the *Diana and her companions*, dated 1648, by the Amsterdam painter Jacob van Loo. This painting, now in the Bode Museum, Berlin, has frequently been cited as the prototype of Vermeer's composition.

The Dresden *Procuress*, painted only in 1656, has qualities that, as Thoré remarked, recall the work of Fabritius and other pupils of Rembrandt; and, of course, the *Woman reading a letter at a window*, also in Dresden, was in the eighteenth century attributed not only to the Rembrandt's pupil Govaert Flinck but even, for a time, to Rembrandt himself. On the other hand, the *Diana*, which is so satisfactory a piece of juvenilia, is nonetheless a less impressive work than the *Christ in the house of Martha and Mary*. If both are, indeed, correctly attributed, it might have been expected that the *Diana* was the earlier of the two pieces. If the resemblance with Rembrandt's *Bathsheba* is more than coincidence, then the *Diana* must have been painted, at the earliest, late in 1654.

With these two canvases, disparate as they are, being the only known works to have been painted, it would seem, in the years between Vermeer's enrolment in the Delft

Johannes Vermeer
Diana and her companions
Canvas, 98.5 × 105 cm
Mauritshuis, The Hague

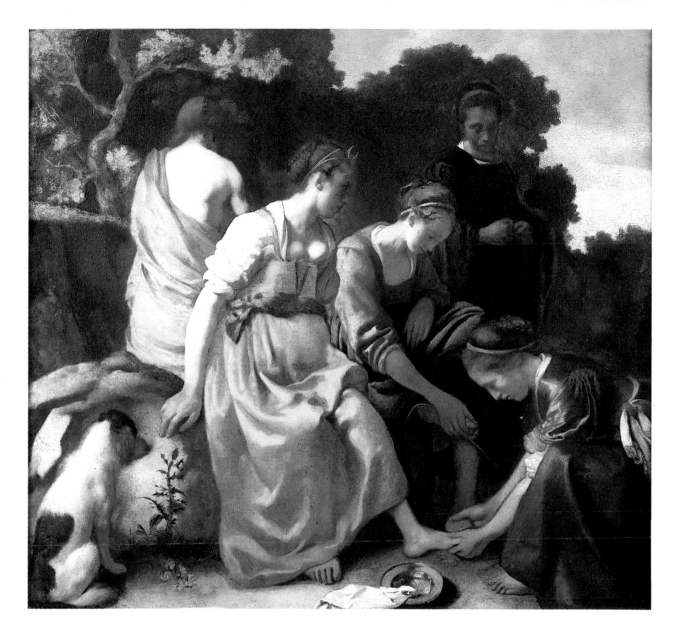

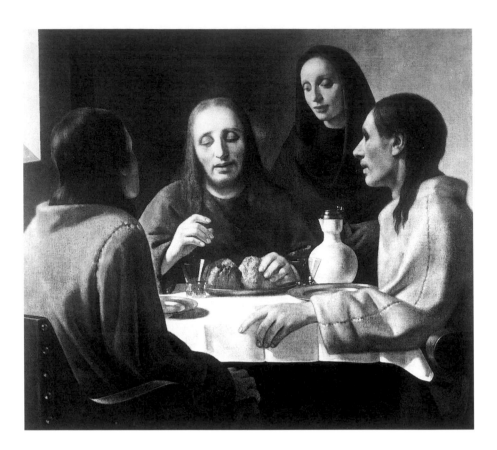

Hans van Meegeren
Christ at Emmaus
Canvas, 117 × 129 cm
Museum Boymans-van
Beuningen, Rotterdam

Guild of St Luke on 29 December 1653, two months after his twenty-first birthday, and the painting of the *Procuress*, dated 1656, scholars have naturally looked, and hoped, for more. In particular, bearing in mind that only months before his entry in the Guild of St Luke, on 5 April 1653, Vermeer had married into a Catholic family, scholars looked at the large *Christ in the house of Martha and Mary* and anticipated other religious paintings secretly commissioned by Catholic patrons.

It was this situation that the forger Hans Antonius van Meegeren exploited when, in 1937, he revealed his *Supper at Emmaus* to the famous scholar Abraham Bredius. Bredius was by that time an old man, the doyen of historians of Dutch art, and he saw the new painting as a masterpiece and the confirmation of his conviction that Vermeer had painted such works. He hastened to publish his find in the *Burlington Magazine*. In December, it was bought by the Rembrandt Society for 550,000 guilders and presented to the Boymans Museum in Rotterdam. The majority of Vermeer scholars were delighted to welcome the forgery as one of the greatest masterpieces of seventeenth-century Dutch painting. Four more early Vermeers (all forged by van Meegeren) were published in 1939: *Jacob's Blessing, Head of the Redeemer, Christ and the Woman taken in Adultery* and the *Last Supper*, of which the last was bought in 1941 by the Dutch collector Daniel George van Beuningen for 1,600,000 guilders. In 1943 the Rijks-museum bought *The Magdalene washing Christ's feet* for 1,250,000 guilders. Some scholars did become suspicious of so many new discoveries, and no doubt the War hampered investigations, but when, in 1945, van Meegeren was charged with war crimes for selling the *Christ and the Woman taken in Adultery* to Herman Goering and, to save himself, he confessed to the forgeries, he was not believed. Even after he had painted *Christ among the Doctors* under court supervision and the earlier forgeries had been examined in the laboratory, some scholars continued to insist that the *Supper at*

Emmaus and the *Last Supper*, at least, were genuine, and that it had been their discovery that had inspired van Meegeren to make his own, later, forgeries. It was not until 1958 that both the photograph and the record of sale were discovered of a seventeenth-century hunting scene by Hondius that van Meegeren had claimed to have bought in 1940 and over which he said he had painted the *Last Supper*. X-rays confirmed that beneath the forgery were the remains of the painting by Hondius and, at last, there was no room to doubt that many of the most distinguished Vermeer scholars had been duped.

Yet, today, looking at the first of the forgeries, *The Supper at Emmaus*, on display at the Boymans van Beuningen Museum well away from its Old Masters, it is hard to understand how any scholar and connoisseur could have accepted it as genuine. Technically, van Meegeren had been both skilful and thorough. He had taken a genuine minor seventeenth-century Dutch canvas of *The Raising of Lazarus*, removed the greater part of the original painting and painted over it using only authentic pigments. For his medium he used a recently developed synthetic resin, not readily analysable by then available techniques, that he hardened and aged by a complex procedure that included baking and rolling to produce a cracquelure into which he rubbed Chinese ink. But as an artist, van Meegeren was less skilful. Nowhere does the draughtsmanship reach the competence of a minor seventeenth-century Dutch painter: in particular, the hands of Christ blessing the bread are appallingly clumsily painted. Another problem that scholars might have considered is that it is impossible to relate it satisfactorily with Vermeer's other works. In its scale and subject, it would be most easily acceptable as a Vermeer painted before the *Procuress* which is dated 1656, that is, in the blank years to which the *Diana* and *Christ in the house of Martha and Mary* had already been ascribed. But the head of the disciple on the right is painted in a pastiche of the *Astronomer*, which is also dated, but twelve years later, 1668. The only genuine large paintings that can reasonably ascribed to that time or later are the *Art of Painting* and the *Allegory of Faith*, and to neither of these does the van Meegeren bear any resemblance. The all-important bread is painted in the manner of the bread in the *Milkmaid*, an undated work but probably painted considerably before the *Astronomer*. Finally, though the composition might be said to follow the precedent of the Utrecht Caravaggists it is unmistakably close to the paintings of the same subject, in the National Gallery, London, and in the Brera, Milan, by Caravaggio himself.

The Procuress

Whatever the authenticity of the Edinburgh and Mauritshuis paintings, the *Procuress*, now in Dresden, is the earliest signed and dated painting from Vermeer's hand. And both by its scale and its theme it could be seen to mediate between the history pieces and the imagery of his mature art.

It is a large picture, almost as large as the Edinburgh work and considerably larger than anything else attributable to Vermeer, being 143 × 130 cm, which gives the figures the scale of life. Its subject, mercenary love, was familiar enough in contemporary painting and was often shown in unmistakably contemporary settings, but in this work Vermeer presents his characters in antiquated and possibly theatrical costumes. It may represent the parable of the Prodigal Son, and thus, as its ambitious scale suggests, be intended as a history painting.

Another reason for Vermeer to have worked on this scale was that it was a format used by the group of painters from Utrecht who, earlier in the century, had visited Italy and fallen under the influence of Caravaggio. (These included Gerrit Honthorst, Hendrick Terbruggen and Dirck van Baburen, and are known now as the Utrecht Caravaggists.) A painting of a *Procuress* apparently after that by van Baburen now in the Museum of Fine Arts, Boston, appears on the wall in two of Vermeer's later interiors: the *Concert*, also now in Boston but in the Isabella Stewart Gardner Museum, and the *Woman seated at the virginals* in the National Gallery, London.

Vermeer's *Procuress* is a powerful piece of painting and will dominate any room in which it is hung. The characterization of the four life-sized, half-length figures is strange and compelling, as is the way in which they are presented. The couple on the right are immediately striking both by the vivid vermilion and lemon yellow of their clothing and for their actions. The man embraces the woman, confidently laying his hand over her breast, as he makes to drop a coin into her waiting hand. She receives his offer apparently willingly. On her lips is the hint of a smile, her head seems to nestle comfortably into the crook of his clasping arm. As an image of mercenary love, it is both bold and subtle: bold in the frankness of its sensuality, subtle in its portrayal of character and mood. Traditionally, in such scenes, the woman is a predator, the man a dupe. The whore not only charges for her services, she also robs her client when she can. It is true that van Baburen's man looks a rake rather than a fool. He and the whore look two of a kind. It is the older woman, the procuress herself, who insists on the commercial side of the affair. But while the relationship of van Baburen's couple may be sized up at a glance, what is going on between Vermeer's pair is more enigmatic, and it remains teasing even after the closest and most prolonged scrutiny.

The enigma is compounded by the other two, less immediately striking, figures. Inventorists of the eighteenth and nineteenth centuries took the black-clad figure behind the rake's arm for a man, but the conventions of the subject would suggest it is the procuress herself. Though she is little more than a mask on a black silhouette, her leering absorption in the activity of the lovers provides an unsettling reflection of the fascination they hold for the viewer.

Johannes Vermeer
The procuress, 1656
Canvas, 143 × 130 cm
Gemäldegalerie, Dresden

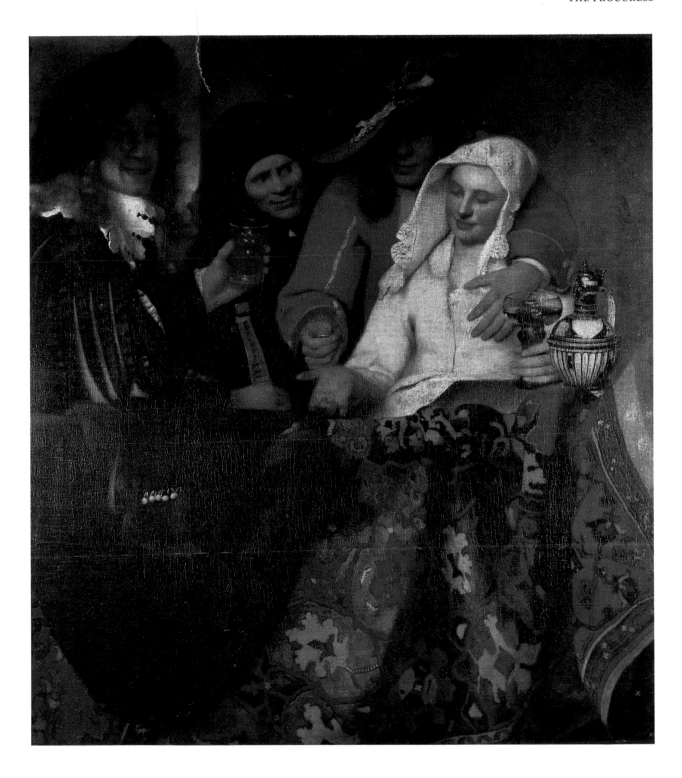

Dirck van Baburen
The procuress, 1622
Canvas, 101.5 × 107.6 cm
Museum of Fine Arts, Boston
(M. Therese B. Hopkins fund)

While the lubricious stare of the procuress mirrors that of the viewer, it is the direct gaze of the figure on the left that uncovers the viewer's complicit attendance at the scene. This is a strange figure, dressed in a costume of the previous century, clasping the neck of a lute and raising a glass. It has often been suggested that it is a self-portrait. Whether or not this is the case (and there are no known portraits of Vermeer to verify the matter) the role this figure plays may perhaps be likened to that of the first-person narrator in a novel who speaks directly to the reader yet is a fiction embedded in the events of the narrative and not the actual voice of the author. By catching our eye, this figure discomfits us, exposes us as voyeurs of the amorous couple and draws us into the action.

It is not only the scale of the figures and the interplay of attention that involve us in this drama. The odd and at first sight inept spatial construction further embroils us. Half the picture is given over to the vertical folds of a Turkey carpet, thrown, it appears, over a balustrade, and a coat or cloak that is thrown over the carpet. This device has its own complexities. The coat or cloak extends along the more or less vertical division of the picture, with the right side vivid, sensual and engrossed in its own activities, while the left is dark and watchful. And although it may be seen as a barrier excluding us from participation it also links us to the figures, who are only just on its far side.

The most disconcerting feature of the painting is the small platform on which stand the whore's glass and wine jug. What is it and where, exactly, is it? It is certainly small, hardly visible, and the wine jug stands uncomfortably close to its hardly discernible edge. Is it the return of the stone balustrade that lies beneath the rug? The improbable, steeply rising fold of the rug at the extreme right denies an answer. Where, indeed, does the action take place? Is it on a terrace, or is that a window behind the figure on the left? Thoré saw it as set on a kind of terrace or balcony, at sunset.

The entire dramatic and spatial construction of the large canvas seems calculated to involve the spectator in its action. Hung at the right height, so that the narrator's eyes are level with ours, the painting would at once invite our involvement and exclude us from participation, reduce us to voyeurs. In this, in its obscured spatial relationships and in the powerful rhythms that articulate its surface, this surprising piece has much in common with certain of Rembrandt's great inventions of the 1640s and 1650s. Théophile Thoré certainly recognised the Rembrandtian quality of the *Procuress*. ''His

large picture in the Dresden museum, with four life-size figures and bearing, beneath a full signature, the date 1656 (the first that we know on his works), is absolutely Rembrandtesque, in composition, in character, in drawing and in colour Ah! what a masterpiece! and one that loses nothing by being hung immediately above a masterpiece by Rembrandt, the famous picture in which he shows himself seated and laughing, with his young wife Saskia on his knee and holding aloft a long glass full of wine. This date of 1656 is also significant, it must be added, because van der Meer never made another picture with life-sized figures; at least, we know of no other that is absolutely authentic. For myself, I hold that this *Courtesan* in the Dresden museum was painted in Amsterdam, close to Rembrandt." However, in contrast with the stilted repetitions of Rembrandtian mannerisms to be seen in the *Diana and her companions*, the *Procuress* is a work of grand theatrical promise.

The *Christ in the house of Martha and Mary* and the *Diana and her companions* share with the undoubtable works of Vermeer a concern with the lives of women, their occupations and preoccupations, but in every other aspect of their invention and construction, they have nothing in common with the mature works. The Dresden *Procuress*, on the contrary, has, despite its rhetorical, theatrical ambition and consequent considerable scale, not only a thematic affinity with later works but an anticipation of their visual preoccupations. There is the precision with which surfaces are established: notably and typically, the richly coloured undulations of the great Turkey carpet in the foreground plane. More significantly, and typical of virtually every mature work and quite unlike the *Christ in the house of Martha and Mary* and the *Diana*, the carpet forms a barrier establishing the inaccessibility of the spaces beyond it. Already, in the *Procuress*, the quality of remoteness is enhanced by the quality of Vermeer's paint surfaces. Viewed from a distance, the painting assumes just the solidity of objects seen at a distance in the actual world. But nothing is made clearer to view by approaching the picture more closely. Objects do not dissolve into brushstrokes, they simply continue to look as if they were at a distance. Already, Vermeer enhances the impression of depth by juxtaposing abrupt contrasts of scale. Here, this is especially striking in the way that the harlot's hand is seen immediately above the parapet and thus its remoteness is emphasized by the contrast in scale between the the firm, even rugged, textures of the carpet and the distance-softened contours of the diminutive hand.

Finally, there is the way, also typical of the later works, that, while the composition is mainly constructed from surfaces that run up and down and along the line of the picture plane, the focus is established by the forearms of the gallant and the harlot, and these are steeply foreshortened. The coin, crucial to the whole transaction, is hardly more evident than it is in ter Borch's famous painting of a courtesan and client in Berlin, known for so long as *The parental admonition*.

What led Vermeer to turn away from this achievement? Not, in all probability, because it was a failure in any fundamental way, but because it is essentially a public work, needing a grand space in which to be seen. It was perhaps soon after this that Vermeer was discovered by his principal patron, Pieter van Ruijven, and van Ruijven collected cabinet pieces.

A Girl asleep at a Table

Possibly the first piece that Pieter van Ruijven acquired from Vermeer, the painting now known as *A girl asleep at a table*, in the Metropolitan Museum, New York, is also the work that most obviously justifies the printer, Arnold Bon, for seeing Vermeer as the reincarnation of Fabritius. The heavily impasted, rich colours suggest the art of one of Rembrandt's pupils. As Thoré said of the *Procuress*: "The strength and harmony of the colour, the boldness of the clear tones with the splendid gradations of chiaroscuro, the laying of the solid paint in the lights, the transparent scumbles in the shadows, the power and strangeness of effect, it was Rembrandt who taught these secrets!" Other scholars have likened the picture to the work of Nicolaes Maes. It must have been painted at much the same time as the Dresden *Young woman reading a letter by an open window*, which was throughout the eighteenth century attributed to Rembrandt himself or one of his circle.

As with the Dresden painting, Vermeer made a number of major changes as the painting progressed: something that is untypical of his mature paintings where there are, more often, a myriad of minute, apparently trivial, shifts of contour. X-rays reveal that at first the portrait of a man hung on the wall in the far room where now there is a mirror. A dog, too, once stood in the open doorway. It disappeared when the chair was placed in the foreground. The painting on the wall above the young woman has been enlarged. The badly abraded glass or roemer lying on its side in the foreground is painted over a white bowl of some kind. Most curious is that the canvas has been trimmed on all four sides, apparently by the artist himself. Despite this, it remains considerably larger than the Dresden *Letter-reader*, and larger than anything Vermeer painted later, except for the *View of Delft* and the two allegories. Possibly it was cut down to meet van Ruijven's requirements. In character, if not in scale, it appears to initiate Vermeer's emergence as a painter of *beeldeken*, or cabinet pictures, that van Ruijven collected so readily.

This *Girl asleep* was, it seems probable, item 8 in the van Ruijven/Dissius sale of 1696 identified as "a drunken, sleeping maid at a table, by the same". The evidence that the young woman in the Metropolitan painting is, indeed, drunken, is there on the table before her, in the form of not one but two glasses and a wine jug. A small wine-glass suitable for a young woman stands almost empty within her reach. The overturned glass at the near side of the table beside the white wine jug is a roemer (or rummer) of the kind used by men. Neither glass is immediately obvious. The woman's glass appears to be intentionally concealed, being almost submerged within the brilliant reds of the carpet, but the overturned rummer has been abraded by overzealous cleaning, or, possibly, to remove obvious signs of indulgence. It has been suggested that the roemer is an addition by a later hand, painted over the bowl that Vermeer had placed there. But several of the objects on the table are difficult to make out. This is partly because the paint surface has been damaged. Even the prominent white wine jug is much worn. But it is also because Vermeer has already begun to demand close attention from his viewer. At the near edge of the table there appear to be not one but

Johannes Vermeer
Girl asleep at a table
Canvas, 87.6 × 76.5 cm
Metropolitan Museum of Art,
New York

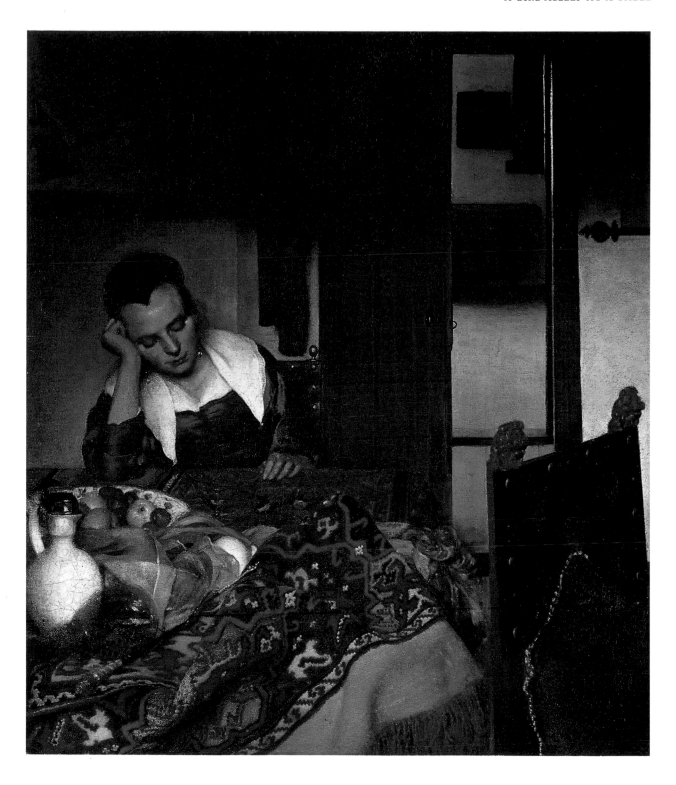

two pieces of tableware: a knife, it must be, lies with its handle poised over the table edge, while resting against the great rising fold in the carpet is a spoon or fork. The two utensils meet, knife-point with bowl or tines, but their meeting appears to be obscured by the diaphanous folds of a chiffon-like fabric that also half-conceals an overturned white jug. On closer attention, it can be seen that, time and wear apart, the principal source of concealment is the angle of sight from which objects are presented to the viewer. From the perspective offered, only the slender profile of the spoon or fork can be seen and even that profile is identified with the edge of the chiffon fabric. The tip of the knife may, or may not, tuck beneath the fabric. Already, in a technique he was soon to turn away from, Vermeer sets his viewer perceptual challenges. To discern the wine-glass against the gaudy pattern of the carpet; to distinguish the profile of the spoon or fork from the rhythm of the fabric's fold; to notice that half concealed among the curves of the chiffon drapery are the curves of an overturned jug; to discriminate two nut-like objects lying a few inches in front of the fingertips of the sleeping girl's left hand from the pattern of the carpet: these are challenges that may lead us to consider the nature of our purchase on the world through sight.

They may lead us to reflect on what seems so certain, so obvious, as not to call for reflection. In the foreground, the carpet on the table rears up in a great ruck like a pyramid before the receding horizontal plain of the table top. On the right, the back of a chair looms almost within reach and beyond it extends a great depth, through a door, across a corridor and across the expanse of a further room. Such things are clear. The world is extension. So, as we turn and attend to it, we see, we recognise, the nearness and distance of things. That Vermeer can set such an extensive view before our eyes by applying paint to a small, vertical, canvas panel may seem magical. But it can also seem so self-evident an achievement that we accept it without question, as we accept our vision of the world itself. It is when we recognise that some things are not clear and that, contrary to the actual world, nothing we can do will make them clearer that we may come to examine more thoughtfully the distinctive character of Vermeer's image.

In contrast with, for example, the interiors of de Hoogh and with much of his own later work, in the *Girl asleep* Vermeer does not use a strong linear perspective construction to create distance. On the contrary, the composition is one of horizontals and verticals. Most are derived from objects and surfaces parallel with each other and with the picture plane; the two visible walls, and their associated features, the distant window-frame, table and mirror, and the nearer door-frame, picture and map, linked by an intervening jamb and threshold. In contrast to these emphatic forms, those that could readily have established receding perspectives are minimised. The distant floors that, as in later pictures, might have been covered in a diagonal web of strongly foreshortened tiles are so faintly articulated that they become assimilated with the rectangular composition. The half open door, too, is knit into the grid because the potential diagonals of its top and bottom edges are excluded from sight. And, just as its near edge becomes one side of the rectangular frame to the rectangle-replete view of the further room, so at the jamb it is linked with the back of the girl's chair. The one horizontal surface that is strongly patterned is the table-top. But here, again, of its two strongly marked receding lines, one, between the fruit bowl and the girl, is reduced to a brief diagonal that is parried and dominated by the diagonal of the girl's kerchief, a diagonal which lies in a plane almost parallel with the picture plane. The other and more striking band of stripes that runs along the table edge as if to lead the viewer's gaze into the distance can point no further than the surface of the door. And as it is, pictorially, a vertical, it is assimilated into the rectangular composition. One strong diagonal only is generated by a rectangular object set obliquely to the picture plane:

Johannes Vermeer
Girl asleep at a table (detail)
Metropolitan Museum of Art,
New York
(Reproduced in full on p.55)

that of the top of the lion-head chair. But it, too, is knit deftly into the rectilinear composition. Its nearer, left corner is on the horizontal established by the far table edge while its further corner is in line with the far edge of the threshold to the distant room. Also, just as the juxtaposition of the diagonal stripe on the carpet with that of the girl's kerchief neutralises its perspectival force, so the angle of the chairback is absorbed into the pattern of angles developed by carpet and cushion. The corner of the cushion is directly beneath the vertical of the doorjamb. The peak of the carpet rises beneath the less obvious vertical where the door is hinged.

These curious devices may be said to matter not because they demonstrate a young painter's mastery of established principles of pictorial composition or can be matched with similar inventions in the art of Vermeer's contemporaries and notably of Pieter de Hoogh: it is, rather, that they establish the paradoxical nature of Vermeer's pictorial vision. Just as, in the real world, an oddly shaped, at first sight unrecognisable object may, usually, be approached, scrutinised from different angles, and even picked up and examined, so in the actual world such perspectival coincidences are ephemeral, so brief and unstable as seldom to be noticed. In the actual world, it is the flatness of the table-top, the rucking of the carpet, the ajarness of the door that we perceive. For an instant, the horizontal band on a table-cover presents an absolutely vertical profile, or doorjamb and chair-back are aligned, and in the next instant, in the flux of appearances, everything has changed, the transient juxtaposition unattended, unperceived. It is only by a deliberate act of attention or in a moment of reverie that we may become aware of curious visual phenomena. And to attend to such patterns, we must suspend our activities, fall into reverie. Vermeer's paintings hold our attention by creating an aesthetic of these perceptions.

And, of course, despite the powerful two-dimensional grid of horizontals and verticals, this painting is vividly three-dimensional, full of light and shadow. The folds of the carpet in the foreground are materially solid, turning in the light to create their own shadows, inviting the eye to assay their palpability, and the imagination to finger their rolling contours. Beyond this convoluted outcrop, the plane of the table surface is no less convincingly material, and unmistakably horizontal. But while the rumpled ridges of carpet scooped up over the near table corner are within reach, the level surface of the table is unmistakably at a distance. The effect is almost stereoscopic. Vermeer achieves what, in the real world, vision achieves through the discrepant views afforded by two eyes and the shifts of perspective discovered by slight shifting of the head – the sense of spatial recession. And herein lies the paradox. Before an actual scene, at those slight movements of eyes or head that are needed to establish the three-dimensional relationships of objects, the edge of the door would eclipse the edge of the distant mirror or reveal more of the hidden wall, the chairback and doorjamb would part or further overlap, the carpet peak would seem to shift to disclose other areas of the patterned surface beyond. The interior would be solidly three-dimensional but the two-dimensional harmonies would vanish.

Vermeer achieves his powerful spatial effects by entirely painterly skills, through contrasting textures and colours. This wizardry has two consequences. The stilling of the flux of appearances into so resolved a pattern imparts a monumental stillness to the momentary, the incidental. And Vermeer distinguishes, for example, the tangible, accessible rampart of folds from the distant table-top by painting the ridges with a bold clarity of form and colour and the horizontal surface with a blunting of definition that makes distance irredeemable – a technique already discovered in the *Procuress*.

Two further observations on the pictorial achievement of the *Girl asleep* might be considered here.

A single detail exposes the risks Vermeer chose to run in his evasion of linear perspective construction. Between the picture frame on the near wall and the hanging garment beside the door, above the girl's left shoulder, is a curious vertical line established by a contrast of tone. Looked at in isolation, it suggests a change of plane in the wall surface. The area on which the big painting is hung, the doorframe and the adjacent wall on which a map is hung are unmistakably parallel to the picture plane and each other: at first sight the entire wall and doorway seem to be in the same plane. If the wall behind the girl is intended to turn at an angle, it can only be a right-angle recession that would set the door and the wall to the right some little distance back from the wall to the left. This is by no means obvious, and, for this reason, a defeat for Vermeer's otherwise total mastery of space. There are three possible causes for this apparent failure. Least sure: the door looks too wide to be so distant from the viewer. There is a glimpse of the threshold: perhaps the judgement should be made while considering the distance between the girl and the wall immediately behind her. More certain is that the light across that area of the wall between hanging garment and door-jamb seems too bright for what would be a shadowy corner. But the third factor is directly consequent on Vermeer taking the final risk. By setting the chairback firmly on the horizontal and aligned with the doorjamb, he ensures the dominance of the pictorial rectangle in the picture plane over the perception of a wall receding at right angles to it.

The second observation is more positive. The manner in which Vermeer has here replaced linear perspective by a perspective of scale, establishing the foreground carpet and chair as strikingly large, dominant, powerfully painted features beyond which other objects and the table, in particular, are evidently diminished, becomes his established practice in later paintings. In those later works, its appearance has been attributed to the influence of the *camera obscura*. But in this early painting there is nothing, otherwise, to suggest any knowledge of the distinctive characteristics of *camera obscura* images. On the contrary, the bold, broad and subtle brushwork, recalling Rembrandt's pupils, Maes and Fabritius, should also call to mind the fascination with perspectival effects these painters shared with others from Rembrandt's circle, such as Samuel Hoogstraten. For these painters perspective was not simply a matter of geometry: it was integral with the art of painting as they had learned it from Rembrandt. So it appears to have been for Vermeer.

The question that remains is: why, for this ambitious and considerable painting, did Vermeer choose the subject that he did? "A drunken, sleeping maid . . ." it was called in the catalogue of 1696. Was this the title that had been given by the artist himself, accepted by the first purchaser, his patron, and transmitted to the consequent owner and, thus, to the catalogue writer, or was it the surmise of an indifferent and uninformed clerk faced with a chore before a forthcoming sale? The form of the entries suggests the latter: they are clear and direct descriptions but give no indication of authoritative knowledge.

But to a contemporary, even late in the century, the signs were there to be read. Two glasses and a wine jug could leave little doubt about the events that had led to this conclusion. Did other objects, other details, offer further clues to the state of the young woman?

In Vermeer's day, the image of a person resting head on hand was readily understood. With eyes closed, the individual was asleep, but in this position was unlikely to be sleeping from honest exhaustion: in all probability, the sleeper exemplified Sloth. With eyes open, the person was suffering from melancholy. The two conditions had much in common, the principal difference being that Sloth was a matter of theology

and morality, being one of the seven deadly sins, while melancholia was the concern of medicine, being one of the four temperaments. The temperaments, the sanguine, the choleric, the phlegmatic and the melancholic, were each caused by an excess of one of the four body fluids, or humours. The well tempered individual enjoyed a balance of the fluids. The sanguine produced too much blood, the choleric too much yellow bile and the phlegmatic too much phlegm. Melancholy was the consequence of an excess of black bile. While Sloth is simply a sin, melancholy has its noble side. By Vermeer's day, it had become associated with intellect, contemplation and even creation and was the humour of scholars and artists.

In 1655, which was probably a year or more before Vermeer painted his "drunken sleeping maid", Nicolaes Maes, who like Fabritius and Hoogstraten had been a pupil of Rembrandt, painted his *Idle servant*, now in the National Gallery, London. The servant, in the classic pose of Sloth, sleeps among unwashed pots and plates while behind her a cat steals a plucked fowl from a plate. Standing beside her, in the centre of the picture, a woman stares out at the viewer and points to the servant with a gesture of her open left hand that, taken with her wry smile, is also a comment on the maid's sad state. Inconspicuous in the woman's right hand is a wine jug.

The *Idle servant* is the earliest known painting of this type to show a view through an open door, or *doorkijkje*. This device quickly became popular with many painters, in particular Pieter de Hoogh, but was used by Vermeer in only three paintings. One is lost, but listed in the 1696 sale catalogue as no.5 "in which a gentleman is washing his hands in an inner room, with sculptures, artful and rare . . .". The other is the painting now in the Rijksmuseum known as *The love letter*. The *Girl asleep* is the earliest use made by Vermeer of a view into a further room. That he should do so in a painting that must have been painted only shortly after the Maes and of a similar subject is interesting, though Maes lived in Dordrecht after 1654, on his return from Amsterdam, and there is no record of a visit to Delft. Also, the *Girl asleep* resembles Maes's *Idle servant* in giving the view through the door only a supplementary role, unlike *The love letter*

Nicolaes Maes
The idle servant, 1655
Panel, 70 × 53.3 cm
National Gallery, London

Joachim Beuckelaer
*The well stocked kitchen, with
Jesus in the house of Martha
and Mary in the background*
Panel, 171 × 250 cm
Rijksmuseum, Amsterdam

and, apparently, the lost *Gentleman washing his hands*, in which the principal action
takes place in the far room.

It is the significance of that view through the door or *doorkijkje* which is in question,
now. At first examination it has an essentially formal value, paradoxically in establish-
ing the two-dimensional composition. And, as with a number of compositions by de
Hoogh, it may be seen to have a quasi-architectural interest in offering to the eye vistas
to explore. But even in de Hoogh's paintings, the interest of such vistas is more than
formal. For example, in his *Maternal solicitude* in the Rijksmuseum, in which a mother
cleans her child's hair of vermin, or in his *Mother lacing her bodice beside a cradle* in
Berlin, the glimpses of further rooms flooded by sunlight extend and enhance the
image of domestic order and maternal provision that is the theme of these paintings.

From the middle years of the previous century, it had been common, particularly
among Netherlandish painters, to set the subject of an elaborate scene in the depths of
the picture, so that it was not immediately obvious. And this was not merely a formal
affectation. For example, in Joachim Beuckelaer's *Christ in the house of Martha and
Mary* in the Rijksmuseum, the enormous panel is filled with enough dead fowl, game,
uncooked meat and vegetables to provision a shop rather than the kitchen that is the
setting. It is only beyond the kitchen and through a distant arch that Christ is shown
on a scale hardly larger than a foreground gherkin. It is the moment when Christ
rebuked Martha because she complained that Mary sat at Jesus's feet and heard his
word instead of helping serve. He said, ''Martha, Martha, thou art careful and troubled
about many things: But one thing is needful: and Mary hath chosen that good part,
which shall not be taken away from her'' (Luke 10: 40–41). The vast painting devoted
to dead flesh and the fleshly appetites gives an exaggerated exemplification to Mar-
tha's preoccupation with material things: it is for the viewer to perceive its spiritual
significance.

Vermeer's contemporaries discovered in the *doorkijkje* a wealth of possibilities.
Nicolaes Maes painted six versions of a woman in the foreground eavesdropping on an
encounter between a man and a maidservant glimpsed through an open door. As she
does, she turns to catch the viewer's eye and lays an index finger to her lips in the
gesture of silence. In each case, like the housewife in the *Idle servant*, the woman

smiles, as if in amusement at human folly. It is as if the principal figure in these compositions has the role of drawing the viewer's attention to an event that, other-wise, might be overlooked and also of indicating the light in which the event should be seen.

Other painters use the *doorkijkje* to frame an image that casts light on the signifi-cance of the principal scene. In Jan Steen's painting of a *Young woman playing a harpsichord to a young man* in the National Gallery, London, a young boy, hardly more than a child, is bringing a lute into the room. No doubt it is for the young man to play a duet with the young woman. But if instead of a *doorkijkje* there had been on the wall a painting of a naked child holding a lute, he would have been instantly recognised as Cupid, because *Amor docet musicam* (Love teaches music) or, as it might be more familiar in English, Music is the food of love. It is as if Steen had presented Cupid not in his classical guise but as a contemporary, in a way that is typical of Netherlandish painting.

In the *Girl asleep* the *doorkijkje* is bereft of significant features but, nevertheless, Cupid does, it seems, appear in classic form. Over the girl's head is the corner of a painting that must be very similar to the complete painting of Cupid seen behind the *Woman standing at the virginals* in the National Gallery, London. The visible difference is that in this earlier fragmentary version, Vermeer has introduced a mask beside Cupid's foot and something that could be an apple, a pear or simply a stone. It has been suggested that the mask indicates deceit, but Madlyn Kahr has pointed out that the mask has been discarded. She remarks that on page 55 of Otho Vaenius's *Amorum Emblemata*, an emblem book published in Antwerp in 1608, an image of Cupid with a discarded mask is explained by a quatrain that in a contemporary translation runs:

> Love in whate'er he doth, doth not disguise his face.
> His heart lies on his tongue, unseen he never goes,
> He wears no Gyges ring*, he is not one of those,
> He doth unclose his thoughts, to gain unfeigned grace.

*Gyges's ring was a magic ring of invisibility

Paintings on the wall had been used even more extensively by seventeenth-century Dutch painters than *doorkijkjes* to inform the nature of scenes enacted beneath them. Vermeer included paintings within fifteen later paintings, and many of these appear to be related to the theme of the work containing them. The difficulty they present, however, is that often the relationship appears to be one of contrast. In the Boston *Concert*, the man and two women making music seem quite unlike the bawdy company of van Baburen's *Procuress* shown in the painting on the wall.

When compared with Maes's *Idle servant* and the variety of significant images being developed by his contemporaries, the *Girl asleep* is either confused and immature or deliberately cryptic. As a piece of painting, it is manifestly far from immature. The revelation by X-rays that Vermeer had originally included a dog and the portrait of a man in the *doorkijkje* but later painted them out suggests that he did deliberately make his work more cryptic. The presence of both Cupid and a dog would have very strongly associated the girl with Venus, the goddess of love. The portrait of a man would have exposed the object of her love. Still, Vermeer presents a number of clues that this is the cause of the girl's state. The overturned roemer suggests that she has not been drinking alone and that her companion was a man – a surmise supported, more symbolically, by the other pairs of objects on the table, and the viewer who could identify the painting above the girl's head might consider those surmises confirmed. In

which case, could the strong light that reflects off the jambs of both doors be entering the corridor from a street door left open when the girl's companion left after overturning the roemer?

Just as by restricting the perspectival construction he achieves a powerful, because mysterious, quality of depth, so by eliminating the more obvious indications of the girl's predicament, Vermeer entices the viewer into speculation. The problem posed by the *Girl asleep* is that if she is, indeed, lost to the world in a drunk sleep she is, thereby, reduced to an object of amusement or pity. Our speculations will be directed only to the causes of her condition and the folly of love. In his later single-figure compositions, Vermeer avoids such condescension. His invitation is to consider the speculations of the solitary individual. Lost in drunken sleep, this girl can be no more than an image of Sloth and, indeed, of the further sins of Lust and Gluttony. Were she awake, then she could be seen to be suffering from melancholy, a state the viewer may imaginatively share. On this vital distinction the features, both erased and existing, of the *doorkijkje* provide no evidence. Both dog and mirror almost inevitably accompany Venus. But the dog may also be the companion of Melancholy, and the mirror held by Prudence would not be inappropriate in that case. The question must be: are her eyes closed or downcast? Are the two nut-like objects before her on the table to be identified as the objects on which her downcast gaze is fixed, the significant objects of her contemplation?

Such speculations appear unanswerable, even misguided. There are two reasons for entertaining them.

First, because the *Girl asleep* is, quite possibly, the first painting bought by Pieter van Ruijven, and if this could account for its having been cut down on all sides, it could also account for the alteration of the *doorkijkje*. It would transform a familiar image, that of Sloth, into something more enigmatic, the significance of which only painter and patron might share. Whether or not van Ruijven did determine the character of Vermeer's imagery in this way, two of the pieces he later owned, the Berlin *Woman with a pearl necklace* and the Washington *Woman holding a balance* are both, it appears, just such subtle transformations of familiar images.

The second reason for seriously considering the possibility that the girl is awake and brooding with downcast eyes is not simply that all Vermeer's later single-figure pieces show an individual in some form of contemplation. This, the earliest such work, might have been painted before he discovered what was to become his central theme. Yet it must have been painted, immediately before or after, or even simultaneously with what is possibly Vermeer's most ambitious, greatest and most subtle such work, the Dresden *Young woman reading a letter at an open window*. Not only are the *Girl asleep* and the Dresden *Letter-reader* similarly painted, as Thoré said, under the influence of Rembrandt, but they are the last figures Vermeer painted from a standing position. For all his later pieces, Vermeer must have sat to paint, like the anonymous artist in his own *Art of Painting* in Vienna, because the eye-level is always that of a seated individual. The Dresden *Letter-reader*, incidentally, is one painting that van Ruijven is not known ever to have owned.

A Glass of Wine

A work that almost certainly was bought by van Ruijven is the small and brilliant painting now in the Frick Collection, New York, and still known by the title given to item 11 in the 1696 sale catalogue, "Soldier with a laughing girl", there described as "very fine".

It seems, at first, surprising that one man should have painted both the Dresden *Procuress* and, probably very shortly after, the Frick *Soldier and laughing girl*. They are not only so different in scale (the Frick painting being less than one-eighth the size of the Dresden picture) but quite at odds in their appeal to the viewer. In turning from the theatrical scale of the *Procuress* to something approaching the miniature, Vermeer removes his viewer from the awareness of his actors. Instead, the viewer becomes an eavesdropper, as it were, an unseen observer peering through the keyhole, or the crack in the shutter. This effect is established by a number of devices. In few of the mature works do Vermeer's characters betray any sense that they are overlooked. Often, they are engrossed in some demanding task or activity. In the Frick canvas, the couple are clearly absorbed in each other. Yet the spectator's viewpoint is intimately close, as the disparity in scale between the two betrays. The officer looms large, the girl, though seated within his grasp, just round the corner of the table, is diminutive, almost remote. It is an effect that photographs taken close-up with a wide-angle lens have made familiar. And it is one of the characteristics of Vermeer's compositions that had led art historians to argue that he used a *camera obscura*. (Another feature that suggests the use of a *camera obscura* is the brilliant, sparkling character of the light reflected from the girl's features, clothing and, most characteristically, by her hands and glass.) But these characteristics do not appear merely to be a consequence of the use of the *camera*. They become exemplary of the distinctive character of the cabinet picture. Instead of the picture being a fictional extension of the interior within which we stand, and into which we can imagine ourselves entering bodily, it offers a vision of an alternative interior from which we are necessarily excluded, except in imagination.

The Frick painting has this quality. We focus on the small image and are drawn to attend minutely to the drama we discover there. But what is happening? Is anything happening? Is it not simply a banal routine occasion? How much of the painting's magic lies simply in its virtuoso brilliance, the delicate precision of its rendering? Is not any story, any drama, we may choose to impose on this simple image no more than a consequence of our own inclination to fantasize? These are not trivial issues, for on their resolution will depend our sense of the weight of Vermeer's imaginative achievement. There are various circumstances, external and internal, that may illuminate this question.

To a contemporary, Vermeer's image would not be unfamiliar. It recalls the theme of mercenary love. Many of Vermeer's contemporaries painted similar scenes. Indeed the principal characteristic of these treatments, the one that distinguishes them from earlier treatments, is that the woman, the whore, is infrequently the predator, more often, apparently, the victim.

Johannes Vermeer
Soldier and laughing Girl
Canvas, 50.5 × 46 cm
Copyright The Frick
Collection, New York

This is strikingly the case in a number of ter Borch's treatments of the theme. In the painting in the Louvre, a broad-bellied, coarse-featured soldier offers a handful of coins to a young woman. Although she holds a glass and a decanter and might be thought to have been expecting, even wanting, this approach, the expression on her face can only be interpreted as blank uncertainty. And in the now notorious case of ter Borch's painting in Berlin, so modest is the pose of the standing woman, that it was engraved in the late eighteenth century and entitled the *Parental admonition*. Yet it has all the imagery of a procuress picture: not only bed, vanity glass, candle and brush on the table, the procuress herself sipping the wine and the young whore, but the male visitor, who may or may not have been holding up a coin between finger and thumb, and is wearing a sword and shoulder-belt and has a large feathered hat on his lap, as do gallants such as he in pictures of this sort.

In Vermeer's painting in the Frick, there is no bed, no glass, no money in sight. The man, though, is unmistakably an officer with his rakish hat and his shoulder-belt across his back, and the young woman holds a glass of wine. Is this enough? There is one other feature that may be significant, and that is the wall-map. It reproduces a real map of the day, showing Holland and West Friesland, designed in 1620 by Balthasar Florisz. van Berckenrode and published by Willem Jansz. Blaeu in a number of editions between 1621 and 1629. In earlier prints worldliness had been personified as Mistress World who balanced a globe on her head. It is unlikely that a contemporary would have looked on this small image without such associations coming to mind.

What then? What, more precisely, does Vermeer present for our attention?

There is the looming silhouette of the officer, his expression invisible to us, concealed from us, both by the angle from which we are shown him and the pose he has adopted because his hand on his hip thrusts up his right shoulder. We have a glimpse, it seems, of his left hand raised towards his chin, suggesting that his left elbow rests on the table. Large and obscure though he is, he seems fixed in position by the forceful bounds of window and map. The silhouetted verticals of the window-frame secure the position of the lion-headed finials on his chairback, one of which, in turn, lines up

Gerard ter Borch
Soldier offering a woman coins
Canvas, 68 × 52.2 cm
Louvre, Paris

Gerard ter Borch
"The paternal admonition"
Canvas, 71 × 73 cm
Rijksmuseum, Amsterdam

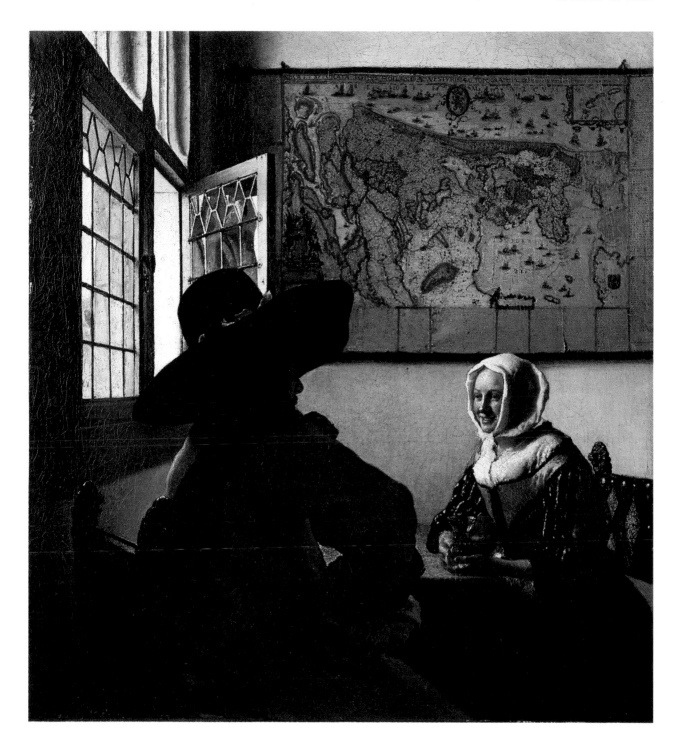

with his shoulder-belt, restraining him in his seat, while the grid of the window-frame and the ebony rod on the lower edge of the map lock his hat in position, so that only that arrogant elbow and the glimpsed, more tentative, gesture of his raised hand enter the young woman's space. Nonetheless, she is constrained on all sides: a small though scintillating image of luminous charm, clipped between map-bar and table-top, chair-back and thrusting elbow. She smiles and smiles, her eyes fixed on his, and one hand holds a glass, the other lying supine and limp on the table. What does that gesture signify? It is ambiguous and obscure.

Here are established, possibly for the first time, so many of the characteristics that come to distinguish Vermeer's mature art. Immediately, there is the glowing, exhilarating quality of light, flooding through the window and giving both form and value to what it illuminates within. With the light come the distinctive visual qualities of Vermeer's mode of representation: forms are so often suggested, hinted at, rather than revealed and defined. Then, more profoundly, there is the sense of thoughts and feelings, immanent but not yet formed or performed. And we, privileged to overlook but not intrude, may only surmise the implications of these pregnant encounters.

Vermeer returns to the theme of the glass of wine in two other surviving canvases. One, now in Brunswick, may be that listed in the 1696 inventory as item 9, "a merry company in a room, vigorous and good". This has several features in common with the painting in Berlin, now known as the *Glass of wine*, which is not recorded before 1736. They are set in similar interiors, with the same pattern of tiles on the floor, the same stained-glass window and a (different) painting hung on the rear wall. And they are on canvases of nearly identical dimensions, though one is used vertically, the other horizontally. The elaborate settings of both works contrasts with the restricted space and sparse furnishing of the Frick painting. The Brunswick painting is one of the two Vermeers to contain a third figure.

In their common theme, these Vermeers may be compared with two paintings by Pieter de Hoogh, one now in the National Gallery, London, the other in the Louvre. The National Gallery painting shows a young woman standing to raise a glass to two men sitting at a table set in a large and lofty interior. The painting is immediately striking in its representation of space. The green and white checkered tiling of the floor, the grid of shuttered and unshuttered windows and the beams of the ceiling, all modulated by a subtle play of light and shade, form a powerful and memorable composition, and as in many de Hooghs of these years this abstract geometry is, as it were, naturalised, domesticated and made to seem the necessary character of the world depicted. But is there more to be perceived here than a vivid visual effect? One of the men at the table is shown by his plumed hat and shoulder-belt or sash to be an officer or gallant, similar to those painted by ter Borch and Vermeer. He watches the young woman raise her glass with rapt attention, his own right hand raised in an enigmatic gesture. The other man crosses the stems of two clay pipes and grins. A maidservant brings a pot of burning coals: is it simply to light those pipes? And is it significant that the large painting over the fireplace represents the Education of the Virgin?

If there are doubts about the National Gallery painting, there can be no doubt about the situation in the comparable painting in the Louvre. Both her expression and her posture reveal that the young woman is not holding up her glass for the first or, very probably, the second time. The man refilling the glass appears to be holding his gallant's hat in his left hand. Behind him, the older woman looks on with concern, her hand raised to her breast. A second man, smoking and wearing his hat, confirms the public character of the events. The painting on the wall, here, is Christ and the Woman taken in Adultery.

Johannes Vermeer
Girl being offered wine
Canvas, 78 × 67 cm
Herzog Anton Ulrich-Museum,
Brunswick

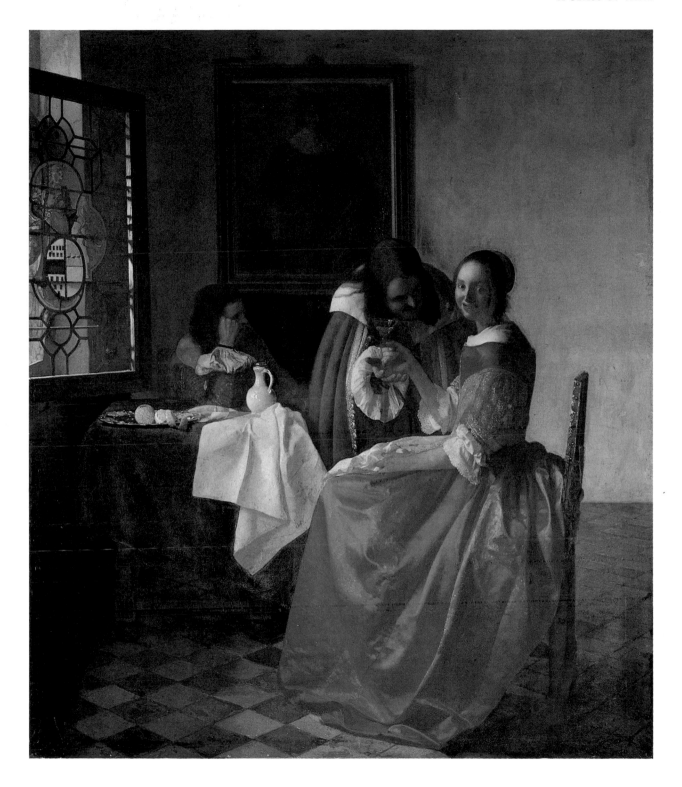

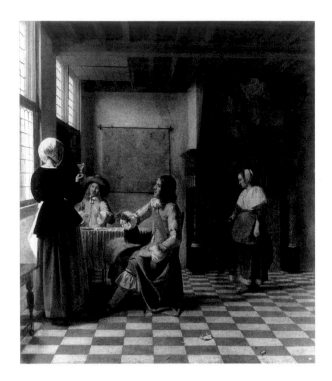

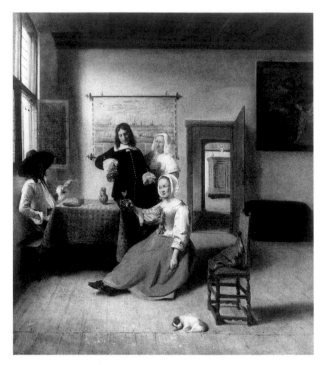

Pieter de Hoogh
*An interior, with a woman
drinking with two men*
Canvas, 73.7 × 64.6 cm
National Gallery, London

Pieter de Hoogh
Young woman drinking, 1658
Canvas, 69 × 60 cm
Louvre, Paris

Johannes Vermeer
The glass of wine
Canvas, 65 × 77 cm
Gemäldegalerie, Berlin-Dahlem

The familiar *dramatis personae* and their accompanying properties, the often rehearsed performances, render these little dramas comprehensible. But, it could be protested, it also renders them insignificant, a mere pretext for a further display of the virtuoso invention of perspectival and atmospheric effects in which de Hoogh excelled.

Whatever force this objection may be felt to have for de Hoogh's scenes, it is not at all the same matter with Vermeer's muted dramas, the Berlin *Glass of wine* in particular. As with de Hoogh, enormous care and skill has been devoted to the rendering of the perspective of the interior and the fall of light and shade across its surfaces. Vermeer makes of the dumb, unremarked back of a chair an object of lyric beauty, angled as it is both to catch and reflect the light bestowed on it by the open window and to rhyme with and respond to the silhouette of the window-frame itself. More generally, the interplay of the strong light flooding through the open window and the muted tones filtering through the curtained window to the rear, reflected from the surfaces in the light to irradiate shadowed areas, is a *tour de force*, both of observation and of representation. But here there is more at stake. Thoré noted that "Vermeer's most remarkable quality, superior even to his instinct for physiognomy, is the quality of his light", which, technically, may seem justified. Certainly, other painters such as ter Borch, who may rival Vermeer in their instinct for physiognomy are no match in their rendering of effects of light. The traditional properties, the music on the table, the lute on the chair, and with it, surely, the gallant's shoulder-belt, by their presence confirm the nature of the drama being enacted, but the drama itself is finely focussed and compelling. The young woman empties her glass (and holding it as she does by its foot, according to contemporary convention, it would be difficult to set down until it is empty) while the man stands over her, waiting, his hand clasping the wine jug in readiness to refill the glass immediately she takes it from her lips. The characterization is precise. The man, swathed in his cloak and shadowed by his hat can, nevertheless, be seen to be watching the woman with unblinking intensity. The woman is con-

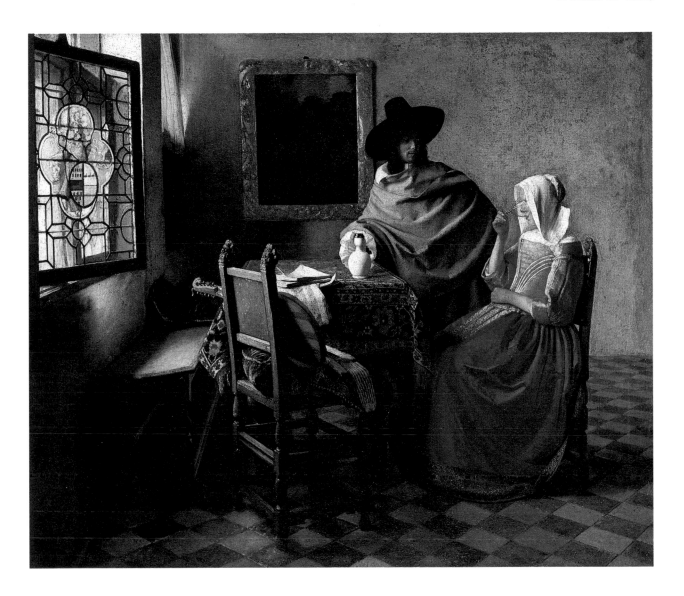

Johannes Vermeer
Girl being offered wine (detail)
Herzog Anton Ulrich-Museum,
Brunswick
(Reproduced in full on p.67)

strained: the elbows of both arms are pressed to her sides; though draining the glass she does so with reluctance: she does not tilt back her head as does the *Woman drinking wine with a sleeping soldier*, painted by ter Borch (who, incidentally, clasps the wine jug herself). As the young woman hesitates and the gallant waits, it is a time of stillness, but not of repose.

The most remarkable feature of the painting, though, is very puzzling, and this is the image in the stained-glass window. This has been identified as the coat of arms of Janetge Jacobsdr. Vogel, first wife of Moses van Nederveen, but it is unclear how Vermeer came to know of it or incorporate it in this and the Brunswick paintings. Janetge Vogel died in 1624 and she and her husband lived at some distance from where Vermeer lived. It seems unlikely that Vermeer acquired an actual window made for Vrouw Vogel. On the contrary, he paints a window with identical leading but with plain glass in five other paintings and in a sixth with a different quasi-heraldic design. It is more probable that it was the imagery of that coat of arms that he wanted and adapted for this painting. In the two paintings in which this heraldic device appears, this Berlin painting and the *Man offering wine* in Brunswick, the window is open and the illuminated image dominates the picture. It is not so much part of the interior as an intrusion into it. It has an emblematic force.

The female figure shown in the glass holding a square and a bridle personifies Temperance. It is fitting that this drama should be seen in such a light. Did Vermeer – and ter Borch – know that, according to Pausanias, the ancient Greek painter Pausias of Sikyon had won immortal fame by a picture of Drunkenness in which could be seen both the glass cup and the woman's face showing through it?

The painting in Brunswick also includes an identical stained glass window and, as mentioned above, may be seen as a variation of the Berlin painting. But it is a more problematic work. It is the only painting other than the Boston *Concert* to include three figures, but where the *Concert* shows two women and a man making music together, the third figure in the Brunswick painting is apart from the couple in the foreground. The obvious explanation is that, as his pose suggests, he, too, is a suitor for the young woman's favours but has been rejected. It is therefore understandable that his position is uncomfortable. In the eighteenth century his figure appears to have been painted out. Overpainting and restoration may be responsible for a certain uneasiness in the principal figures, too. The proportions of the woman to her chair are, perhaps, a little odd; it appears, from the perspective of the floor tiles, as if she is sitting a little distance forward of the table, yet the gallant who bends over her to press on her the glass of wine appears to be standing beyond the white tablecloth. This painting and the very badly damaged painting of a *Girl interrupted at her music* in the Frick Collection are also exceptional among Vermeer's small multi-figure paintings in having a character meet the viewer's eye.

Music is the Food of Love

Wine, love and music go together. Love teaches music: music is the food of love. A lute lies on the empty chair in the Berlin *Glass of Wine* and a wine jug appears in two of Vermeer's paintings of music-making. Making music, as well as drinking and gaming, accompany love-making among the pursuits of the Children of Venus, and music always accompanies the prodigal debauches of the Prodigal Son as it regularly does in the paintings of merry companies made in Haarlem and by Anthonie Palamedesz. in Delft a generation before Vermeer.

Musical instruments appear in ten of Vermeer's paintings, including the *Procuress*, but only in three is music made in company. Of these, the Frick *Girl interrupted at her music* is now a sadly damaged piece. The birdcage is a later addition and much of the original surface is lost. Nevertheless, it contains a number of features found in other authentic Vermeers. The chair with lion-head terminals is familiar, the pattern of the leaded window is that already noted in the Berlin *Glass of wine* and also, in this form, in the *Music lesson* in the British Royal Collection, for example; and the painting of Cupid (appropriate to the theme of the painting) on the rear wall, attributed to Cesar van Everdingen, appears in the *Woman standing at the virginals* in the National Gallery, London. The man bending over the young woman is very like the man proffering a glass of wine in the Brunswick painting. More significant, the quality of the light in the area of the window, as it is reflected from the back of the empty chair and the instrument on the table, is characteristic of Vermeer; so, too, is the composition of such effects as the alignment of the young woman's back with the finial on her chair.

The Boston *Concert* and the *Music lesson* are almost identical in size but while the *Music lesson* could be item 6 in the 1696 sale, "A young lady playing a clavecin in a room, with a gentleman listening", the Boston painting is first recorded in 1780. Their size apart, the two works have a number of features in common but the most distinctive is the remoteness of the viewer from the activity within the depths of the interior. In this respect they are in sharp contrast with the Frick *Soldier and laughing girl*.

The music makers in the Boston painting are not so very distant physically. But the heavy, carpet-covered table and the double-bass beside it on the floor appear as obstacles to a ready approach and a screen for the reticent observer. This is most striking where the table-top, loaded with obscurely foreshortened but almost accessible carpet and violin, is juxtaposed with the profile of the player at the clavecin, thus emphasizing her small scale and, thereby, her remoteness.

As befits a representation of music-making, the painting is a miracle of measure and harmony. The bold quadrilaterals of the ebony frames on the rear wall are set against the complex perspective transformations of the far smaller but similarly rectangular floor tiles, and within this grand theme a multiplicity of rhymes and contrasts is established. The vertical of the clavecin lid continues the line of the landscape's frame and so creates a frame for the cameo profile of its player, while the sweep of its other edge modulates the relation of singer to the other painting. The black edging on the clavecin player's robes not only completes the framing of her profile but also links the

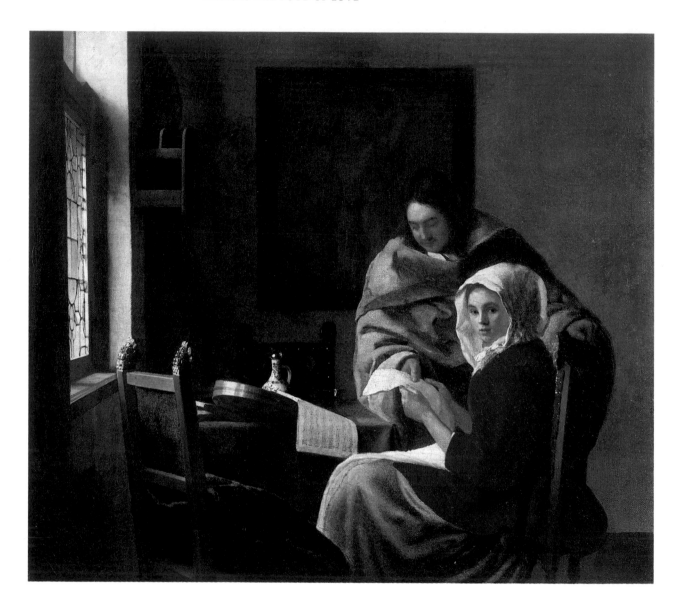

Johannes Vermeer
Girl interrupted at her music
Canvas, 39.3 × 44.4 cm
Copyright The Frick
Collection, New York

Johannes Vermeer
The concert
Canvas, 72.5 × 64.7 cm
Isabella Stewart Gardner
Museum, Boston/Art Resource, NY

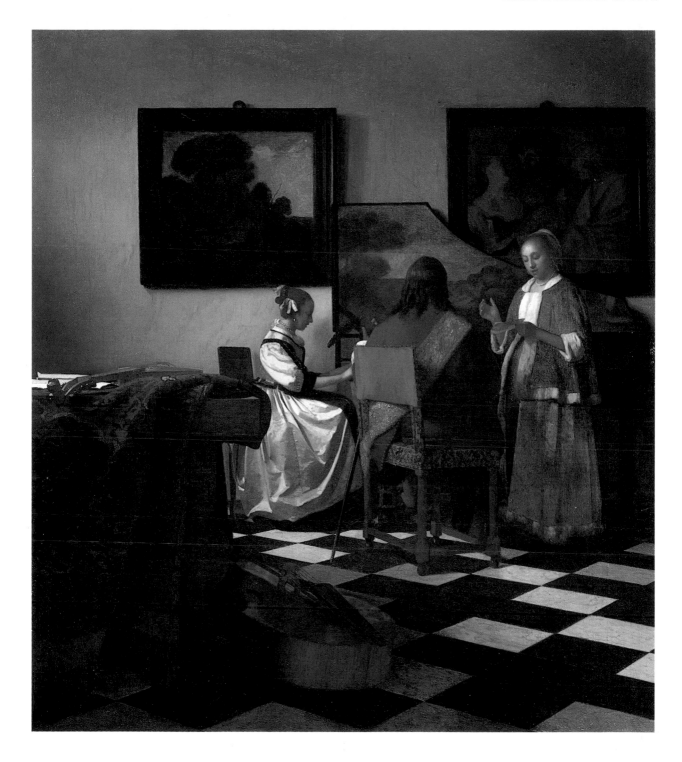

unmodified rectangularity of the clavecin frame with the man's sword and thus with the perspective of the tiling. At the heart of the painting is the glowing, golden-orange lozenge that is the back of the cithern-player's chair and which dominates a further set of rhythms: between this chair back and that of the more distant, shadowed back of the clavecin player's chair, linked as they are by the black edging on the woman's skirt; and with the man's shoulder-belt, so closely related in proximity, colour and form and with the complex foreshortening of the chair's own legs and cross-bars in their relations with the diapering of the floor-tiles. Such relationships are at once absorbing and inexhaustible, it seems.

If the painting may in this way be said to exemplify visually the nature of the musical harmony it represents, what of the significance to this sense of harmony of the quite unharmonious painting on the wall to the right, which is that painting of a *Procuress* by Dirck van Baburen? This, too, contains three characters, a gallant and two women. And it is notable that Vermeer has left his cithern player rather improbably wearing his identifying shoulder-belt and sword (although his plumed hat is not in sight). But his back is turned, his face hidden. All that is offered is a play, a counterpoint, between the bawdry of the painting on the wall and the apparently chaste harmonies created by the trio within the room.

If the Boston *Concert* is among the most complex, subtle and nuanced of Vermeer's inventions, then the so-called *Music lesson* is his *tour de force*. Its motif is certainly not original and, equally, it is hardly a music lesson. Jan Steen's version, dated 1659, in the National Gallery, London, is quite explicit. His young woman player is not wearing the modest chemise to be seen on Vermeer's player (and also, in Steen's own variation on the theme in the Wallace Collection, in which a demure girl cowers before the attentions of a Pantaloon). She is not abashed by the knowing look of the young man leaning possessively on the instrument. The motto on the instrument's lid, "*acta virum pro-*

Jan Steen
Young woman playing a harpsichord to a young man,
1659
Panel, 42.3 × 33 cm
National Gallery, London

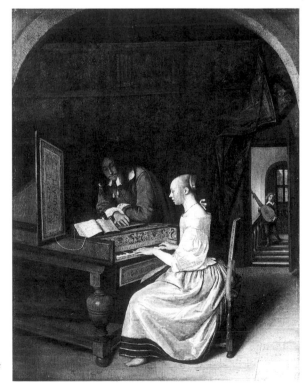

Johannes Vermeer
The music lesson: a lady at the virginals with a gentleman
Canvas, 73.3 × 64.5 cm
British Royal Collection;
Reproduced by gracious permission of Her Majesty the Queen

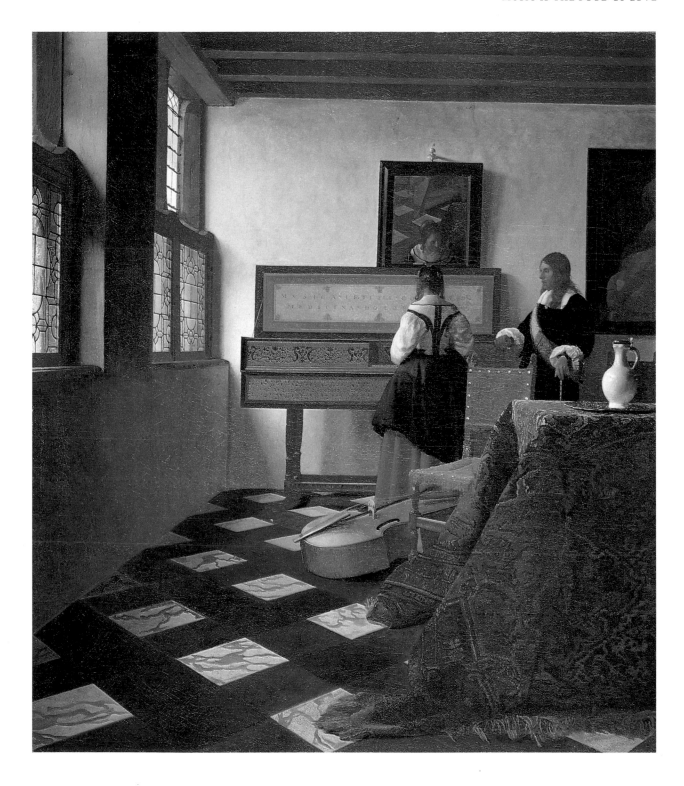

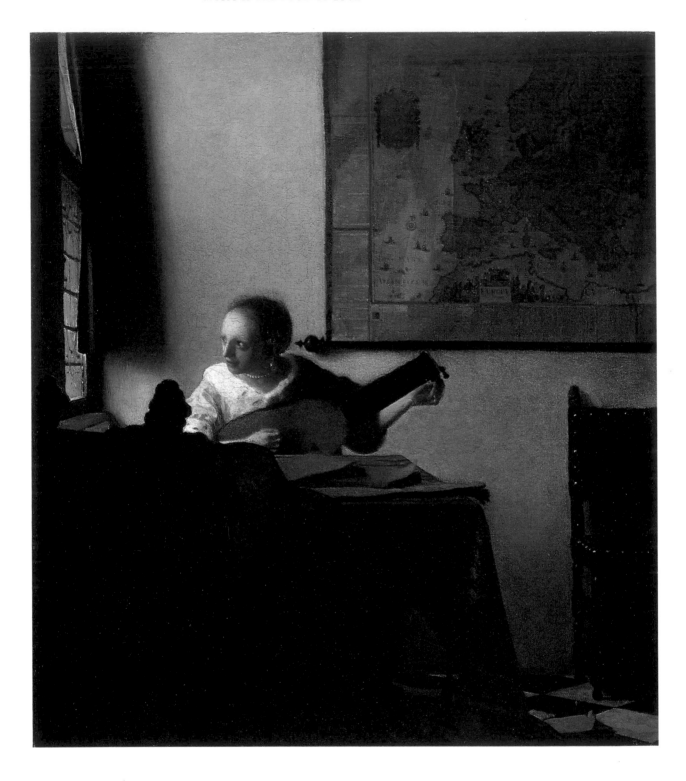

Johannes Vermeer
Woman tuning a lute
Canvas, 51.4 × 45.7 cm
The Metropolitan Museum of
Art, New York (bequest of
Collis P. Huntington, 1925)

Johannes Vermeer
The guitar-player
Canvas, 53 × 46.3 cm
Iveagh Bequest, Kenwood,
London

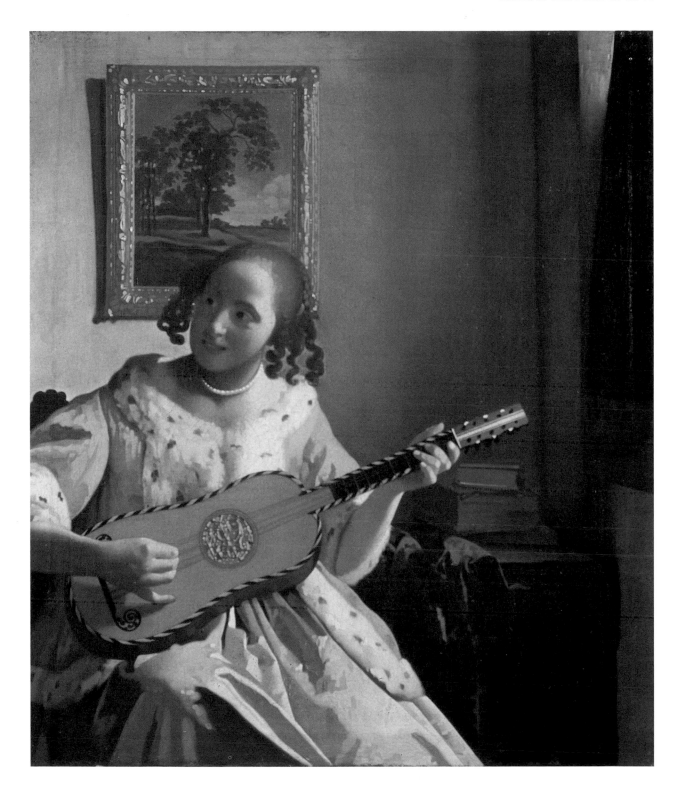

bant'' [deeds prove the man] and the curtained bed immediately behind only confirm the nature of the couple's mutual interest. The youth carrying a lute and framed in the doorway suggests a modern version of Cupid who also was known to carry a lute.

There can be little doubt that the couple in Vermeer's version are held in the thrall of love. All is crystalline, both in the artful structure into which everything is locked and in the cool clarity of the light falling through glass which though clear is set in familiar leads. Here, little needs to be said on the geometry of the composition. One vertical of the mirror is continued by the back of the chair, the other falls over the edge of the niche within which the keyboard of the virginals is set. Though the chair sits obliquely to the instrument, the horizontal of its back is so close to the picture's eye-level that it hardly deviates from the horizontal of the instrument's keyboard.

Two features, both characteristics of its perspective, are less immediately obvious. Here, the couple is even more distant than is the trio in the Boston painting. Here, too, similar obstructions bar the way. But here, the precise distance between the viewer and the couple appears to be measured. In the glass above the clavecin is reflected not only the head of the young woman but the table, part of the floor and a curious structure that can only be the foot of the artist's easel (though the artist himself is not to be seen). It seems as if the precise number of tiles between the rear wall of the room and the foot of the easel can be counted and an accurate enough estimate of distance thus calculated. But the woman's head conceals the reflection of the point at which the carpet in the foreground rests on the tile. Yet the sense of the artist's presence within the room as witness of this moment is compelling.

It is also worth noting, in this painting about measure, distance and spatial relationships, that the perspective of this room converges over or perhaps a little below the young woman's heart.

Apart from the curious *Love letter* in the Rijksmuseum, the remaining four paintings of music makers are all of a single woman player. Two half-length figures, one in the Metropolitan Museum, New York, and another in Kenwood, London, continue a tradition of paintings of musicians that can be traced back to Giorgione, though unlike such contemporary examples as Jan Steen's *Cittern-player* in the Mauritshuis, Vermeer's players, quite noticeably, do not meet the eye of the viewer. The two in the National Gallery, London, are very distinctive and were, arguably, painted as pendants and, for that and other reasons, will be considered separately, later.

Letters

Letters are received, read or written in six of Vermeer's surviving paintings. It was a theme he returned to over the years. What is probably the earliest, the *Young woman reading a letter at an open window* in Dresden, appears to have been painted shortly after the *Girl asleep at a table* in the Metropolitan Museum, New York. A painting "representing two persons one of whom is writing a letter" was left in his studio at his death.

The letter was a motif much used by Vermeer's contemporaries: Steen, ter Borch and Metsu, in particular, each painted several versions. The popularity of the subject may reflect increased literacy, an improved postal service and a fashionable interest in the art of letter-writing as a social skill. But in painting it had its own, older tradition in which the recipient of the letter was a young woman at her toilet. She was Bathsheba, wife of Uriah the Hittite, whose story is told in the Second Book of Samuel, 11. One evening when she was washing herself, David king of Israel saw her from the palace roof and "sent messengers and took her; and she came in unto him, and he lay with her". It is the letter from the king commanding her to come to his bed that the young woman at her toilet receives in sixteenth-century paintings. The king's lust had further consequences. Bathsheba's husband, Uriah the Hittite, one of King David's mighty men, was away at the seige of Rabbah. So when Bathsheba told David she had conceived he sent for Uriah on the pretext of learning how the seige was progressing. But when Uriah refused even to enter his own house while his comrades were encamped outside Rabbah, he sent him back to his commander with a letter containing instructions to ensure that Uriah died a hero's death. Uriah was duly killed and David married Bathsheba. "But the thing that David had done displeased the Lord", and their adulterously conceived child died after seven days. But that is not quite all: "David comforted Bathsheba his wife and went in unto her and lay with her: and she bore a son, and he called his name Solomon: and the Lord loved him." And, at last, David's troops took Rabbah.

Turning to Vermeer's pictures of contemporary letter-readers, it may seem quite irrelevant and even perverse to recall the Old Testament history. But there are reasons not to dismiss it entirely from mind. That a modern Bathsheba was not unthinkable to Vermeer's contemporaries is demonstrated by Jan Steen's small painting now in a British private collection. The elegantly dressed young woman standing in a room in which a curtained bed and a chamberpot set on a chair are the prinicipal furnishings might be mistaken for a whore, the old woman who brings her a letter being her procuress. But on the letter may be read: "*Alderschonte Barsabe – omdat. . .* [Most beautiful Bathsheba – because . . .]".

At first sight, Steen's modern Bathsheba is unique among contemporary paintings on the letter theme. Gerard ter Borch, in particular, painted a considerable number of variations on the theme and none immediately recalls the Old Testament narrative. The painting known as *The letter* in the British Royal Collection shows an interior in which a young woman reads a letter to her companion and a boy who appears to be a servant.

There is nothing to indicate the contents of the letter except that both companion and servant stare fixedly and with apprehension at the reader. Whatever its contents, the letter offers cause for concern. Otherwise, it is another of ter Borch's contemporary dramas. But if one turns to consider other variations on the letter theme by ter Borch, then a continuity with the Bathsheba story is discernible. In the Munich *Letter*, the letter actually arrives. The messenger is in military uniform and has a long-barrelled gun slung over his shoulder. The young woman cocks her head and eyes him quizzically. With both hands tucked into her fur-edged jacket, she makes no effort to accept the letter he holds out to her. Her maidservant looks on with an apprehensive air, like the page in the Royal Collection painting. Other features recur in both works. The young woman stands before a curtained bed. Her maidservant, like the page boy in the Royal Collection painting, has a dish and ewer for a toilet. In both works, a lapdog occupies a stool. In the Royal Collection painting it curls up asleep but in the Munich *Letter* it crouches uneasily. Then again, in a painting in the Metropolitan Museum, New York, it is a young woman who is writing the letter. Another young woman stands before her and another girl leans over the back of the writer's chair to read over her shoulder. The lapdog sits up on the stool as if it, too, is participating in the writing of the letter. It cannot be insisted that the Munich version in which the letter is delivered by a soldier is intended even to echo the Bathsheba story. However, when placed among similar works by ter Borch, there can be little doubt of the emotional register on which the work is set, or that ter Borch's inventions are essentially variations on a theme.

Ter Borch's minor dramas might be the productions of a small repertory company. The young woman who modelled for the letter reader recurs in other paintings: she is said to have been the painter's stepsister Gesina, the servant his stepbrother Moses. The same furnishings and objects, too, reappear in other works. This could be the kind

Jan Steen
Bathsheba
Canvas?, 42 × 33 cm
Private Collection,
Sussex, England

Gerard ter Borch
The letter
Canvas, 81.6 × 61.25 cm
British Royal Collection;
Reproduced by gracious
permission of Her Majesty
the Queen

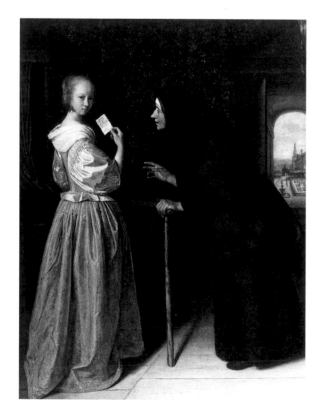

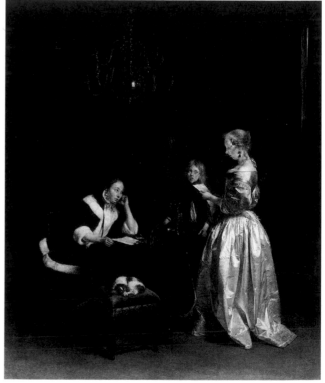

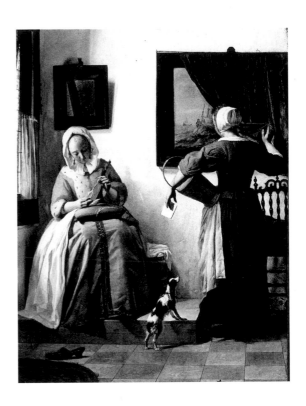

Gabriel Metsu
Woman reading a letter
Panel, 52.5 × 40.2 cm
National Gallery of Ireland,
Dublin (Beit collection)

of painting criticized by Gérard de Lairesse in *Het Groot Schilderboek* of 1707. He objected that among painters of contemporary life "one paints . . . the air of his wife, though ever so ugly, with all her freckles and pimples very exactly; whereby the agreeableness of a beautiful woman's face is quite lost . . . Another will put a lord's dress on a schoolboy, or his own son. . .". But his notion of an acceptable painting of modern life also brings the work of ter Borch to mind. He proposed such subjects as "two virgins. . . seen at a table drinking tea". This would provide "an example in treating and refusing": one tries to press a cup of tea on the other who refuses. This the stuff of drama: "These two passions cause two contrary motions in the whole body, hands, feet and face."

There can be little doubt about the origin of the letter received by the young woman in Gabriel Metsu's painting of a *Young woman reading a letter* in the Beit collection, because the artist painted a pendant showing a young man writing what must be the very letter. He sits at a table covered by a splendid Turkey carpet at an open window. Behind him on the wall is an Italianate pastoral landscape. On the table, seen through the opened window, is a globe. He is a handsome young man, still little more than a youth, dressed in fine expensive fashionable dress. He is dressed for the street and his hat hangs on the back of his chair. By contrast, the young woman reading his letter is not alone. She sits on a small platform by the window with her needlework on her lap while a maidservant stands on the right. Seen together, the pendants provoke a narrative concern. Was the young man in the town when he met the young woman's servant? Did he waylay her, persuade her to wait while he rushed inside to scribble a hurried note? Is she now waiting to take a reply? This version may fit the facts better than the surmise that the servant is employed by the young man. But, significantly, such surmises could only arise when the pendants were seen together. In isolation, the *Letter-reader* is a coherent and complex image of a type not unrelated to the Bathsheba type. In contrast to its pendant, its imagery is familiar: the young woman sewing or making lace, a cast-off shoe in the foreground, on the wall a mirror and a painting of a

ship at sea – all these features recur in similar scenes, though not necessarily together. In particular, the seascape to which the servant draws attention by the act of uncovering it has been established as signifying the pleasures and pains of the lover tossed on the seas of love.

What distinguishes this pair and what unites them is not simply the letter that, we assume, has passed from one to the other but that both writer and reader con the missive by a window and that both small paintings are rich with sunlight and the play of reflected lights among the luminous shadows. We recognise that the pair are united by their common illumination by the same sun.

Vermeer's painting known as *The love letter* is an oddity. It is overloaded with significant details. The young woman sits holding a lute by its neck in her left hand and in her right hand is a letter that she must have just been given by her maidservant. Almost at her feet is a work basket holding linen and beside it a sewing cushion. In the doorway are a pair of cast-off shoes and a broom, on the rear wall a pastoral landscape and a seascape and on the shadowy corridor wall to the extreme left a map, the same map as that in the Frick *Soldier and laughing girl*. On the chair on the right foreground is sheet music. Dramatically, it makes little sense. The woman is dressed in fine clothes (from Vermeer's property basket: the fur-trimmed jacket appears in other paintings and was listed in the inventory after the artist's death). The interior is that of a wealthy household. What was the young woman doing before the servant brought in the letter? Had she been sewing, as Metsu's young woman clearly had been? Does her pose imply that she has abandoned the virtuous activity of needlework for the more questionable pleasures of making music? Why are two shoes and a broom left across the entrance? The shoes belong in a bedroom, discarded before getting into bed. When accompanied by a broom shoes suggest mercenary love. The broom is used to beat out the lover when his money has been spent. The painting is saturated with imagery: it might be a parody of the letter theme. Only the overt *Allegory of Faith* is so manifestly crammed with symbolism.

Yet, curiously, while Metsu's little painting hinges for its effect on the maid's unseen gaze as she uncovers the seascape and thus reveals to the viewer the character of the letter the young woman is reading, and also on the quality of sunlight that gives to the work its benign atmosphere – in other words, depends on essentially symbolic features to establish its subject, Vermeer's does not. Embedded though they are in an encrustation of symbols, the power of this work is contained in the exchange of glances between mistress and maid. Despite the contrast of their clothing that implies a contrast of status their exchange is one of complicity. And in the contrast of spirit, the maid is clearly superior to the mistress: expression, posture and position, all establish this.

This is a theme that reappears in the very different painting of *Mistress and maid* in the Frick Collection. Despite the surprising variety in Vermeer's small œuvre, it would be fair to call the Frick painting anomalous. Although the canvas itself is somewhat smaller than either the *Allegory of Faith* or the *Art of Painting*, the half-length figures of the two women are larger than anything Vermeer had painted after the *Procuress*, approaching the size of life. Many have thought the work unfinished because of the plain dark background, and therefore that it might be one of the two paintings accepted by the baker, van Buijten, from Vermeer's widow to pay the bread bill, the "large painting" by Vermeer owned by van Buijten at his death. It is the one painting in which Vermeer could be said to have essayed the dramatic subtlety characteristic of ter Borch's pieces and on a grand scale. In its precise rendering of both expression and gesture it challenges comparison even with Rembrandt. The servant's interrogative

Johannes Vermeer
The love letter
Canvas, 44 × 38.5 cm
Rijksmuseum, Amsterdam

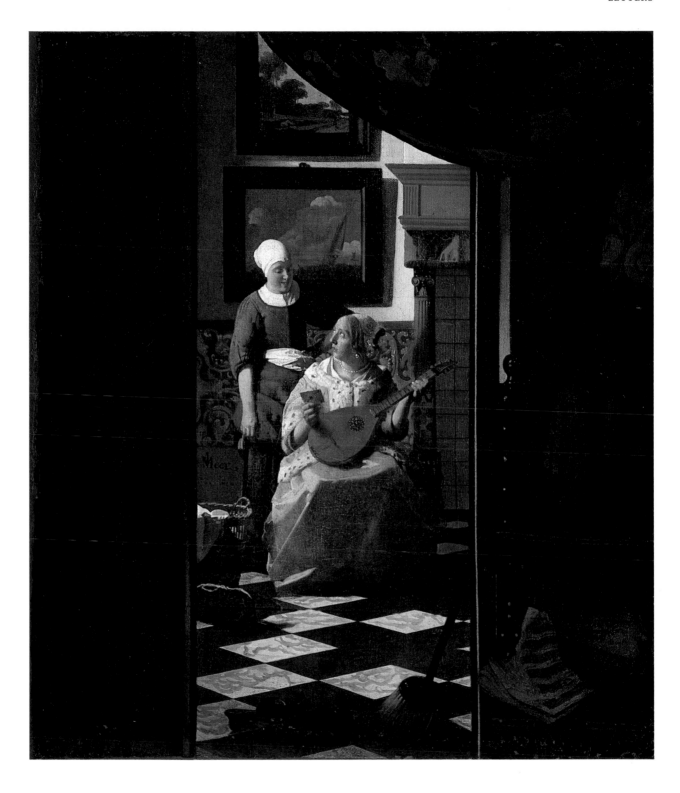

gaze is vivid, while the expression, the crucial expression, of the mistress is more obscure, partly because of the turn of her head, partly because of the elusiveness with which her features are represented. All that is revealed is the gesture of the hand raised to the chin. Is she surprised to receive the letter? The ambiguity of the gesture of her left hand is balanced by the obscurity of the action of her right hand. There appears to be writing on the paper before her, but the position in which she holds the pen does not suggest she has been writing. Was she writing herself when her maid interrupted with this letter? Is she preparing to reply even before she has read the letter? Or is it the mistress who has written the letter, has asked the maid to deliver it, and the maid is putting an awkward question to her employer? The relation of *Mistress and maid* resembles that of the Rijksmuseum *Love letter*, but in this reduced setting, without the conventional attributes of that work, there is only the ambiguity of a dumb show, and the focus is on the essential but ambivalent psychology of that relationship of quizzical servant and uncertain employer.

The third of Vermeer's two-figure treatments of the letter theme, the *Lady writing a letter with her maid*, in the Beit collection, is different again. The two figures are once more mistress and maid but here there is no exchange between them. The mistress is absorbed in writing a letter, the maid, too, is lost in thought; the two are unaware of each other. Formally, this piece has significant features in common with the British Royal Collection *Music lesson* and the Boston *Concert*. The window-frames and leading are similar to those of the *Music lesson* and the marble tiling has the pattern of the *Concert*. But such alterations are familiar in Vermeer's works. It is more remarkable that the three works are of very similar size. In all three, the relation of actors to each other and of the viewer to the actors is the central concern. In the Beit painting, the figures are closer to the viewer, it would seem. Certainly, there are far fewer floor-tiles visible between the bottom edge of the painting and the rear wall. But three features negate this greater proximity. First, although the distance between the front of the picture and the standing maid is clearly established, the position of her mistress between her and the front of the table is less easy to assess. From the low angle at which it is presented to the viewer, it is virtually impossible to estimate the depth of the table. Second, the heavy curtain in the left foreground hangs in an obscure and ambiguous relationship to the picture frame through which we look and the floor in the foreground. It may be seen as hanging very much closer to the viewer than anything else visible within the frame, and, thus suggesting a greater distance between viewer and the women than the visible tiles might indicate. This is a device that Vermeer uses with even more force in the *Art of Painting*. Thirdly, and most decisively, where, in the *Concert* and in the *Music lesson*, the participants are turned away from the viewer in their mutual relationships, here, their absorption in their separate mental preoccupations isolates them as much from each other as from the viewer.

It is a sober, even sombre work. The light appears much restricted, in part literally so by the translucent linen curtain over the window, in part as an illusion created by the shadow of the foreground curtain that so restricts the area of the stage. But, whatever the causes, much of the painting is shadowy. Light illuminates and emphasizes the profiles of objects. In particular, it catches and outlines the fine white diagonal of the writer's quill separated by the shadow of the writer's fingers from an only marginally broader horizontal band of white that is the rectangle of paper on which she traces her thoughts. As with the more or less contemporary *Lace-maker*, Vermeer represents a complex of mental and physical activity by a curiously allusive pattern of light and shade.

By contrast, the attendant maid is lucidly displayed, the direction of her gaze

Johannes Vermeer
Mistress and maid
Canvas, 90.2 × 78.7 cm
Copyright The Frick
Collection, New York

84

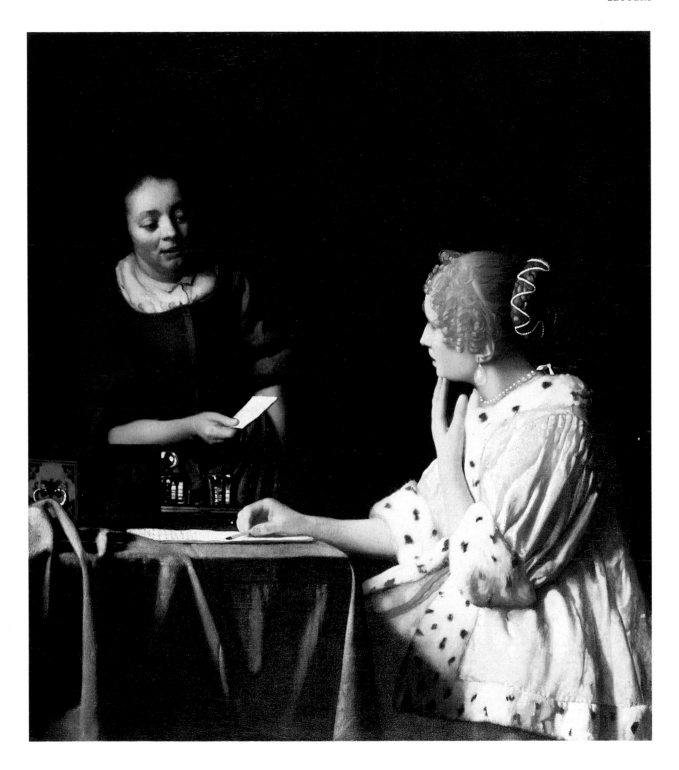

apparently unmistakable. But is she absently gazing through the window-pane or at the image on it? Archivists have identified the coat of arms and device that Vermeer incorporated into this same pattern of leading for the Berlin and Brunswick drinking pictures, but no one, it seems, has identified the more discreet device imposed here. Scholars and commentators have identified the painting on the wall as *The Finding of Moses*, have noted that it is the same image though on a vastly larger scale as that on the rear wall of the Louvre *Astronomer*, and have asked what significance it may have for the subject of the painting. But it is characteristic of the servant's placing that by standing before the shadowed painting and staring at the luminous image in the glass she draws attention to a potential relationship between these and the thoughts of her mistress that are, as she waits, becoming manifest on the paper on the table.

This concern: the relation of the visible and invisible, of carnal and spiritual, of material and ideal, illusion and reality, is perennial, but it was in Vermeer's age a constant theme of painting. From one point of view, it was the question raised by the *paragone* (comparison) of the arts: what were the limits of painting? It is the question provoked recurrently by the art of Rembrandt, not only in the mind of the modern viewer face to face with the great self-portraits, but also for contemporaries, for example in the claim by Vondel that Rembrandt had failed to portray the true Cornelis Anslo the Mennonite preacher because, due to the limits of his art, he could show only the least or outward part. He should have been able to paint the preacher's voice. Then there is the teasing riddle (as it has been seen by some modern historians) of Rembrandt's intended meaning when he wrote to his patron, Constantijn Huygens, that he had sought to represent *"de meeste en natureelste bewechlicheidt"* – does this mean the greatest and most natural movement or the greatest and most natural emotion? Clearly, it means both, the idea of the motions of the spirit being familiar at the time. The accepted truth was that the painter could represent the motions of the mind only through the outward, visible movements of the body, which is what Rembrandt was doing in the paintings of the *Passion of Christ* which he was writing about to Huygens. But in one of his most memorable achievements, his painting of *Bathsheba* of 1654, now in the Louvre, Rembrandt might be said to have succeeded in making thought visible. Bathsheba is a life-sized naked woman sitting on the edge of a bed while an older

Johannes Vermeer
Lady writing a letter with her maid
Canvas, 71.1 × 58.4 cm
Formerly National Gallery of Ireland, Dublin (Beit collection)

Rembrandt van Rijn
Bathsheba, 1654
Canvas, 142 × 142 cm
Louvre, Paris

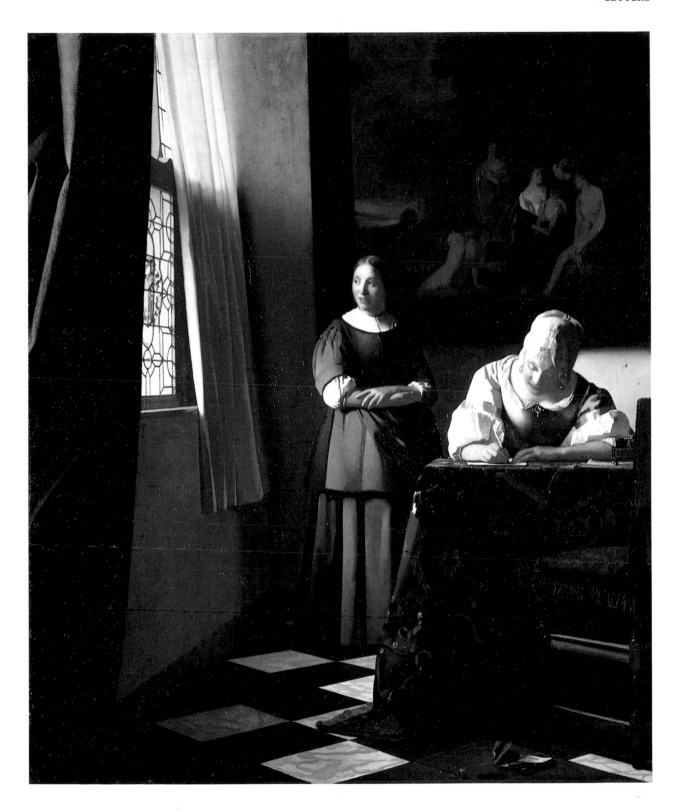

woman washes her feet. Her right hand resting on her crossed knee holds a letter, the letter, and it seems she must have read it already for she holds it text-side down, as a curling edge reveals. She is deep in thought. She must be, can only be, meditating on the implications of that letter. It is impossible to read the thoughts of another human being. As King Duncan says in Macbeth, "There's no art/ To find the mind's construction in the face". So, how can it be possible to read the thoughts of a painting? But the viewer who knows the story told in II Samuel 11 knows very well what Bathsheba must be thinking about, knows, indeed, the outcome of which she is still ignorant at the moment represented. The viewer contemplating Rembrandt's painted Bathsheba can rehearse the matter of her meditations. Rembrandt's painting provides the topos that directs the flow of our contemplation.

Whether Vermeer knew Rembrandt's painting is unknown: it seems unlikely that he saw the original. But the Mauritshuis *Diana* with her attendant washing her feet attributed to Vermeeer is strongly reminiscent of the Bathsheba, clothed and in reverse. This *Diana* was once attributed to Rembrandt's pupil, Nicolaes Maes, and also recalls something of the manner of Rembrandt's pupil, Carel Fabritius, whose relation to Vermeer has already been considered.

The Dresden *Letter-reader* is among the most ambitious and distinguished of Vermeer's paintings. Its relative immaturity is revealed only indirectly, by X-rays which show that he made many radical changes as the work developed. Originally, a large painting of Cupid, the same that is included both in the damaged Frick *Girl interrupted at her music* and the National Gallery *Woman standing at the virginals*, dominated the rear wall. Far more significant are the discoveries that the linen curtain on the right was a late addition: initially a large roemer or glass had been painted on the table to the right; and the letter-reader herself had been somewhat more to the left, closer to the window and turned slightly more away from the viewer, as if, initially, one would have looked to the reflection in the glass to study the reader's expression.

The painting's relatively large scale is, perhaps, the most telling indication of its early origin. Though minute beside its companion in the Dresden Gallery, the *Procuress*, it is larger than any but the largest of the later multi-figure pieces. In consequence, the figure is larger than almost every figure painted later (except, paradoxically, that of the *Lace-maker*, his smallest piece) yet she is dwarfed by the lofty bare wall against which she stands. She is also rendered remote by her isolation beyond the table, which in its turn is seen beyond the added foreground curtain. In this way, Vermeer sustains something of the theatrical character of the *Procuress* even on this smaller scale. The physical and dramatic proximity of the *Procuress*, in which the life-size figure on the left looks the viewer directly in the eye and even the gallant and whore seem unconcerned by any onlookers, however close to hand, is abandoned for a distant, intrusive, unwelcomed view, but nevertheless a view that links viewer with the viewed in a sense of continuous space. It was the creation of a sense of continuous space shared by his viewer and the characters within his pictures that Vermeer turned away from when he took up the format of the true cabinet picture; that he played with, teasingly, in the three larger paintings of his mid-career, the *Music lesson*, the *Concert* and the *Lady writing a letter with her maid*, and to which he returned only once again, in the *Art of Painting*.

The effect that the viewer is looking across a considerable space to the distant letter-reader is achieved by the curious and paradoxical device of the foreground curtain, which Vermeer added as the painting got under way. It is because the curtain unmistakably hangs at the level of the picture's surface that the small scale of the reader may be perceived as the consequence of her remoteness within the space

Johannes Vermeer
Young woman reading a letter at an open window
Canvas, 83 × 64.5 cm
Gemäldegalerie, Dresden

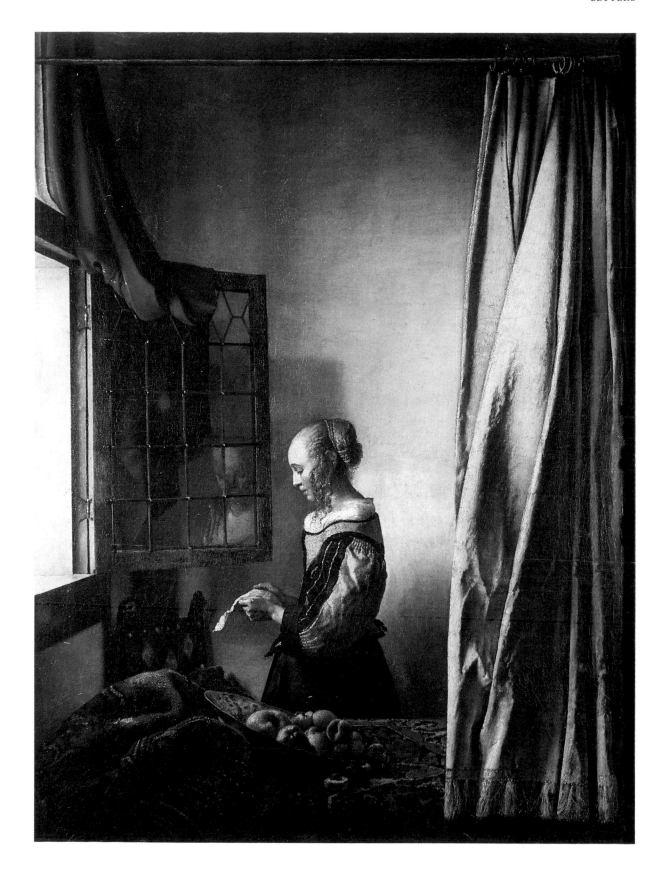

Johannes Vermeer
Woman in blue reading a letter
(detail)
Rijksmuseum, Amsterdam
(Reproduced in full on p.93)

beyond. The proximity of the curtain unifies the spaces, otherwise disjunct in their disparate scales, of viewer and letter-reader. Paradoxically, though, the curtain may be seen to emphasize the fictitious nature of the scene beyond it. It recalls and, indeed, resembles those curtains hung across valuable, and curious, pictures to preserve them from the sun and the eyes of the profane. Yet no *trompe-l'oeil* effect is intended — neither curtain nor rail casts its shadow on the picture's surface; only a teasing ambiguity is established.

The sense that this ambiguous curtain has a greater than fortuitous significance is augmented by the distinctive style of the second curtain represented in this painting. With its distinctive tight sinuous swag and crimson colour, is there another curtain like it to be found outside the paintings of Caravaggio? It was Caravaggio's realism and, more specifically, his light, that had so profoundly affected those painters from Utrecht, notably Dirck van Baburen, who had, in their turn, inspired these early works of Vermeer. This crimson curtain may be seen as looped back to admit that distinctive light by which we are enabled to see the letter-reader. But this is to reflect back on the distinctive character of the curtain across the front of the picture. Unmistakably, in order that the viewer may see the letter-reader, it, too, must have been drawn back. This would, without doubt, have brought to the mind of any educated contemporary Parrhasios, one of the most renowned Greek painters of the fourth century BC. It was Parrhasios who, said Pliny, was "reputed to have entered into a contest with Zeuxis, and when the latter depicted some grapes with such success that birds flew up to the scene, Parrhasios then depicted a linen curtain with such verisimilitude that Zeuxis, puffed up with pride by the verdict of the birds, eventually requested that the curtain be removed and his picture shown, and, when he understood his error, conceded defeat with sincere modesty, because he himself had only deceived birds, but Parrhasios had deceived him, an artist." Vermeer, of course, has painted both a curtain that appears to be linen and the picture beneath it.

But all this is of significance only to the extent that it focusses a particular kind of imaginative attention on the young woman reading the letter. It is in the characterization of this young woman that the painting may truly be called Rembrandtian. It is at once a most novel and subtle representation of the fall of daylight over material surfaces and volumes and a profound evocation of a human being. And, of course, neither achievement would have been possible without the masterful control of his medium that Vermeer displays. The paint is applied in a variety of procedures, but the dominant is a series of small dabs like crumbs of light adhering to and defining the surfaces of things. Already, there is the first development of that technique of minimal definition that is the basic characteristic of his mature style. In the second of the letter-readers, the *Woman in blue* in the Rijksmuseum, there is a white lozenge, a diamond, set against the tawny gold of the map beyond: this the viewer has to recognise as the top folded strip of the letter the reader is holding. In the Dresden painting, the letter is unmistakable, substantial. It looks corrugated as if from frequent handling. But this effect is imparted largely by a serpentine ripple of impasted white paint that at its farthest tip broadens into a loose anticipation of the more ideally geometric form of the Rijksmuseum letter. A dab of deeper tone establishes a glimpse of the underside of the sheet. And, as the paint becomes crumbs of crystallized light that form the textures of stone, wood, glass, porcelain, fabric, fruit, hair and skin, so, too, they form the hardness of the young woman's brow, the softness of her parted lips. They form the tense grasp of her hands on the paper held taut between them. They come to represent her pent breath and intense concentration.

In contrast to Rembrandt's *Bathsheba*, the viewer cannot know this young woman's

Johannes Vermeer
*Young woman reading a letter
at an open window* (detail)
Gemäldegalerie, Dresden
(Reproduced in full on p.89)

thoughts, but a sense of the motions of her spirit is, surely, perceptible. Did Vermeer know of the discussion on painting said by Xenophon to have been held by Parrhasios and Socrates? Socrates asked Parrhasios: ''Is painting the representation of visible things? By making likenesses with colours you imitate forms which are deep and high, shadowy and light, hard and soft, rough and smooth, and young and old.'' Parrhasios agreed with this and other propositions, but when Socrates went on to ask: ''Do you not imitate the character of the soul, the character which is the most persuasive, the sweetest, the most friendly, the most longed for, and the most beloved? Or are these things inimitable?'' Parrhasios replied: ''But how could a thing be imitated, o Socrates, which has neither proportions, nor colour, nor any of the things which you mentioned just now, and which, in fact, is not even visible?'' To which Socrates said: ''Is it not natural for a man to look at certain things either with affection or with hostility?''

''I suppose so'', said Parrhasios.

''Therefore this much must be imitable in the eyes?''

''Yes certainly'', agreed Parrhasios, as all Socrates' interlocutors must. Socrates then matched his initial list of opposite qualities with another and proposed that happiness and sadness, ''grandeur and liberality, as well as lowliness and illiberality, moderation and thoughtfulness as well as insolence and vulgarity – these too are revealed through the expression of the face and through the attitudes of the body both stationary and in movement.''

''You are right'', answered Parrhasios.

''Therefore these too can be imitated?''

''Yes, of course'', answered Parrhasios, who, presumably, went away to apply the lesson.

It was just this issue of the visible form of such moral features that seems to have preoccupied Rembrandt and which, in a more elusive way, seems to be Vermeer's concern in this, the most Rembrandtian of his works.

In sum, what may be recognised in this work is the material form of imagination at work. There is first the creative imagination of the painter, imaginatively attending to the world, to other paintings, meditating in his imagination on the nature of painting as he and his predecessors had understood it and then creating forms in paint that give material form to his imagination. Then there is the imagination of the viewer, attending to the painted surface, contemplating its textures and how it gives form to other visible things and how those painted forms represent invisible things. In this case, both painter's and viewer's imaginations are contemplating the workings of a third imagination, that of the letter-reader herself.

The contrast between the Dresden and Rijksmuseum letter-readers is shocking. The latter is one of Vermeer's small paintings of single figures, eleven of women, two of men, the smallest of which is only 24.5×21 cm and the largest no more than 55×45 cm; it is 46.5×39 cm. In these mature and characteristic works there is still a sensibility or sensitivity to the emotional life of others like that in the Dresden *Letter-reader*, and this concern for the inner life remains important, but there is also an extra element – or at least in these mature works the sensibility and responsiveness do not seem to be the centre of gravity.

How this is brought about is not easy to see. It is, almost certainly, a consequence of the scale Vermeer chooses but, equally essentially, of the mode of presentation. In all the small paintings of more than one figure the viewer seems to be an invisible eaves-dropper, a spy through a knot-hole in the shutter. This is equally striking in the Frick *Soldier with laughing girl* and in the British Royal Collection *Music lesson*. In the first, the viewpoint is improbably close to so intimate an encounter, in the second, it is

irremediably, fixedly, remote (tied as it is to the station-point of the easel reflected in the mirror). But in the mature single-figure works, although almost always the single figure is hemmed in by table and chairs, this seems more to provide the figure with a firm foundation or pedestal than to exclude the viewer. On the contrary, everything in the internal structure establishes that the viewpoint is close to the figure but not intrusively close.

The formal harmonies that are so striking in the multi-figure compositions assume, in the single-figure pieces, an almost heraldic quality. X-rays of the *Woman in blue reading a letter* reveal not major changes as in the Dresden painting but more subtle adjustments: the vertical edge of the map that, initially, almost clipped the white diamond of the letter was extended to the left by perhaps a centimetre to frame it more securely, and the back of the reader's jacket originally billowed out behind her. A more problematic alteration was made to the bottom edge. Damaged paintwork revealed by the X-rays indicate that at some time or other, the bottom edge of the canvas was turned under on a smaller stretcher, cutting off the image along the line of the near edge of the chair-seat to the right. Overall, receding planes and other forms of foreshortening have been diminished and surface continuities have been emphasized. This is strikingly revealed by a comparison of the hands of the Dresden and Rijksmuseum *Readers*. In the Dresden painting the dominant effect is of the two hands holding the paper taut between them. In the Rijksmuseum painting the emphasis is on the rise and fall of the line of letter, hands and single visible arm above and below the horizontal of the map rod. On the table, what may have been the outer cover or envelope for the letter is reduced to a chevron of light and dark that links together the table's edges with vertical and horizontal edges of the reader's blue jacket so that zigzagging verticals and horizontals established by strong shadows meet at a small diamond of light. To itemise further such continuities and conjunctions would be to suggest that the painting is no more than the sum of such contrivances. It is not. Nevertheless, it is, in considerable part, the inevitability with which, to take another example, the woman's nose tip meets the corner of the rectangle inscribed on the map behind her that contributes to the immutable monumental grandeur of this small painting. And all this without any apparent forcing of the material relationships of the real world and as if it all came about as the indirect consequence of a rendering of the gradations of light falling across and reflected by the surfaces of the world.

The Rijksmuseum picture transforms the concerns of the Dresden painting. There, the theme is the inaccessibility of the young woman and her concerns to the viewer. By contrast, the Rijksmuseum painting, by its achievement of such subtle but striking and captivating pictorial harmonies, presents an image that is at once particular to its time and place and to an individual moment in the life of an individual being, yet also has a quality of timeless universal human value. This young expectant mother is not obviously a Bathsheba. Perhaps an appropriate light in which to perceive her is this: she represents the truth that though her love is physical and fruitful its fundamental reality is spiritual.

Johannes Vermeer
Woman in blue reading a letter
Canvas, 46.5 × 39 cm
Rijksmuseum, Amsterdam

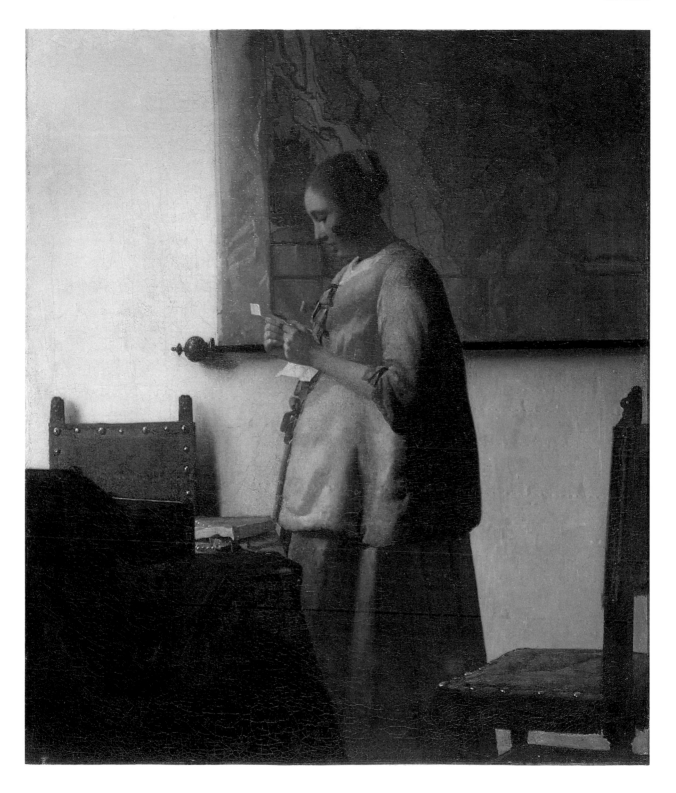

Exemplary Images

There are four other paintings of a single half-length female figure that are of almost identical dimensons to the Rijksmuseum *Letter-reader*: the *Milkmaid* which is also in the Rijksmuseum, the *Woman with a ewer* in the Metropolitan Museum, New York, the *Woman holding a balance* in Washington and the *Woman writing a letter* also in Washington. It is generally agreed that the *Milkmaid* is the earliest of all these small paintings, being painted not very long after the Dresden *Letter-reader* and about the time of the Frick *Soldier and laughing girl*. It is with little doubt the work listed in the 1696 sale inventory as item number 2: ''A girl pouring milk, extremely well painted''.

It is the various character of the technique that suggests an early date. The representation of the loaves by a sprinkling of dabs of pale colours that suggest the light sparkling from the coarse wholemeal grain exaggerates a characteristic of both the Dresden and Frick paintings. Technically at odds with this broad optical quality is the precise representation of the flaws in the plaster of the two walls, including two nails and holes where other nails have previously been. Again the young woman's forearms are drawn in a slightly impasted paint that has retained the traces of brush-strokes, recalling the school of Rembrandt and Carel Fabritius.

But, like the Dresden *Letter-reader*, its early date and mixed modes of handling do not make it an immature piece. On the contrary, it is among Vermeer's most memorable and powerful inventions: among the smallest of his pieces, it is one of the most monumental.

As an image of a kitchen maid, it is virtually unique in its seriousness and the dignity it imparts to its subject. Metsu's *Cook*, in Berlin, is holding an empty spit as she quizzically looks the viewer in the eye. In similar paintings from the previous century, by Beuckelaer, buxom kitchen maids have already impaled the plucked chicken on the spit as they knowingly hold the viewer's gaze. The motif had developed, largely, within pictures of Christ in the house of Martha and Mary in which the foreground kitchen showed an exaggerated preoccupation with the carnal at the expense of the spiritual.

If Metsu's kitchen maid is potentially indecent, what of de Hoogh's small painting in the Rijkmuseum in which a young woman dressed as a servant offers a jug to a richly costumed child? Surely this is an image of domestic propriety. But through the open door of the pantry can be seen a beer barrel, clearly broached. The tiled floor of the room is littered with straw and through the door to the right can be seen the portrait of a man above an empty chair. If all these features are intended to have significance, that can only be that here is a bad servant who leads the child of the house astray when the master is away.

By contrast, Vermeer's servant appears to be beneficent. She has turned her back on the luxury of the foot-warmer over which an idle woman would sit, and to the ample quantity of bread on the table she pours a stream of milk that, like the widow's cruse, is inexhaustible. It has flowed endlessly since the day the painting was completed and will continue so long as the painting survives.

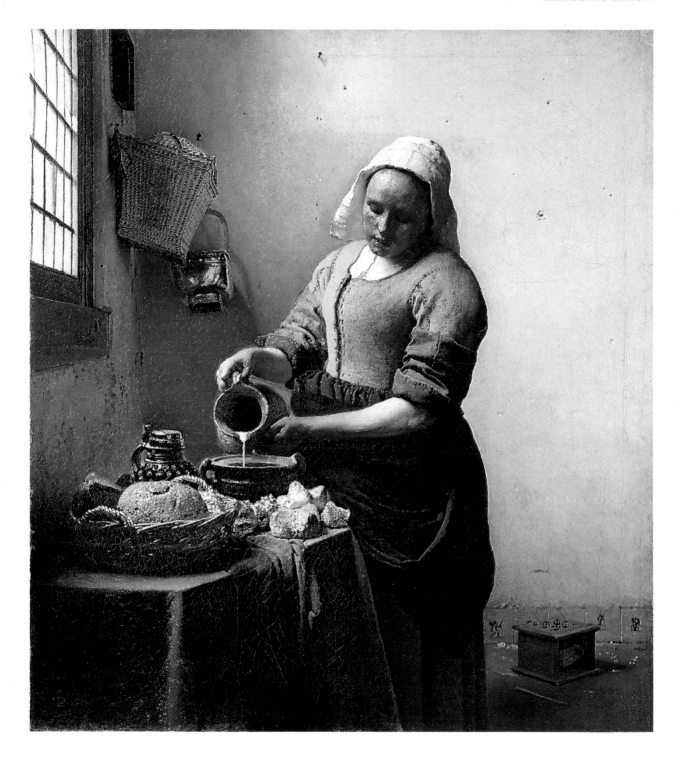

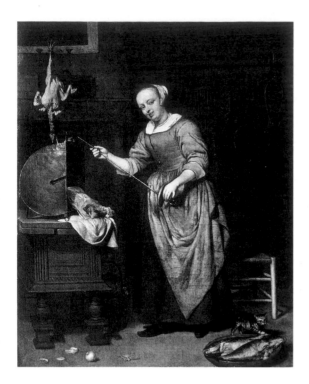

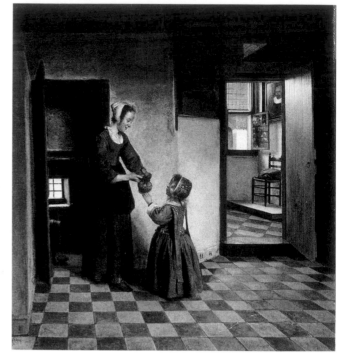

Gabriel Metsu
The cook
Canvas, 54 × 42 cm
Gemäldegalerie, Berlin-Dahlem

Pieter de Hoogh
Woman with a child in a pantry
Canvas, 65 × 60.5 cm
Rijksmuseum, Amsterdam

The *Woman with a ewer* in the Metropolitan Museum is almost identical in size to the *Milkmaid*, and in its subject it has a distinct affinity. But in technique, it is markedly different. It has, justifiably, been recognised as exemplifying the qualities of Vermeer's mature style. Where, in the *Milkmaid*, the brushwork was markedly varied in different areas, in the *Woman with a ewer* the paint is applied in a very delicately varied but apparently coherent range of touches and glazes. Though others among his contemporaries were also attentive to light effects, as Metsu was in his *Letter-reader* in the Beit collection, none achieved the luminosity or the richness that Vermeer displays here. Here, too, are the strikingly refined abstractions of form that distinguish his mature art. This is typified in the relationship he has created of arm and ewer. The foreshortened forearm and hand are reduced to a pattern that would be almost unrecognisable but for the context, while the reflections in the ewer almost dissolve it away. So much of a unity are woman and ewer that the line of the metal lip is aligned with that of her sleeve and its angles cunningly related to the black band of her cuff. Such inventions anticipate the rich and strange obliquities of the Louvre *Lace-maker*.

The significance of the subject is not obvious. There is not a familiar prototype that a contemporary would immediately have recognised. There are curious features of which the artist, at least must have been aware. The young woman wears the bodice worn by the Dresden *Letter-reader*, the *Soldier with laughing girl* at the Frick and by the young woman at the keyboard both in the *Music lesson* and the *Concert*. Costumes and properties recur in Vermeer's images as they do in the productions of a small repertory theatre, of course, but the reappearance of this familiar bodice serves to establish the transforming character of the deep collar and head-dress that signifies a contrast with the worldly interests of its other wearers. The window leading is that of the Berlin *Glass of wine*, but without the image of Temperance. The ewer stands in its own bowl and is one used for washing hands. The woman's pose is distinctive: poised between window and ewer. She turns her back on the image of the world represented by the map and from the jewel box on the table. Grasping the ewer, as if about to wash her

Johannes Vermeer
Woman with a ewer
Canvas, 45.7 × 40.6 cm
Metropolitan Museum of Art,
New York

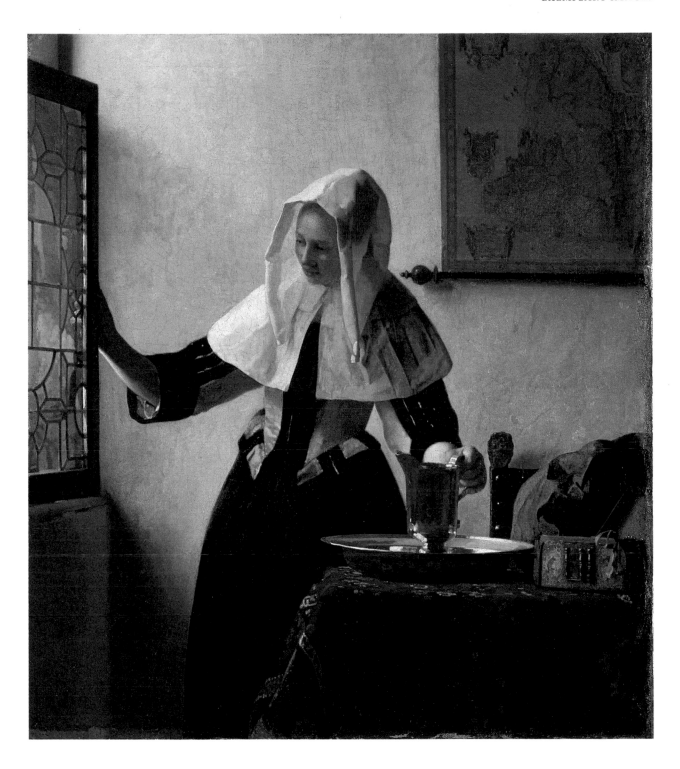

hands, she turns to look not through the open window but through the glass that though clear seems filled with an image of clouds and sunlight.

Another small painting of a single figure, the *Woman holding a balance*, now in Washington, is among the most renowned and problematic of Vermeer's inventions. This is almost certainly the first painting listed in the 1696 Amsterdam sale: "A young lady weighing gold, in a box by J. vander Meer of Delft, extraordinarily artful and vigorously painted". It sold for 155 guilders: only the *Milkmaid* fetched more. The reference to a box has taxed scholars. It has been suggested that it was a perspective box or peepshow like that by Hoogstraten or Fabritius's *View of Delft*, discussed earlier. But while the perspective of the Hoogstraten appears wildly distorted when not viewed through its peepholes and in the Fabritius, too, the perspective appears to be distorted, the perspective of the Vermeer is completely orthodox and in no striking manner different from that in other works. Most probably, the box was to protect this "extraordinarily artful and vigorously painted work": it is the only work so highly praised in that catalogue.

It is certainly artful, meaning both skilful and ingenious. A woman weighing gold, as the catalogue calls it, traditionally exemplified Avarice, though the woman was, equally traditionally, shown old. Pieter de Hoogh's painting, now in Berlin, that was probably painted at much the same time as this Vermeer, certainly shows a woman putting a gold piece on to the scale-pan. The gold brocade covering the wall and the rich reds of the carpet and the woman's skirt create an air of opulence that supports the sense that the woman's concern with gold involves a commitment to worldly and material goods and an indifference to spiritual matters – the recurrent theme of *vanitas* paintings. This de Hoogh is unusually reminiscent of Vermeer's favoured format (though slightly on the large side) but scholars are inclined to date both this de Hoogh and the Vermeer *Woman holding a balance* after 1660, when de Hoogh left Delft for Amsterdam.

The significance of Vermeer's painting, it has long been recognised, is more problematic than the de Hoogh. The painting behind the woman is a Last Judgement, there is a mirror on the wall by the window, and the woman herself appears to be pregnant. The favoured interpretation was, for many years, that this woman, too, is vainly preoccupied with the life of this world and turns her back on life eternal. Then, in 1977, Arthur Wheelock, noted that the scale-pans were empty. The woman is not weighing gold, though a jewel box, pearl necklace and gold coins are on the table in front of her. Among the reassessments that followed this observation, the most convincing was that, just as in the day of the Last Judgement, for souls to be justly weighed the scales wielded by St Michael must be precisely balanced, so this woman, too, is concerned, on an earthly level, that her balances are just.

In 1983, Nanette Saloman proposed that the crux of the painting was the woman's pregnancy. The empty scales represented the still to be judged fate of the child's soul. The blank mirror, too, alluded to the child's unknown future.

In 1984, Ivan Gaskell proposed a different interpretation. He pointed out that the *Last Judgement* had been traditionally associated with the final revelation and vindication of truth, which had been the purpose of Christ's incarnation. The ancients, too, had known that Truth was the daughter of Time: at the last, all would be known. Cesare Ripa, whose *Iconologia* became a handbook for the guidance of artists from its first edition published in Rome in 1593 and was published in a Dutch translation in Amsterdam in 1644, described Truth as a female figure holding a balance and a mirror. Ripa explains, Gaskell noted, that Christ alludes to the fullness of time when He shall be in heaven and the truth of all things shall be known; therefore He is also called the

Johannes Vermeer
Woman holding a balance
Canvas, 42.5 × 38 cm
National Gallery of Art,
Washington (Widener
collection)

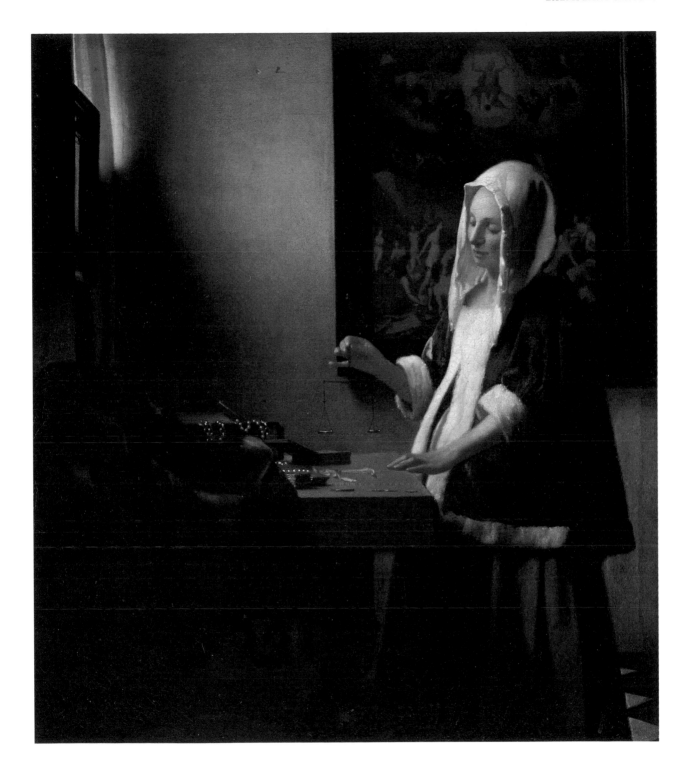

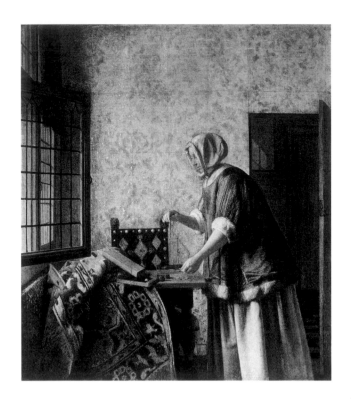

Pieter de Hoogh
Woman weighing gold
Canvas, 61 × 53 cm
Gemäldegalerie, Berlin-Dahlem

Nicolas Tournier
Allegory of Justice and Vanity
Canvas, 104 × 84 cm
Ashmolean Museum, Oxford

Light and the Truth, in which character He is to be seen in representations of the Last Judgement. Gaskell compares Vermeer's piece with a painting in the Ashmolean Museum, Oxford, attributed to Nicholas Tournier but probably from Utrecht. It shows a half-length female figure holding a balance with empty pans and a mirror that reflects a skull balanced on a weighty, leather-bound book. This, Gaskell proposes, is Truth as described by Ripa. Vermeer's woman is neither weighing nor testing her scales, Gaskell suggests. She is contemplating their justness. He quotes from the Book of Proverbs (11:1): "A false balance is abomination to the Lord: but a just weight is his delight." The mirror on the wall is there for Truth to contemplate herself. Truth is arrived at when the intellect is in full command of phenomena, just as the mirror is perfect when it reflects a true likeness. The pearls on the table are not necessarily signs of vanity. Truth in the Ashmolean painting has a single pearl on her brow, which could bring to mind the pearl of great price spoken of by Christ when he preached to the multitude from a boat (Matthew 13:46). Gaskell sees the painting as representing the divine truth of revealed religion, "a simple but ingenious allegory". In its use of Ripa, it is like two other allegorical paintings, the *Art of Painting* and the *Allegory of Faith*.

The *Woman holding a balance* is not an allegory in the way those other two paintings are. Faith, in the large painting in the Metropolitan, is instantly recognisable as a personification rather than a Delft housewife, while the anonymous painter in the *Art of Painting* wears a costume from the past. The *Woman holding a balance* appears to be a wealthy citizen of seventeenth-century Delft. In this, she is little different from the actors in many other contemporary paintings, including de Hoogh's *Woman weighing gold*. Rather than personifying qualities, virtues or vices, they exemplify them.

The essential difference between de Hoogh's *Woman weighing gold* and Vermeer's *Woman holding a balance* is that the former is engrossed in her activity which, in so far as it is a worldly activity, is a vanity. The viewer may, of course, unreflectively delight in the picture's opulent surfaces and so, too, commit a vanity, or may stand back from

100

her involvement and recognise its folly. Vermeer's woman, too, is absorbed in her activity, but that activity, it is clear, is mental rather than practical. To assay the justness of the scales calls for bodily stillness and for careful attention. Not only must the balance be true, but eye and mind must judge it true. And to judge the significance of the painting, the viewer must attend to the balance as attentively as the woman

This woman's absorption resembles that of Vermeer's letter-readers. What is it to contemplate an object as one might read a letter? What is it for the viewer to contemplate this image in the spirit of contemplation of the letter-readers? The woman's head is set against the image of the Last Judgement. The hand holding the balances is set against the picture's frame, the frame that separates and links the image of the Last Judgement and the present world. It is into the present world that the balance descends, as it were, from the space of the Last Judgement. To see this woman heavy with child, before a mirror, holding a balance against the image of death, resurrection, judgement, heaven and hell, is to accept the duty of Christian souls to speculate on Truth and Judgement.

There is, beneath the table, a curious serpentine form that scholars appear to have overlooked. Certainly, it has not been identified.

The *Woman with a pearl necklace*, now in Berlin, is one of the largest of Vermeer's small, single-figure paintings, having a few centimetres more height than the National Gallery paintings, for example. It is probably the work listed in the 1696 inventory as ''a young lady adorning herself, very beautiful''. Yet despite this and its size it was priced at only 63 guilders, in contrast with the smaller but in many ways similar *Woman holding a balance*.

Even within the restricted range and constant repetitions of Vermeer's pictorial topography, these two most narrowly coincide. Only the *Woman tuning a lute*, in the Metropolitan, New York, which is on the scale of the *Woman with a pearl necklace*, might be compared with them. All three show the window butted against the plain rear wall; the leading, where it is visible, is the clear version of the heraldic pattern seen in the other Berlin painting, the *Glass of wine*. All three have a similar heavy table placed against the window wall, slightly to the fore of the window. Two further similarities are shared by the *Woman with a pearl necklace* and *Woman holding a balance*: the carpet covering the table is rucked back to form an irregular range of ridges and valleys, at once exposing the bare table-top and obscuring the objects on it, and beside the window hangs a similar mirror. Oddly, perhaps, the mirror into which the woman with a pearl necklace is looking is smaller than that in the *Woman holding a balance*. In reproduction the two appear to make a pair not dissimilar to the two in the National Gallery, London. In reality, the difference in size means that they cannot have been intended as pendants in the strict sense. Nevertheless, as they both were, in all probability, bought directly from the artist by his patron, van Ruijven, it may be that the second piece (whichever that might have been) was painted in the knowledge that the two works would remain in the one collection and be seen in a similar light.

Like the *Woman holding a balance*, the *Woman with a pearl necklace* recalls earlier images. Most similar is that of Superbia, the sin of pride. In his table of the Seven Deadly Sins, now in the Prado, Hieronymous Bosch had exemplified Pride by a bour-geois woman admiring herself in a glass held up by a devil, and behind her is an open jewel box. The objects on the table in Vermeer's painting are obscured by shadow and their overlapping contours but, in addition to the large Chinese jar, they include a powder brush and comb. (However, the rectangle rising above the level of the table is not a jewel box, as in the *Woman holding a balance*, but, as the shadow on the wall reveals, the back of a chair.) In a closely allied image, many of Vermeer's contempo-

raries represented a young woman rising from her bed and dressing before a glass to evoke the traditional motif of the goddess of love, Venus, at her toilet. This could be equated with another sin, that of Luxuria or lust. Again, it could be a *vanitas* image, a reflection on the ephemerality of youthful beauty, the brevity of human life and the inevitability of death. But mirrors had many meanings in Netherlandish painting. They could reflect Truth, as it has been claimed for the mirror in the *Woman holding a balance*. It was for this reason that Prudence regards herself in a glass, to know herself more thoroughly. Sight, one of the five senses, also has a looking glass as one of her attributes.

At first sight, the *Woman with a pearl necklace* appears unlikely to exemplify Truth, Prudence or the sense of Sight. Truth should be naked or, at the very least, have a balance, too, as in the Washington painting. Prudence would have a serpent (is the unexplained shadow beneath the table of the Washington painting a serpent?) Sight would be accompanied by the sharp-eyed eagle or, more domestically, a cat. Faced by an image of a young woman adorning herself before a glass without further attributes, a contemporary would recognise the sins of Pride and Lust, or, responding to the beauty of this young woman, would reflect on the brevity of life and the vanity of worldly desires.

To see the painting in this light, however, is to miss its singular distinction. In the tradition of images of vice and folly, the sinner is heedlessly, or even vaingloriously, engaged in, committed to, vain pursuits. It is the viewer alone who stands back and considers the consequences of those blind passions. But Vermeer's young woman stares at her own outward beauty visible to herself alone in the glass, and just as the glass reflects her face so, manifestly, she reflects on it. As in the Rijksmuseum *Letter-reader* and the Washington *Woman holding a balance*, here, too, a simple profile establishes for the viewer a sense both of intimacy and of distance, of individuality and universality. This most abstract of painters, concerned with the appearance of light reflected from surfaces, nevertheless leaves no room for doubt that the young woman appears as she does because the rapid and deft movements with which she had placed the pearls around her throat, movements that reflected her innocent self-satisfaction, have been stilled as more profound and sobering reflections cross her mind. There can be no doubt, that is, if the viewer will contemplate this image as the young woman regards her own. It is an image that leads the mind from vanity to self-knowledge and truth through the sense of sight by physical and mental reflection.

Johannes Vermeer
Woman with a pearl necklace
Canvas, 55 × 45 cm
Gemäldegalerie, Berlin-Dahlem

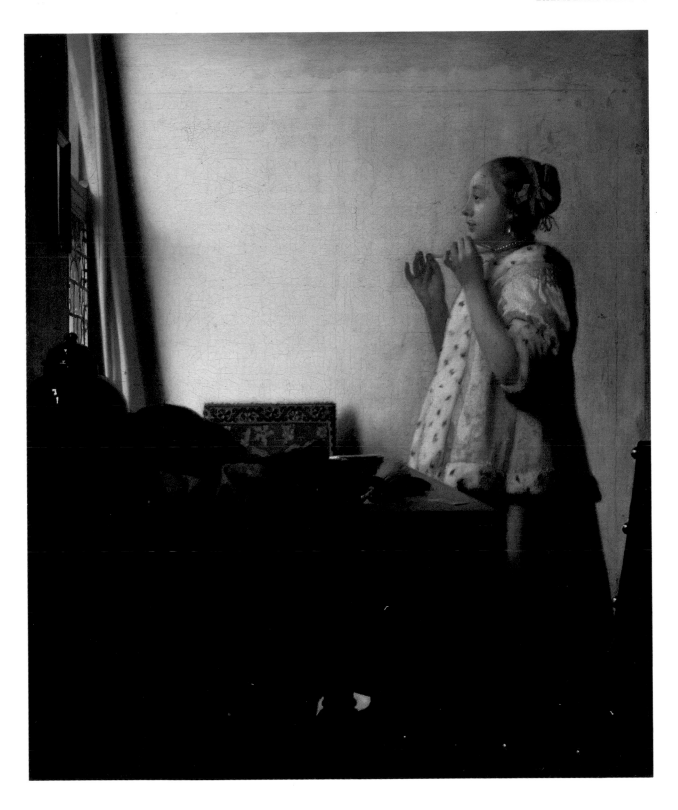

Three Commissioned Works

Among the single-figure compositions three are distinctive: two represent a male figure, and one is a large allegorical piece, and all three were probably commissioned works.

The male-figure pieces are very similar in size, the man and the interior in which he works seem identical in both, and the subjects are complementary: the *Astronomer* and the *Geographer*. Both paintings are signed and dated, the only dated works after the *Procuress*. The *Astronomer* is signed with a monogram and dated MDCLXVIII (1668) on the cupboard door, the *Geographer* has the same monogram rather dimly inscribed on its cupboard door, but also conspicuously on the wall in the upper right corner there is a complete signature with the date MDCLXVIIII (1669). From the earliest record, a Rotterdam sales catalogue of 1713 where they are listed as items 10 and 11, they appear either as pendants or as consecutive items in four further sales, the last in 1797 (though an engraving of the *Astronomer* dated 1784 and published in Paris in the 1790s claimed it was then with a Parisian dealer). Despite all this evidence, some scholars had doubted that these pieces were intended as a pair, simply because the figure faces to the left in both paintings. But the recent discovery that the celestial and terrestrial globes shown in the paintings were published as a pair by Jocodus Hondius in 1600 is a further proof of the kinship of these works.

The nature of the kinship has proved problematic in several ways. Since neither of the pieces appears to have been owned by van Ruijven and they survived as a pair until the end of the eighteenth century it seems probable that not only were they bought from the artist by the same, unidentified collector, but they were commissioned as a pair. Arthur Wheelock has proposed that the works were commissioned by and also portray the inventor of the microscope, Antony van Leeuwenhoek, a citizen of Delft who was praised by an historian of the city as skilled in "navigation, astronomy, mathematics, philosophy, and natural science". Wheelock sees a striking resemblance between the young man in the paintings and a portrait of van Leeuwenhoek made eighteen years later, in 1686. Van Leeuwenhoek was born in the same year as Vermeer and after the latter's death he was appointed curator of the artist's estate. But J. M. Montias finds no evidence in the archives to confirm a friendship between the two men and observes that Vermeer's Catholic widow, Catharina Bolnes, would have been unlikely to have selected as curator van Leeuwenhoek, a member of the Reformed Church, who more likely was imposed on her by the aldermen of Delft. It would nevertheless seem probable that the original purchaser of the pair had an interest in their common theme, and might, indeed, have proposed it.

The two subjects are now identified as an astronomer and a geographer and these titles are clearly apposite. Not only have the globes been identified as a complementary pair, but the book before the astronomer has been recognised as *On the Investigation or Observation of the Stars* by Adriaen Metius. James Welu, who identified the volume (and, indeed, all the maps and the two globes represented in Vermeer's paintings) remarks that this was a basic volume on astronomy and geography.

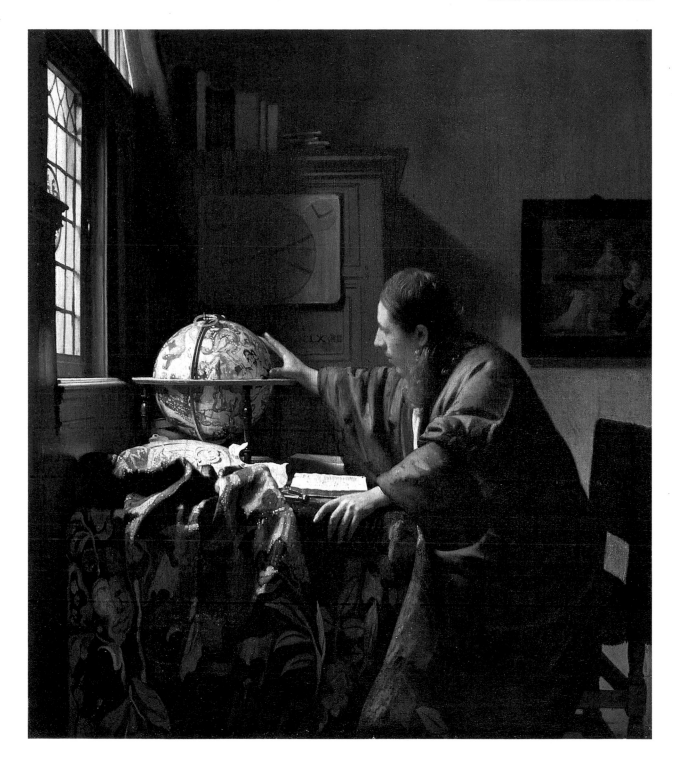

The question has been raised why a painting of the Finding of Moses should be on the wall behind the astronomer, while behind the geographer is simply a sea chart. Wheelock suggests that "the Finding of Moses and his welcome reception prefigured the eventual reception of Christ's ministry by the community of the faithful. This also came to be associated with the guidance of Divine Providence. If, then, the astronomer reaches for the celestial globe, he is in essence reaching for spiritual guidance."

Welu observes that Vermeer's representation of Metius's volume is so detailed that it is possible to identify the opening pages of Book III. On the right-hand page the astronomer could have read: "The first observers and investigators of the situation and course of the stars have been, as history points out, our ancestors the patriarchs who through inspiration from God their Lord and the knowledge of geometry and assistance of mathematical instruments have measured and described for us the firmament and the course of the stars." Welu suggests that the Finding of Moses symbolically reflects the spirit of Metius's acknowledgement. Also, he points out that the Acts of the Apostles (7:22) says, "And Moses was learned in all the wisdom of Egypt . . .", a civilization that has always been linked with the early study of astronomy. If so, this would further harmonize the pair as pendants, for Moses, because of his wanderings and, above all, the journey of the children of Israel to the Promised Land, was recognised as the "oldest geographer".

On the globe that the Astronomer turns to, and also turns, the constellations are represented by their mythological images of the Great Bear, the Dragon, Hercules and Lyra. Not only is he examining it after studying Metius's account of his own recently invented astrolabe – an invaluable modern aid to navigation – which is illustrated on the left-hand page of the opening, but one of Metius's astrolabes lies on the table before him. It is difficult to identify as it lies half-concealed between the rucked-up carpet and the globe. The pair to this celestial globe which is included in the picture of the geographer is put to one side, on the cupboard, while the geographer is busy with a modern map.

That the globe in the *Astronomer* is to be understood allegorically rather than seen as a reliable aid to navigation is supported by its reappearance in the one insistently allegorical painting that Vermeer produced. This is the work now known as the *Allegory of Faith* in the Metropolitan Museum, New York, and is the painting first recorded in a catalogue of paintings, sold on 22 April 1699 in Amsterdam by Herman van Swoll, in which it was item 25, described as "a seated woman with several meanings, representing the New Testament by Vermeer of Delft, vigorously and glowingly painted". It is a large painting of unmistakably symbolic import. A grandly dressed woman sits at an altar-like table on which are a large book, a chalice and a crucifix, while behind her is an immense painting of the Crucifixion. She rests one foot on that terrestrial globe already noted in the *Geographer* and she, the altar and the globe are raised on a low, carpet-covered dais. On the actual and familiar tiled floor of the room are a bitten apple, recalling that eaten by Adam and Eve, and, at the front of the scene, a serpent crushed under a stone so that blood flows from its open jaws. Suspended from the rafters is a crystal globe that reflects the interior of the room. In all this, Vermeer has followed with some fidelity the programme for the representation of Faith set out in the 1644 Dutch translation of Cesare Ripa's *Iconologia*.

She does not actually hold the chalice or rest a hand on the book, as in Ripa, nor does she wear a crimson outer garment or a laurel wreath. The corner-stone (Christ) that crushes the serpent (Sin) does not support the book. Nor is Death with his arrows broken to be seen beside the serpent and beneath the stone. And instead of a crown of thorns hanging on a nail on the wall behind Faith and a distant image of Abraham

Johannes Vermeer
The geographer
Canvas, 53 × 46.6 cm
Städelsches Kunstinstitut,
Frankfurt/Artothek

106

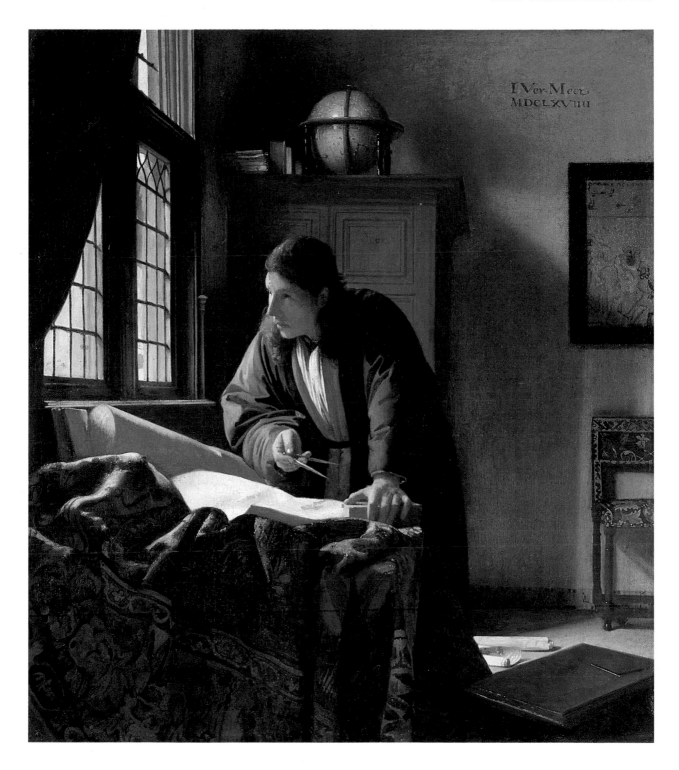

about to sacrifice Isaac, which would in different modes symbolize the Crucifixion, there is a painting of the Crucifixion itself. It has also been suggested that Faith's gesture and white dress are derived from another description in Ripa, that of the Catholic or universal Faith. The glass sphere, it has been suggested, is taken from an emblem book of 1636, Willem Hesius's *Emblemata Sacra de Fide, Spe, Charitate* (Sacred Emblems of Faith, Hope and Love) in which the sphere is described as representing the human mind. Just as the small sphere can reflect the entire universe, so can the human mind, despite its limits, contain the vastness of the belief in God.

Recent historians have been cool about this work. It has been seen as a tired, late work, and almost certainly a commission that Vermeer mistakenly undertook because of his conversion to the Catholic faith. His temperament was not suited to allegory, which he set in a Dutch living room.

It *is* an odd, unconvincing work. But its genuine weakness lies in the execution of the figure of Faith herself. It is not simply that the conventional gesture, imposed by Ripa's *Iconologia*, is unconvincing: the pious mingling of grief and hope represented by uplifted eyes is not less stereotyped. But the entire figure is unconvincingly painted in a material way. The articulation of Faith's left leg is incomprehensible. Most striking and quite out of character is the curiously dark tonality and contours of the area of gown that extends over Faith's right thigh and into her lap. It appears far too dark for its position and for consistency with other areas of the gown. It might almost be taken for a sort of apron or other cloth draped over that thigh: there is the suggestion of an edge or border both along the line that falls from under the right hip towards the left knee and also in the lighter fold that runs between the knees. But at the crest of the right knee there is no trace of an edge or overlap of fabrics. It is as if the entire figure had been abandoned in an unresolved state.

There is a consensus among contemporary scholars that the work was probably commissioned by the Jesuit Fathers who lived only a few doors away from Vermeer. Yet van Swoll, in whose collection the painting is first recorded, was a Protestant.

Johannes Vermeer
Allegory of Faith
Canvas, 114.3 × 88.9 cm
Metropolitan Museum of art,
New York (bequest of Michael
Friedsam, 1931)

The Lace-maker

The *Lace-maker*, in the Louvre, is the smallest and most jewel-like of Vermeer's paintings. It is also the most enigmatic. Into its small dimensions are crammed not only the lace-maker herself with her elaborate coiffure and her own lace collar and the lace she is actually making, there is also the wooden frame or working table that supports her work and another table covered in a rich Turkey carpet on which is a sewing cushion and a small book. And all these objects are represented not only with meticulous precision but also with an obliquity that exceeds the most obscure of Vermeer's other inventions. It has been suggested that some of the oddity of the painting derives from Vermeer's use of the *camera obscura* and no doubt some of the features he has developed here were suggested to him by a study of the optical features to be observed in the images produced by the *camera*. But here the devices are developed more extravagantly than anywhere else in his work and, also, the principal characteristic is not necessarily a consequence of studying optical images.

The optical features are, indeed, striking. There is the sharp contrast between the two sharply defined threads the lace-maker is actually manipulating and the broad vagueness of the threads falling out of the sewing cushion in the foreground, for example. There are the circular dabs that establish highlights in various parts of the picture, both in the foreground and on the girl's collar, that have been said to correspond with the discs of confusion produced in out-of-focus optical images. But perhaps the most distinctive effect of the optical imagery is to make the objects and activity represented hard to perceive or elusive to the eye.

The elusiveness of representation is more than the use of out-of-focus effects or the represention of the complex form of each of the bobbins beneath the lace-maker's right hand by two or three dabs of paint in a manner suggested by the *camera*. The form of every object is presented from an oblique, unfamiliar angle. This is least apparent in the presentation of the lace-maker herself. She may seem, at first sight, and to a culture educated in photographic images, a simple uncomplicated image. But a comparison with Caspar Netscher's conventional profile representation of the same subject in the Wallace Collection, London, will draw attention to the foreshortening of her skull that emphasizes the full depth of the coiffure, itself represented in a subtle balance of fine detail and broad, suggestive brushwork, and reduces her features to a crescent in the lower quarter of the area. There is no clear articulation of either head or right arm to the torso and the left hand is a dislocated pattern of light and shade. Nevertheless, the lace-maker is undoubtedly recognisable. But what is the shape of the work-table she uses? This is most obscure today when such pieces are not in use. The rectangular column topped by a knob is not, as it appears at first sight, a leg on the corner of the table but a centrally placed column a little distance in front of the work surface behind which the lace-maker sits. The sharply defined central seam in the lace-maker's bodice, the similar central join in the clearly lit work surface, and the column are in a single line at right angles to the visible front face of the work-table. The box-like work-table is supported by a projecting flat, narrow bar the rounded end of which fits

Johannes Vermeer
The lace-maker
Canvas applied on wood,
24 × 21 cm
Louvre, Paris

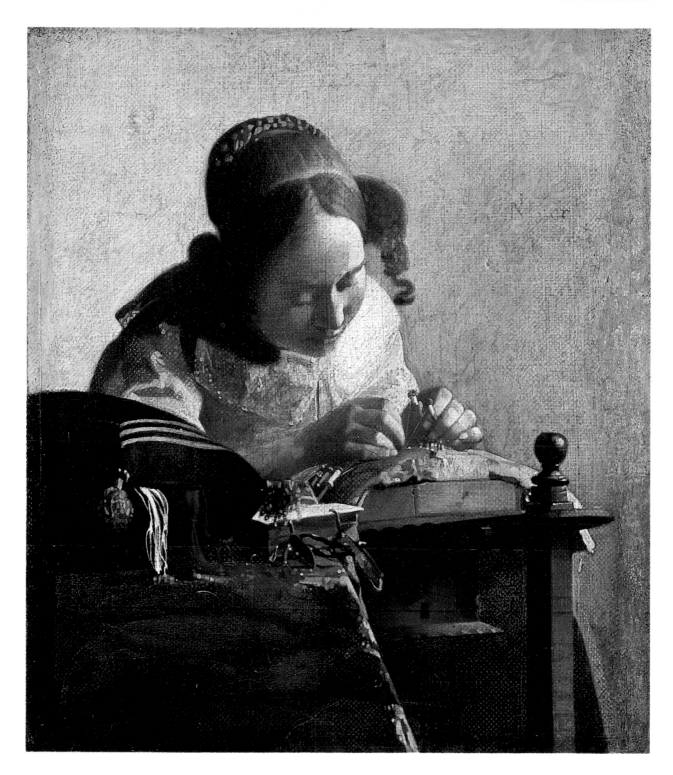

Caspar Netscher
The lace-maker
Canvas, 34 × 28 cm
Wallace Collection, London

over the column and is held at a convenient height by a just visible peg fitted into the highest of a series of holes drilled into the shadowed side of the column. This complex structure is difficult to discern because the illuminated front surface of the work-table and the shadowed bar projecting centrally at right angles to it are reduced by perspective until they almost merge into a single band. Nonetheless, the foreshortened upper edge of the bar does rise very slightly to occlude the right end of the scalloping on the lower edge of the work-table.

This curious pictorial invention may have been suggested to Vermeer by his study of images in his *camera obscura*. It is, nevertheless, remarkably similar to certain of Rembrandt's inventions. The depiction of the table and the objects on it at the left of the work table is no less idiosyncratic. The receding horizontal edge of the table and the descending fold of the cloth hanging over its corner meet at the slightest of oblique angles, which is another ambiguity not dependent on the *camera obscura*. More dependent on essentially optical obscurities is the small book with the pale yellow binding. This is closed by tapes knotted in two bows that dissolve into a blur of shimmering patches concealing the edge of its lower cover while its upper cover is half hidden by a fuzz of darkness that is one of the tassels on the needlework box. This box is a square-based, rectangular wooden box encased, above and below, in padding to have the appearance of a square cushion with a tassel at each corner. Again, the essential structure of the box is rendered most obliquely. The bulbous silhouette is revealed to have a basic rectangular character only by the three chevrons of light and dark that we must recognise as lit and shadowed sections of three pale squares, probably of braid, that decorate the upper face of the cushioned box. The square opening of the box is reduced, here, to a single almost horizontal gap, from which spill white and scarlet skeins of thread. These threads do seem to spill. They are not merely blurred and out-of-focus by contrast with the fine lines of the threads being worked. They have a fluid quality. The paint defining them has a still liquid character. The red thread is a *tour de force* of painting. It might have been poured on to the horizontally laid canvas from a fine nozzle rather than applied by any brush. If optical images did suggest the

mode by which these threads are depicted, it can only have been because Vermeer recognised in them some metaphoric or figurative force that appealed to him.

But what can this be? What significance does this image hold? It is, unmistakably, an image of application, an image of care and skill. The viewer is not shown the results of this craft, the achievement, only the intensity of the worker. In this it is one with the other single-figure works. And not only does the image offer an exemplary figure: it is itself exemplary. It demands of its viewer something of the attention that the worker gives to her task. Even the apparent lucidity of the image is not simply offered to view but is to be arrived at through concentration. Each mark and pictorial contrivance only reveals its true identity after close scrutiny and in the light of its place within the whole configuration. This is true of every small detail, but nowhere is it more striking than in the representation of the work-table. The very structure of the painting is transformed by the perception of the knob-topped column as not being to one corner of the work-table but as projecting beyond its front.

So much is clear. But the question, what made the image of a lace-maker so appropriate to this concern, is not so readily answered. Would not any similar task demanding concentration, skill and concern have done? In short, what traditional image might lie behind this specific one? And what images of a lace-maker are contemporary with this?

Embroidery was, traditionally, the occupation shown in representations of the Education of the Virgin. In seventeenth-century Dutch paintings, it appears to represent the occupation of the virtuous young woman, a virgin, presumably. It is lace-making or embroidery that is put to one side when a love letter arrives, as has been seen in the pictures of love letters by Metsu and Vermeer. In the well-known painting of a young lace-maker by Caspar Netscher in the Wallace Collection, the young woman wearing simple, even poor, clothes and shown clearly in profile against a wall is surrounded by a curious array of objects. The broom, the discarded shoes that are not, it seems, her own and the mussel shells are more familiar in brothel scenes. The shellfish are provokers of lust, the shoes are those cast off before lovers get into bed and the broom is that used by the whore to beat out the Prodigal Sons once their inheritances are spent. In the case of Netscher's lace-maker, it seems that virtue may be under threat. But may any of this apply to Vermeer's diligent young woman?

Her diligence preserves her virtue: of that there is little doubt. Within easy reach of her right hand lies a book which is, surely, the Book, the Bible. But what is the work box doing there, so prominently placed; why should those threads of white and scarlet spill from it so copiously? The work box was known in Vermeer's day as *naaikussen* which is, literally, a needle cushion. But *naaien* means, vulgarly and metaphorically, to copulate, and though the noun *kussen* means cushion, the verb *kussen* means to kiss. The threads that gush from the gape in this swollen *naaikussen* evoke the blood red and milk white spilling from the womb that precede the birth of a child.

The London Pendants

The paintings of a *Woman standing at the virginals* and a *Woman seated at the virginals* in the National Gallery, London, are virtually identical in size but scholars are uncertain whether they are to be seen as a pair. In particular, it has been questioned whether such similar subjects would have been intended to be hung together. One scholar settled the matter by dating the works four years apart and claiming that while the *Woman standing at the virginals* was "one of the master's finest works", the *Woman seated at the virginals*, which he said was painted in the year of the artist's death, "shows a noticeable decline in Vermeer's powers".

It is true that the pieces appear to have led separate existences until the nineteenth century. One may have been in the van Ruijven collection, being that listed as item 37, "a young woman playing the clavecin". The other could, possibly, have been that sold in Antwerp on 12 July 1682 from the collection of the late Diego Duarte, a jeweller and banker: item 182, "a piece with a lady playing the clavecin with accessories by Vermeer . . .". They were brought together only in 1867, when Thoré bought the *Woman seated at the virginals* from the Pommersfelden collection, where it had been for over a century, to join the *Woman standing at the virginals* that he already owned. It was of the *Woman standing at the virginals* that Thoré wrote: "Often in Vermeer, as in Jan Steen, the accessories, and especially the pictures on the wall, are very significant. In a *Sick lady* by Jan Steen, one sees over the bed the Abduction of the Sabines – fortunate Sabines to be abducted by those strong Romans! thinks the love-sick beauty, no doubt. In the *Weigher of pearls* by Vermeer, the picture in the background represents the Last Judgement: Ah! so you are weighing jewels? You will be weighed and judged in your turn! In my own *Young woman at the clavecin*, the head is set against a picture showing Cupid who runs forward with a letter in his hand. – Love runs in her head. – Indeed he is on his way bringing her a love letter. Unaffectedly anxious, she hopes, she improvises on the piano, awaiting the arrival of love."

"All this without resorting to emblems. Beware, nevertheless, of Gérard de Lairesse and his mythological epics which are close at hand. This naked Love, with his bow used as a walking cane, could well be by de Lairesse. Happily, with Vermeer, one only discovers these small allegorical niceties after one has understood everything simply from the expressions of the personages." The works were separated again in 1892, following Thoré's death, and it was not until 1910 that they were permanently reunited.

The two pieces clearly have much in common. The two women appear to be quite different but they wear similar costumes of the 1670s, the seated player wearing an additional overskirt. The instruments might be identical except for the landscapes painted on their raised lids. Then, the room in which they play is the same room but with the window covered in the one case. This last point, though, is curious. As has already been noticed, though it would seem that Vermeer used the same interior for many of his paintings, he did not hesitate to modify what might have been thought to have been permanent features. Both National Gallery paintings have floor tiles and a

Johannes Vermeer
Young woman seated at a virginals
Canvas, 51.5 × 45.5 cm
National Gallery, London

114

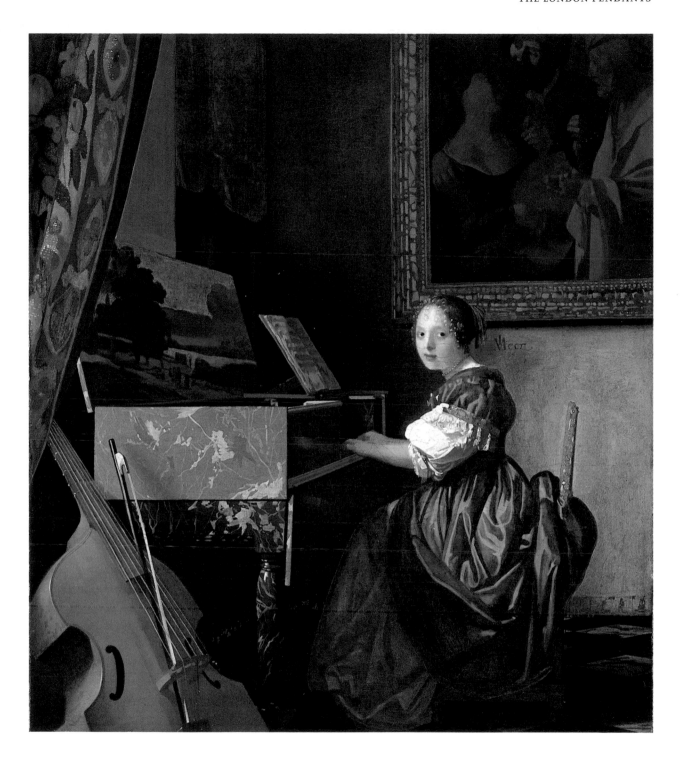

skirting of Delft tiles like those in the Beit *Letter-writer* but the pattern of leading in the window is that seen in the much earlier Frick *Soldier and laughing girl*. In similar cases, already discussed, Vermeer seems not have hesitated to alter the relation of windows to rear wall. What, then, is the significance in the case of the *Woman seated at the virginals* of the window being curtained rather than simply eliminated? Was it to establish a final point of continuity and contrast between the two works?

The similarities and differences in imagery between the works have often been discussed. It is not surprising to discover that two contrasting prototypes exist. Both Mary Magdalene and St Cecilia have been represented at the keyboard, though the latter usually plays a portative organ.

It is apparent that the National Gallery paintings are linked by the theme of music and that of love. Love, as is well known, teaches music. Behind the standing woman is a picture of the god of love, Cupid, painted in the manner of Cesar van Everdingen, which could be the painting of Cupid listed in the inventory following Vermeer's death ''above in the back room''. Cupid holds up what appears to be a playing card and this, though blank, has been interpreted by scholars as intended to represent an ace (of hearts, possibly) and thus symbolize the virtue of singleness of heart. This has been contrasted with the presence, behind the seated player, of van Baburen's *Procuress* which suggests she represents mercenary love. Whether it is appropriate to see the paintings on the wall as reflecting so directly on the characters of the two players has been questioned, though Leonard Slatkes has pointed out that ''upright'' carries the same moral overtones in Dutch as it does in English.

Whether the two paintings were intended as pendants and, if so, whether they were meant to be seen as contraries is not documented, of course. Good fortune rather than design appears to have brought them together in the National Gallery. But seen together, there can be little argument that they do appear as contraries. There is the obvious contrast in pose between standing and sitting. There is the contrast in orientation and the position of the instrument, so that the players face in opposite directions: it is this that makes this pair more apparently pendants than the paintings of the *Astronomer* and *Geographer*. There is the difference that the standing player has before her an empty chair while the seated player has by her instrument a bass viol, its bow held between its strings, ready for someone to join her in a duet. The seated woman plays from a score while the standing woman plays by heart.

Then again, the two women are set in very different relationship to the picture on the wall behind them. The standing player's head is virtually enclosed by the black frame linking her with the figure of Cupid, drawing attention to their shared upright stance, that each is alone at the centre of their individual picture, each directly meeting the eye of the viewer. The woman stands in close relationship to the painted Cupid behind her. The relation of the seated player to van Baburen's *Procuress* is far less striking or obvious. The painting hangs above and behind her, hardly more than a dimly visible decorative furnishing. It is noticeable, though, that the proportions of the *Procuress* are different from the version included in the Boston *Concert*, so ensuring that all three characters in the van Baburen are included and identifiable. Then again, the features of gallant and procuress are discernible while the face of the grinning whore is reduced to little more than a pale patch above the head of the seated player. Does the painting hover thus over her head like an image of her thoughts as she stares inscrutably into the eyes of the viewer?

The two paintings have curiously contrasting perspective systems. While the receding parallels of window-frame, wall and virginals all converge over the heart of the standing player, the lines of the instrument played by the seated woman converge at a

Johannes Vermeer
Young woman standing at a virginals
Canvas, 51.7 × 45.2 cm
National Gallery, London

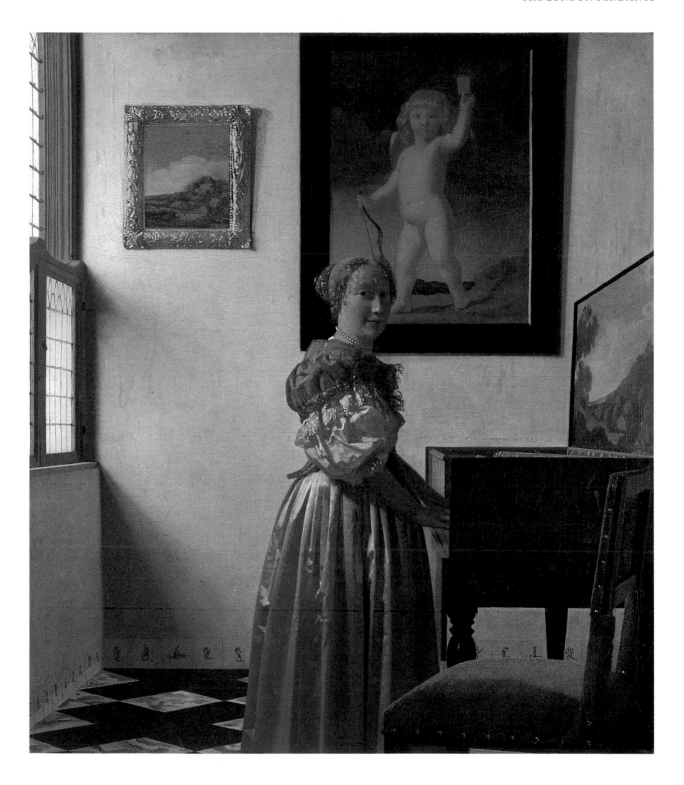

point over the back of her chair.

Above all, the lighting of the two pieces is in total contrast. Daylight floods through the window within the painting of the standing player, establishing a luminous and lucid image of clear contrasts into which the viewer may look from the shadows. But the seated player sits within a shadowy depth, revealed by the withdrawing of a curtain that allows light to enter the picture from the space of the viewer. It may be to emphasize the significance of this contrast that the window has been retained but covered by a blind in the painting of the seated player.

The significance of the contrast between these paintings does not lie in a conceit to be uncovered by interpretation. It is something to be discovered through long contemplation in the mood of contemplative revery in which one might listen to two contrasting pieces of chamber music. After an extended and concentrated exploration of the *Woman standing at the virginals*, what is the experience of turning to the *Woman seated at the virginals*? Is it not to discover that every proportion, harmony and tone is countered, contrasted, inverted? Is it not to discover that every term that might define a quality of the one must be abandoned for its converse in the other?

If the figures of St Cecilia and the Magdalene come to mind before this pair of images, it is well to remember that while St Cecilia was chaste (converting her bridegroom to celibacy and Christianity) and the Magdalene was a whore, the latter, too, was sanctified after repentance.

The Art of Painting

On the 24 February 1676, a little over two months after Vermeer's death, his widow, "Juffr. Catharina Bollenes, widow of the late Sr. Johan van der Meer living in Delft" appeared before a notary to declare that "she hereby ceded in full and free property, both for herself and in her capacity as widow and trustee, and also as guardian of her children, procreated by the aforementioned Vermeer, her late husband, to her mother Juffr. Maria Tins, widow of the late Reynier Bollenes, a painting done by her aforementioned late husband, in which is depicted The Art of Painting [*de Schilder-konst*]". This, with other forfeitures, was, she said, to reduce her debts to her mother. The following year, on 12 March 1677, Maria Thins attempted to prevent Anthony van Leeuwenhoek, the curator of Vermeer's estate, from auctioning the *Art of Painting*, which he appears to have seized in part-settlement of debts owed by the estate. The outcome is not recorded.

The painting that provoked these exchanges was undoubtedly the great painting now in the Kunsthistorisches Museum, Vienna. It is little wonder that it attracted litigation after the artist's death. It is a work of the highest ambition and excellent achievement. It celebrates painting as an art in the most artful of paintings. It is a work of amazing intellectual and pictorial complexity and refinement.

Initially, it shows a painter in his studio working from the living model. To one with knowledge of Vermeer's work, the setting, at first, is familiar. There is the floor of white and black marble square tiles, the black set to form crosses, as in the Rijksmuseum *Love letter*, the Beit *Lady writing a letter with a maid* and the London National Gallery pair. The beamed ceiling may be seen in the *Music lesson*, in the British Royal Collection. The table recalls the table in the Washington *Woman holding a balance*, the Berlin *Woman with a pearl necklace* and the Boston *Concert*. The plain, pale, rear wall hung with a map of the Netherlands is also familiar, though this particular map does not appear in other works. The chairs sport red fringes not seen elsewhere in Vermeer's work. The deep folds of the tapestry curtain make it difficult to identify. But these are the cunning departures from the literal typical of Vermeer's art. Only the chandelier is novel (though it was a currently fashionable type, with similar pieces appearing in contemporary paintings by ter Borch and de Witte, among others). But this is not another exemplary image from contemporary life.

The artist in his studio was a popular theme among Vermeer's contemporaries, and many variations had been made on it. Adriaen van Ostade, in a painting in Dresden, presents a scene that in its slovenly clutter would, in the following century, become recognisable as the quintessence of the picturesque. The studio must once have been a mansion, now decaying into the condition of a barn. The walls and floor are littered with the apparatus of art, including among the detritus of papers and paints a horse's skull and a lay figure. In the shadowy depths of the interior, an apprentice laboriously grinds the day's fresh colours on a stone slab. The artist is something of a comic figure. Ostade, by giving a view over his shoulder at the painting on his easel, condescends.

He, Ostade, paints not simply as well as his fictional painter, he is his superior, embracing that achievement easily within his own.

Ostade's painting is one among many that show the painter's life as one of constant, comic muddle, or, more popular among Vermeer's more refined contemporaries such as Frans van Mieris, as one of elegance and skilful performances, on the canvas and among the ladies. Vermeer's artist has nothing in common with any of this. The most telling comparison and contrast with his image is that painted perhaps forty years earlier by the young Rembrandt and now in the Museum of Fine Arts, Boston. This shows a solitary young painter (who has been variously identified as Rembrandt himself or as his then pupil, Gerard Dou, but this is as irrelevant as the claim that Vermeer's painting, too, includes a self-portrait). The door is bolted and the slab for grinding colours rests unused on a table, as if to emphasize the artist's isolation. He is not actually painting, but standing back to study his invention, an invention that (like the thoughts of *Bathsheba*, for example) the viewer can only imagine. Whatever it is that he is inventing, his ambition is grand, his panel large. It dominates the bare studio. But Rembrandt's actual panel, in the Boston museum, is no more than 25.1 × 31.9 cm. Like the mind, its size does not restrict its universal grasp. The panel might be an analogue for the glass sphere in Vermeer's *Allegory of Faith*.

The mystery of Vermeer's painting does not depend upon obscurity. A young woman stands to pose in the light of the studio window: the painter studies her and paints. (He does not, incidentally, skulk concealed within the tent of a *camera obscura*.) Over the painter's shoulder, the viewer may study what, and how skilfully, he paints. But he has scarcely begun. All the viewer can assume is that for so consummate a painter as Vermeer to represent this artist means that his work will, when he has completed it, rival if not excel the work that celebrates him. In this, it is in contrast to Ostade's painting but not dissimilar to the Rembrandt in inviting the viewer's sympathetic imaginative collaboration.

Rembrandt van Rijn
An artist in his studio
Panel, 24.8 × 31.7 cm
Museum of Fine Arts, Boston
(Zoë Oliver Sherman collection, given in memory of Lillie Oliver Poor)

Johannes Vermeer
The Art of Painting
Canvas, 120 × 100 cm
Kunsthistorisches Museum, Vienna

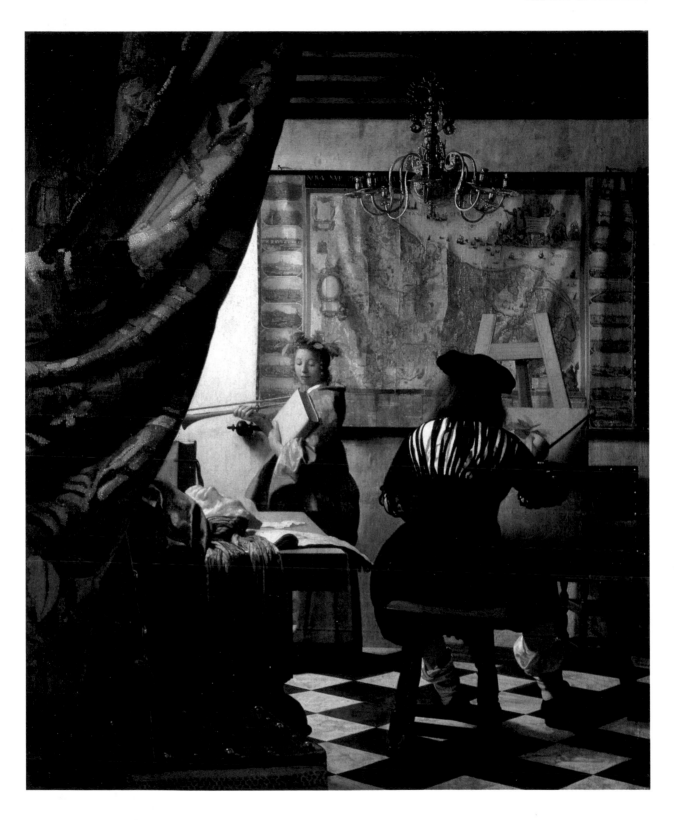

THE ART OF PAINTING

Johannes Vermeer
The Art of Painting (detail)
Kunsthistorisches Museum,
Vienna
(Reproduced in full on p.121)

Vermeer's painter has, so far, painted nothing but the laurel wreath worn by his model (the curious blue, like that of the wreath she wears, is, very probably, the result of time and paint chemistry). She wears a wreath because she is costumed as the Muse Clio, the Muse of History, who, according (once again) to Cesare Ripa, carries a book, a trumpet and a laurel crown. The book, that may be by Herodotus or by Thucydides, represents the art of History. The trumpet signifies Fame. The laurel crown may signify the victor, but a grove of laurels grows on the mountain of Parnassus, home of Apollo and the Muses, and a laurel crown is bestowed on the worthy poet or painter.

On the table behind the painter are a solidly bound book standing upright, a plaster cast of a sculpted head and a slimmer manuscript book, among a familiar tumbled tapestry and silkier draperies. The manuscript has been identified both as containing architectural drawings and as a music manuscript. In its present condition, which cannot be decided. These objects have been interpreted as the attributes of three of Clio's sister Muses. The manuscript score is that of Euterpe, Muse of Music and lyric poetry, the plaster cast is the mask of Thalia, Muse of Comedy (though it could equally be that of Melpomene, Muse of Tragedy – it is, anyway, curiously unmask-like) and the book that of Polyhymnia, the Muse of Heroic Hymns, though only Clio has a book as her regular attribute. More credibly, the three objects represent the other arts of sculpture, poetry and music.

On the wall behind the model is an identified map of the Netherlands, published by Nicolaes Visscher, known as Piscator. Its inscription, partly obscured by the chandelier, runs: NOVA XVII. PROV[IN]CIARUM [GERMANIAE INF]ERI[O]RIS DESCRIPTIO ET ACCURATA EARUNDEM DE NO[VO] EM[EN]D[ATA] . . . REC[TISS]IME EDIT[A P]ER NICOLAUM PISCATOREM. A distinctive feature of the map is that it records the Netherlands as they were before the wars and the Treaty of 1648 that definitively separated them into the Spanish South and the United Provinces of the independent North. But by a deep crease in the map, accentuated by the light, that division is, nevertheless, made salient.

Over and against the map is hung a chandelier. Despite its similarity to other chandeliers then fashionable in other paintings, it is made quite distinctive by the curious silhouette of its upper portion. Recently, this has been interpreted as an image of the phoenix, to be understood as an image of a resurrected and reunited Netherlands. But, though not indisputable, the resemblance to the double-headed eagle of the Hapsburgs, often noted, is more convincing.

Then, into this complex of conceits, each and all of which may be imagined as the contrivance of the painter, is introduced what, at first encounter, might seem to be the ultimate conceit: the painter himself is in costume. The curious slashed sleeves and bodice of the jacket, the baggy breeches, the hose, the floppy beret derive from a notion of sixteenth-century Germanic costume, owing much, it would seem, to contemporary theatre. This artist is an actor.

The question that must strike any visitor to the Kunsthistorisches Museum is: how does a picture founded upon fantastical conceits so take the breath away when the approximately similar painting of the *Allegory of Faith* so signally fails to convince?

There is, primarily, the superb craftsmanship with which the painting is contrived. How did an artist who painted so few works arrive at this mastery of his craft? The paint is applied with effortless control. And its application is so various. It is, overall, applied as if invisibly. Touch, the evidence of the master's hand, is not the hallmark of Vermeer's craft. Yet the white lead paint that establishes the glowing reflections on the arms of the chandelier and the studs on the preposterously uncomfortable foreground chair itself stands proud in metallic bands and studs.

Then there is the cunning of the composition, an achievement that defies descrip-

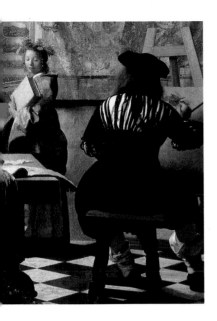

Johannes Vermeer
The Art of Painting (detail)
Kunsthistorisches Museum,
Vienna
(Reproduced in full on p.121)

tion. It is a virtuoso feat of perspective composition that appears as flawless naturalism and yet engages every feature of the scene into a dense pictorial structure. All the effects derive from the complex patterns generated by the perspectives of the tiled floor. This is the ground on which the relation between artist and model is founded, both literally and metaphorically. Literally, the tiling establishes precisely their distance apart. The hem of the model's gown is only a little further from the artist's left toe than his stool is from the easel; the appropriate distance, possibly, for the painting of a life-size, half-length image. Yet their separateness is more evident than their proximity, a perception provoked by a more figurative function of the tile pattern, and a product of the chosen angle of perspective. The actual geometrical vanishing point of the perspective does not fall over any obviously significant feature. (It is on the blank wall a little below the prominent bulb of the finial on the map's roller bar, about level with the model's left wrist and the point at which the artist's brush emerges above his shoulder.) Though similar tile patterns occur in nine other paintings by Vermeer, only in the Boston *Concert* is the identical pattern used to comparable effect. But in the *Concert*, a vanishing-point placed well to the left, immediately above the bridge of the violin on the table and below the left corner of the landscape picture-frame, and the deep shadow cast over the tiles by the table, also the angle at which the double bass is lying across them, all combine to give emphasis to the diagonal perspectives established by the black crosses, diagonals that, as it were, embrace and unite the trio. In the *Art of Painting*, an apparently trivial shift in the vanishing point and the placing of the table generates a perspective for the black floor tiles that allows the viewer to perceive them either as a train of crosses laid diagonally across the floor and receding to right and to left, or as St Andrew's crosses or multiplication signs receding from foreground to rear wall. The equilibrium of these alternatives is disturbed in favour of the latter by a number of small features. In the *Concert*, the diagonals formed by the arms of the crosses are supplemented by the diagonal established by the three clearly visible crosses that leads from the bottom right corner, beneath the gallant's chair, to the clavichord player. By contrast, in the *Art of Painting*, the visible area of the floor is dominated by just two almost completely visible crosses, and the alternative to the diagonals formed by their arms that they offer leads from front to back of the space in a unmistakable orthogonal to the picture plane. This, and the setting of two corners of the foremost square equidistant from the bottom edge of the canvas coerce them into the aspect of the St Andrew's cross. More distantly and generally, the beams of the ceiling and the heavily accented roller bars of the map, top and bottom, give emphasis to a horizontal, lateral axis, against diagonal forces. Even the mass of the table appears firmly aligned with transverse rather than diagonal directions.

Within this set of directional forces the painter is established. His stool is set on the nearest cross, his feet and easel on the two further, and only other fully recognisable, crosses within the picture space. His archaic costume may be seen as a transformation of the rectilinear geometry of the floor tiles into an ample, convex mode, topped by the deliquescent diamond tile of his black beret. It is the stool that mediates this transformation, combining the rectilinear with the curved, the horizontal with the vertical. The horizontal cross bars and the seat are square, the rising, not quite vertical, legs are bulbous.

While the legs and cross bars play a basic part in this mediation, the emphatic line of the stool's seat is given the crucial role in the complex integration of plane and depth. By its visibility, isolated as it is among blacks and shadows, the lit edge of the seat draws the eye to its characteristic angle which is neither on the diagonal of the floor tiles, nor is it parallel with the rear wall, as almost every other object except the

foreground chair is. But it is, practically enough, set at the angle of the easel and, thus, of the essential canvas within the canvas. It is not obvious that the canvas is set at a shallow angle to the rear wall. On the contrary, the two visible edges of the canvas are knit into the horizontal and vertical. The top of the canvas looks parallel with the lower, inner border of the map, and the vertical edge is directly in the vertical linking the border of the map with the front right leg of the chair against the wall. That canvas and easel are set at an oblique angle is not readily discernible from the visible portions of the easel itself. One front leg is concealed behind the legs of the painter's stool, the other is in shadow and the rear leg is almost hidden by the painter's right leg. The only firm evidence of its precise angle is given by the low horizontal bar connecting the front legs, and this is largely in shadow and inconspicuous. This bar not only establishes that the easel is at an angle between that of the rear wall and the diagonals of the tiles, it modulates between them. To the left, glimpsed beneath the arch of the stool, it conceals and takes over the line where wall and floor meet and on the right its descent from that horizontal appears to be continued beyond the easel leg by a triangle of black tile. Once this is noticed, other, extraordinarily tight, pictorial rhymes at this juncture become insistent. Not only do the legs of the stool cover one leg of the easel, they extend its line downwards. The vertical edge of the map, on the right, emphasized by deep shadow, is continued downwards by the line of the chairback and rear leg and, continued further, meets the other front foot of the easel. If the diagonals of the easel's legs are continued upwards to complete a triangle, the apex will be on the top bar of the map, immediately to the right of the right-most candle-holder on the chandelier. These are not merely accomplished examples of current compositional devices. They are further inflections of the transformations initiated by the ambiguous foreshortening of the black marble crosses. Between the vertical frontality of the rear wall, with which map and chair are aligned, and the horizontality of the floor, with its vertiginous alternatives of direction, are poised the planes of stool-seat and canvas, precisely aligned neither with wall nor floor but only with each other. This is where the painter practices his art. His shoulders, bearing the ultimate variation on the theme of black and white diapering, and his working hand are themselves painted on the canvas on which he rehearses the act of painting.

But if the painting of the painter exemplifies the art of painting, what of his model? Her career has scarcely begun. She stands, as she must for an incalculable future, aloof both from painter and viewer. Her remoteness, too, is an effect of perspective, generated by the tiled floor. She stands apart from the energetic criss-cross pattern of black tiles on which painter is based, beyond the line of white tiles that runs across the width of the picture, parallel with the wall. From the viewer's perspective, a path of white tiles, like stepping stones, leads directly to her feet, but they run beneath the solid obstacle of the table-top. The function of the perspective is, rather, to give extension to the vertical that sustains her pose. It is a vertical that has its origin at the point where the curtain meets the top edge of the picture. It becomes visible as the descending border of the map is continued in the line of her nose, reappears briefly between her chin and her book and makes its last appearance as the far corner of the table. But then the baroque swellings of her robe are directed into a broad flow of vertical movements created by falling draperies on either side of the bulbous table-leg. The single, evident vertical established at the farthest plane in the painting by the map's border above the model is replaced below the level of the table-top by a variety of vertical objects that, from the edge of the foreground chair to the folds of the model's skirt, are ranged through the depth of the interior and are clustered into a pictorial unity by perspective alone. It is perspective, too, that aligns the broad decorative border to the model's skirt

with the square panel of the table-leg and so establishes a solid horizontal base that with the massive, shadowed edge of the table-top locks the fall of verticals into a visual plinth on which the model is based. And it is to this pictorial base built from materially vertical objects that the perspective of white tiles runs. It runs back and it runs up. If the vanishing point had been placed over the model's heart, as in the *Woman standing at the virginals*, the tiles would have become a symmetrical zigzag of diamonds so dominant that it would have refused a horizontal role but insisted on adhering to the vertical.

Colour, too, separates artist and model. She is all azure and gold, the colours of the heavens, of light, and is turned towards the light that floods from the unseen window, which is at right angles to the rear wall. But his bold black and white spread against the rear wall is bound there by the black map-bars and by the sudden scarlet of his stockings repeated in the tip of his maulstick, on the map and in the tassels of the chair.

The two are held together, oddly, by the band of black tiles on which she stands, a band extended visually from the leg of the painter's stool, through the broad border on her skirt to the decorative square on the table-leg. Higher, they are also firmly bound by the horizontal of the black map-bar. The void between tiles and map-bar is bridged, though only to the viewer's eye, by a limb of paper that, curiously, appears projected from the model's space to brush the soft convexity of his breeches.

Beyond all this, beyond its craftsmanship, beyond its conceits of image and structure, it is through its power as painting that the *Art of Painting* transcends the fustian of its allegory, the illusionist virtuosity of its composition. This power is not simply the technical virtuosity seen and admired among the *fijnschilders*. It is an achievement as fine and subtle as the space and light it creates so magically. How it was done, only Vermeer himself could have told.

What he has done is breathtaking and it is breathtaking because the painting is so large. It is not simply that he has sustained and even extended the mastery he had first perfected in such cabinet pictures as the Rijksmuseum *Woman in blue reading a letter* on a canvas larger than anything he had painted since the *Procuress* (even the *View of Delft* is fractionally smaller). It is as if he had returned to his early ambition to paint life-sized figures. It is something he had not essayed since painting the Dresden *Young woman reading a letter at an open window*. Like that Dresden painting, these figures are not actually life-sized. But they appear life-sized. By virtue of its scale, the *Art of Painting* has a quality quite alien to traditional cabinet pictures. By the quality and power of his painterly skills, Vermeer is able to achieve an effect quite unparalleled in the art of painting. A curtain that appears to have been swept to one side to allow us to see into the room beyond is a device that Vermeer used in the Rijksmuseum *Love letter* and the Beit *Lady writing a letter with her maid*, as well as the Dresden painting and the *Allegory of Faith* (even, surreptitiously, in the Frankfurt *Geographer*), but only in the *Art of Painting* does the curtain unmistakably hang near at hand. It has something of the scale of life. Of course, it being a curtain, we cannot be sure just how big life-sized would have to be. But the masterly painting of its rugged, slightly frayed texture imparts a powerfully close-up tangible quality and the scale is sufficiently large to be credibly within reach. A further compositional device contributes to this effect. The sweeping tapestry cuts through, inevitably, the beams of the ceiling, but also the top corner of the map, the trumpet of Fame, the upright book and draperies on the table and the chair-back. At each point of overlap there is a subtly different optical contrast between the silhouette of the curtain and the more brightly lit surfaces beyond, which imparts a novel conviction to the depth extending beyond the curtain. But this, for Vermeer, is the art of painting. From the painting of the *Procuress* and the *Girl asleep at*

a table, he had been concerned with the effect of remoteness on appearances. In the intervening cabinet paintings, he had abandoned the rugged, Rembrandt methods employed in those early pieces for effects more subtle, more truly optical. The fundamental achievement of the *Art of Painting* is to sustain that subtlety over so large a canvas. The painter and his model are not small, finely painted images to be pored over, to be admired for the skill with which they have been painted and enjoyed in the imagination: they are to be seen to be there before us but distant. In a way quite unlike the cabinet pictures, in a return to the ambitions of the Dresden *Young woman reading a letter at an open window*, the effect is to give the scene beyond the curtain the quality of being an extension of the space in which we, too, are standing.

Once again, it is a work that recalls the achievement of Parrhasios. Here, the curtain has been drawn back and yet the illusion does not end. Hoogstraten and Fabritius, to achieve their illusions, used perspective boxes that exclude the viewer, both from an examination of the mechanisms by which the illusion is created and from a sense of being present before the illusory scene. Vermeer, the phoenix Fabritius reincarnated, achieves his illusion without concealment. However minutely we may scrutinise it, we shall never comprehend how the illusion is achieved.

Finally, two further conceits, not yet considered. The *Art of Painting* is a celebration of the art of Netherlandish painting. The map on the wall shows the Netherlands before the political divison that followed the revolution against Hapsburg rule. The artist wears a fanciful version of a costume from the same era. But the chandelier bearing the Hapsburg two-headed eagle is without candles: the light of the Hapsburgs has gone out. Instead the clear, northern light, that has both created and been created by the art of Vermeer, illuminates the interior and of necessity reveals the rift, the deeply shadowed crease, that marks the present political divisions. Truth, though bitter, is superior to fancy, however attractive. That is the art of History painting.

Light must reveal one further thing. Here, in contrast to virtually every other painting Vermeer painted, there is no telling what this young woman is thinking about. She is only a model, only enacting a part. The mind at work, here, for only the third occasion in Vermeer's œuvre, is that of a man. We cannot know what he is thinking. He is not Vermeer, and the picture he is setting out to paint will be, we can already see, very different from the work we are contemplating. Yet he is rather like Vermeer. His subject is Clio, the Muse of History, but he is staring at a young woman. The resulting painting, though rather larger than most by Vermeer, will resemble his in its concentration on an solitary young woman. Perhaps when it is finished the viewer will feel inclined to attribute thoughts to her, to imagine the preoccupations of the Muse of History, while all the while admiring her chaste beauty.

We canot see this artist's mind, we cannot see his face. But from the light reflected from his chestnut hair (hair that matches the chestnut of the stool-seat) we can recognise the turn of his head, the direction of his gaze. From the level where his eye must be the lower, almost golden border of the map forms a fourth and final link between artist and model. On that narrow band is inscribed: I Ver-Meer.

Acknowledgements

Théophile Thoré's researches on Vermeer were first published under the name W. Bürger in the *Gazette des Beaux-Arts*, xxi, 1866, pp.297–330, 458–70, 542–75. The text from which I have taken my quotations is that published by André Blum in his *Vermeer et Thoré-Bürger*, Geneva 1945, pp.81–191.

Readers may have recognised how much I owe to the extensive and revealing archival researches that are the foundation of J. M. Montias's *Vermeer and his Milieu*, Princeton University Press 1989. I have also found invaluable the provenances for Vermeer's paintings established by Willem van de Watering and published in Albert Blankert's *Vermeer of Delft*, English edition Oxford 1978. I found further useful documentary material in what is in many ways an eccentric and superseded monograph, P. T. A. Swillens's *Johannes Vermeer Painter of Delft 1632–1675*, Utrecht 1950.

Arthur Wheelock, Jr., *Vermeer*, new edition London 1988, and the Rizzoli edition of *The Complete Paintings of Vermeer* (numerous editions internationally since 1967) remain useful. Leonard Slatkes makes many both learned and perceptive observations on individual works in his *Vermeer and His Contemporaries*, New York 1981.

Among the papers referred to in my text, Ivan Gaskell's "Vermeer, Judgement and Truth", on the *Woman holding a balance* in the National Gallery of Art, Washington, was published in the *Burlington Magazine*, cxxvi no.978, 1984, pp.557–61. James Welu's "Vermeer's *Astronomer*: Observations on an open book" appeared in the *Art Bulletin*, lxviii, no.2, June 1986, pp.263–67. On "The 'View of Delft' by Carel Fabritius" see the paper of that title by Walter A. Liedtke in the *Burlington Magazine*, cxviii, no 875, 1976, pp.61–73. For Samuel Hoogstraten's peepshow box in the National Gallery, London, see the *National Gallery Technical Bulletin*, xi, 1987, pp.60–85, with references to all essential previous literature on perspective and optics.

Two personal acknowledgements must be made. Many years ago now, my friend and sometime colleague Philip Dann worked out, and drew my attention to, the contrasting vanishing points of the National Gallery pendants. It was Charles Ford of University College, London, who in a conversation we had in 1987, while looking at Hoogstraten's peepshow box, pointed out to me that when viewed appropriately the painting on its top exterior also gives the illusion of Venus and Cupid being enclosed within the box.

My grateful thanks must go to Ivan Gaskell for supporting me in this project and to Frances Jowell for her expert help on Thoré.

I owe a real debt of thanks to Magnus Angus and especially Philip Buckley for their willingness repeatedly to put to one side their own researches to help me over my teething troubles with my first word processor. They have been enormously generous.

Finally, I want to thank Deborah Povey for everything. This is for her.

J. M. Nash, Wivenhoe, 22 March 1991

Index